GRANT
WOOD

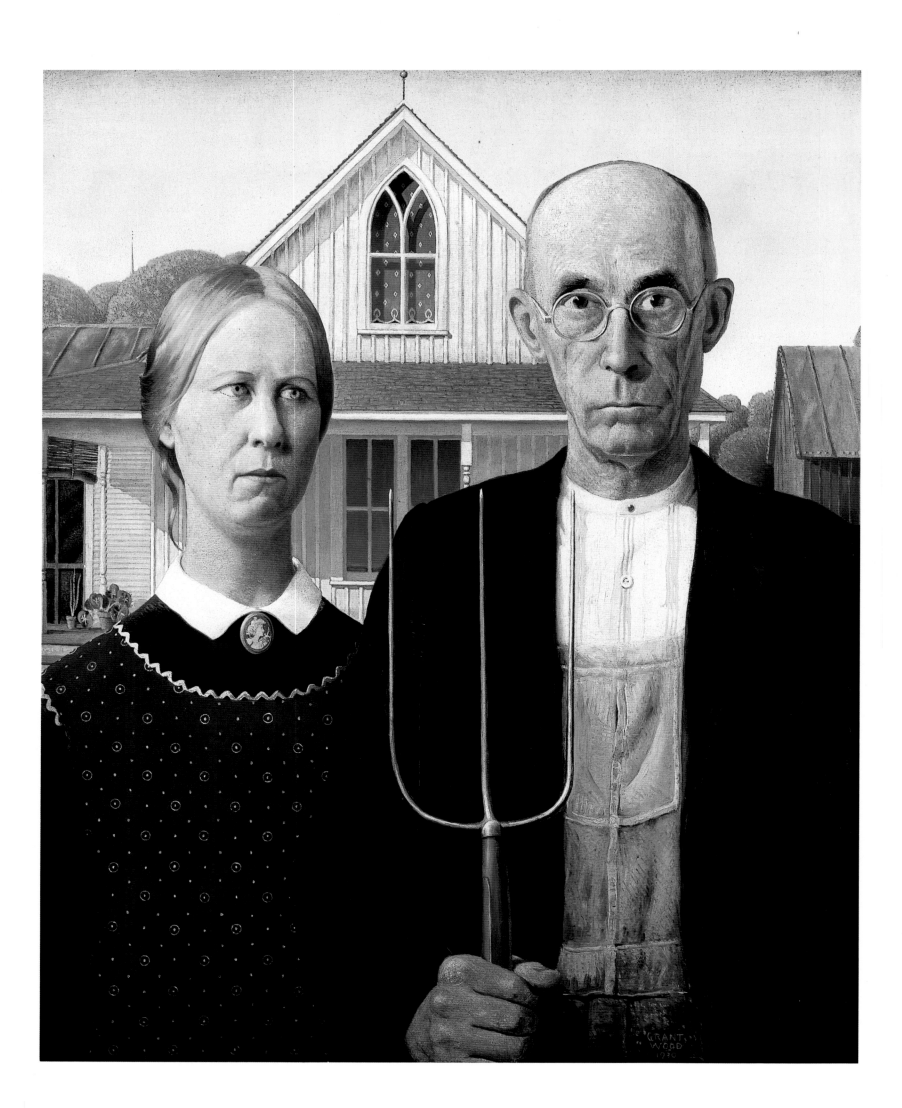

GRANT WOOD

Kate Jennings

Crescent Books
New York/Avenel, New Jersey

Page 2: American Gothic
1930, oil on beaver board, 30 × 25 in.
Friends of American Art Collection, photograph © 1993,
The Art Institute of Chicago, Chicago, IL, All Rights Reserved (1930.934)

Below right: The Birthplace of Herbert Hoover, West Branch, Iowa
1931, oil on composition board, 25⅝ × 39¾ in.
The John R. Van Derlip Fund; owned jointly with the Des Moines Art Center,
The Minneapolis Institute of Arts, Minneapolis, MN (81.105)

Copyright © 1994 Brompton Books Corporation

This 1994 edition published by Crescent Books,
distributed by Random House Value Publishing, Inc.,
40 Engelhard Avenue,
Avenel, New Jersey 07001

Random House
New York · Toronto · London · Sydney · Auckland

Produced by Brompton Books Corporation
15 Sherwood Place,
Greenwich, CT 06830

ISBN 0-517-10298-6

8 7 6 5 4 3 2 1

Printed and bound in China

Contents

INTRODUCTION 6

EARLY YEARS 38

TRAVELS 54

PORTRAITS 64

REGIONAL SCENES 90

LIST OF COLOR PLATES 112

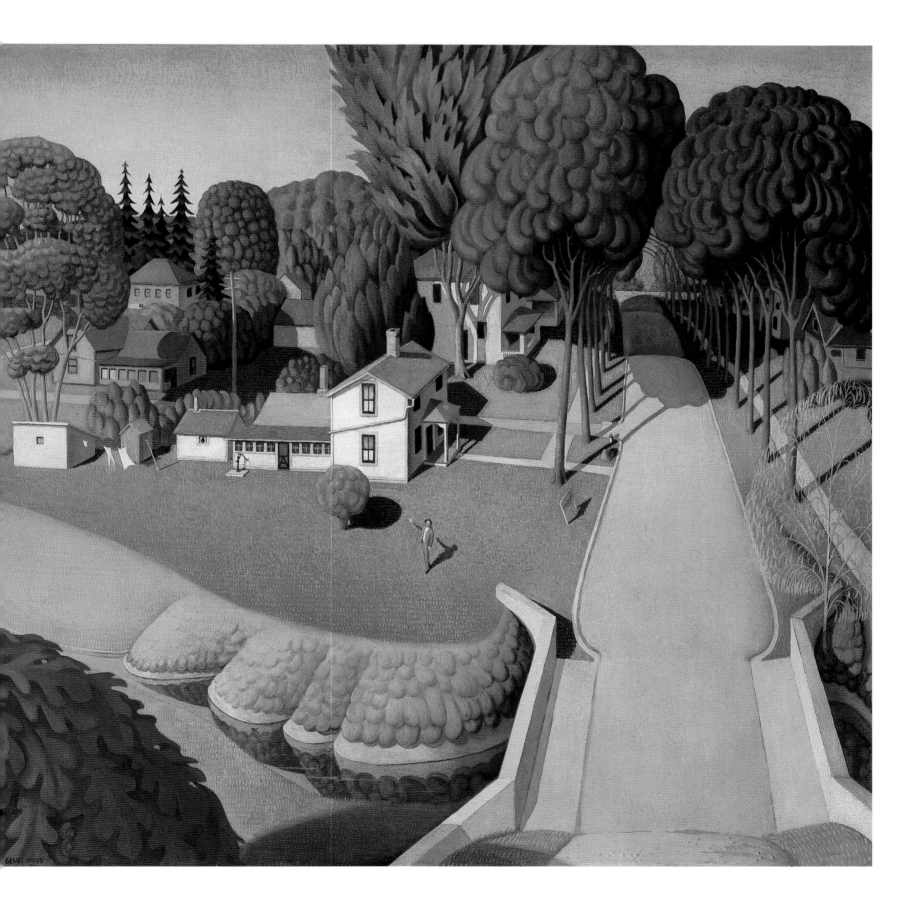

INTRODUCTION

Grant Wood grew up in the heartland of American farming territory – Cedar Rapids, Iowa. His familiarity with the town's carefully planned fields, religiously tilled acres and taciturn, homespun residents would contribute a unique, regional style to his paintings, particularly the well-known canvas, *American Gothic*.

Wood prized the rational, orderly aspects of these great expanses of corn and wheat, and distilled this quality of rhythmic precision in his brushwork. He added a sly Midwestern wit to his portraits but always maintained a sense of honor for hard, physical labor and an abiding love of the land and the people who worked it. He founded his art on his heritage, what he termed "an honest reliance by the artist upon subject matter he can best interpret because he knows it best."

American Gothic is the most famous canvas by Grant Wood, painted at the mid-point and what some critics consider the zenith of his career. It has been parodied by cartoonists, copied by illustrators and misinterpreted as to its intent and even its characters. The man and woman featured in the painting were the artist's sister, Nan, and a local dentist. They were posed by Wood as a farmer and his spinster daughter rather than man and wife as is commonly believed.

Below: Grant Wood poses in his Turner Alley studio in Cedar Rapids with *Arbor Day*, 1932. The artist's American style intrigued such Hollywood denizens as movie director King Vidor, who purchased *Arbor Day*.

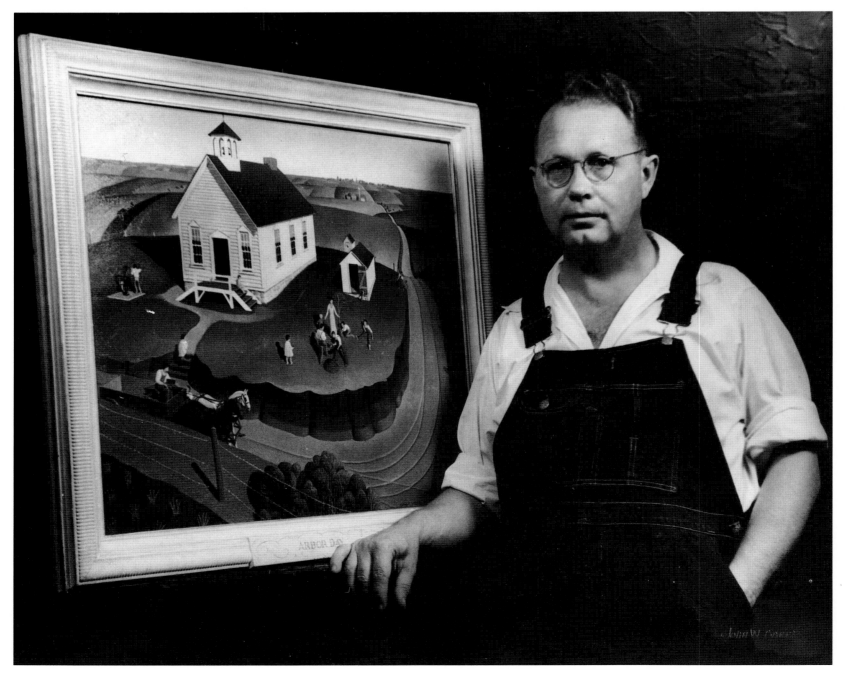

The painting has assumed the quality of myth in this country and seems so indelibly a part of the national spirit that it might well have been limned in colonial times. But that is not the case. The artist's Midwestern roots and family forebears and the Depression era all contributed to the creation of *American Gothic* in 1930, and to a singular career in American art.

Grant Wood was born February 13, 1891, and lived on a small farm near Anamosa, Iowa, for the first ten years of his life, a period that would later seem idyllic to him and provide inspiration for his best paintings. He was the second son of Francis Maryville Wood, known as Maryville, and Hattie Weaver Wood, a young woman who was the organist at the Presbyterian Church when Maryville met and wooed her. Maryville was then the superintendent of the Sunday School, and they married when she was 26 and he was 30. Hattie bore four children in 13 years: Frank in 1886, Grant in 1891, John in 1893, and Nan, Grant's only sister to whom he was devoted throughout his life, in 1899.

Maryville was of Pennsylvania Quaker stock and Hattie's ancestors were New England Puritans. A sense of austerity, thrift and careful attention to tasks was instilled in Grant at an early age. His father was somewhat remote, a stern authoritarian figure who banned Grimm's fairy tales from evening reading because he felt their make-believe aspects were mere "foolishness." He was quite well-educated, though, having attended two years of college, and impressed the value of study and literature upon his son. Hattie Wood was a more sympathetic character, which is apparent from Grant's 1929 portrait of her. His protectiveness toward her after Maryville's early death was notable.

Grant was a farmer's son who raised chickens, ducks and turkeys and was educated in a one-room schoolhouse. Anamosa was a village of only 2,000 citizens. There were no telephones, radios or automobiles to distract him from the duties and pleasures of rural life.

He entertained himself by drawing all kinds of pictures of chickens using a charred stick and brown wrapping paper. He even sketched the head of a chicken as a present for his teacher, Robin Wilson. At ten, the artist sent a list of 55 species of birds and their habits to the local newspaper, the *Anamosa Eureka*. This submission was a measure of his keen gifts of observation.

When Grant Wood reflected upon the insular environs of his rural boyhood and its influence upon his artistic style, he remarked, "In my own private world, Anamosa was as important as Europe to Columbus, and the Wapsie Valley, a half-dozen miles from our farm, had all the glamour that the Orient had for Magellan and Vespucci." The "Wapsie" was the Wapsinicon River where Maryville Wood and his family often ventured on Sunday outings.

Maryville Wood had a bad heart and died at 46 in 1901, an event that had dramatic consequences for his family. They moved soon after to Cedar Rapids 25 miles to the south. With a population of 45,000, Cedar Rapids seemed a large, bustling city after the sleepy calm of sparsely populated Anamosa. The Woods were forced to auction off all the farm goods to afford the purchase of a small two-story frame house. Grant traded his farm chores and free time for odd jobs in the new neighborhood to augment his mother's meager savings.

He was a blond, square-faced, plump young boy whose shyness and habit of swaying side-to-side when he spoke made his adjustment to Cedar Rapids an awkward one. He continued to focus on artistic projects and in the eighth grade won a national crayon contest for his study of a cluster of oak leaves. This symbol of sturdiness and fruition would reappear in a 1931 painting called *Herbert Hoover's Birthplace*, a 1928 stained-glass window memorial and a 1940 portrait commission of a Michigan banker.

While at Washington High School, Grant and his friend Marvin Cone made stage sets for plays and worked most afternoons for the Cedar Rapids Art Association. Grant occasionally spent the evening on a cot in the art gallery acting as night watchman.

Upon graduation from high school in the summer of 1910, Grant headed out to Minnesota to attend the Minneapolis School of Design, otherwise known as the "Handicraft Guild." He was attracted there by one of its teachers, Ernest Batchelder, the author of *The Principles of Design*, a book expounding the Arts and Crafts style. The teacher also wrote several articles that appeared in *Craftsman* magazine, to which Wood had a subscription in high school. Batchelder had taught at Harvard's Summer School of Design and his classes emphasized simplicity, repetition of motif, pleasing contour and plentiful design schemes. He particularly praised and espoused the virtues of Gothic architecture.

Batchelder's class was the first of a variety of courses Grant would enroll in over the next six years. His interest was in large part determined by financial considerations. In Minneapolis his training included shop sessions of metalwork and jewelry making, skills he improved upon when he returned to Cedar Rapids in the fall. Once there Wood exchanged free interior decorating services with his friend, Kate Loomis, for the use of her metal shop, and furnished and sold items of jewelry there. He also started up an illustration business with another friend, Paul Hanson, a photographer. Their company, Hanson and Wood, was short-lived and Grant returned to Minneapolis for a second summer.

Batchelder left the Handicraft Guild in the spring of 1911 and Wood completed his studies there soon after. His next professional foray was in teaching, which in time would promise a more productive future for him. Wood received a provisional teacher's certificate, and from 1911-1912 taught in a one-room country school called Rosedale located three miles from Cedar Rapids. He earned $35 a month. He also took a night class in life drawing at the University of Iowa and collaborated with Paul Hanson on a couple of magazine articles describing log cabin construction for *Craftsman* magazine. These netted the two of them a total of only $50 but at first their journalistic prospects seemed so bright they opened an office in Chicago.

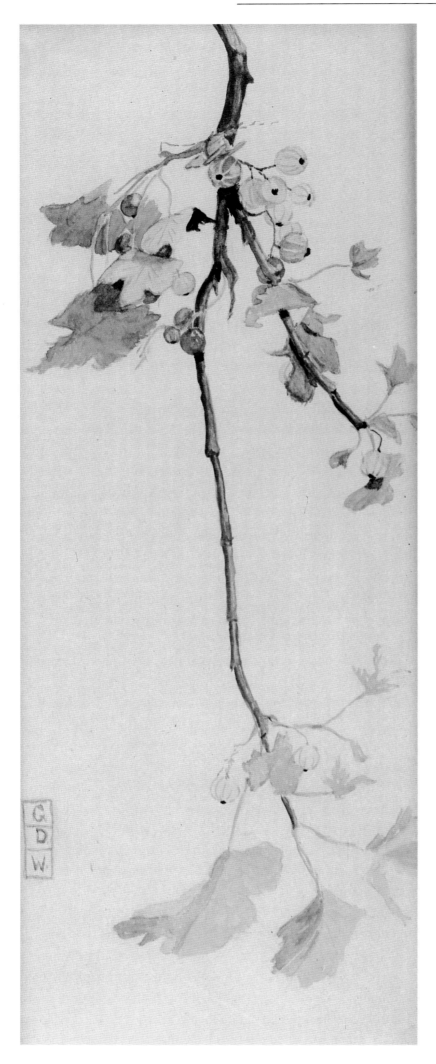

Above: Grant Wood painted *Currants* in 1907, when he was 16 years old. Many of Wood's early subjects were drawn from nature and farm scenes.
(The Davenport Museum of Art, Davenport, IA)

When they failed to place more than two stories they returned to Cedar Rapids.

In 1913 Grant took a job at Kalo Silversmiths in Chicago for $16 a week so that he could attend night classes at the Art Institute there. He opened up an independent venture called the "Wolund Shop" with several Norwegian craftsmen but this, too, was not a money-making enterprise. He signed up for a final semester at the Art Institute in the fall of 1916 but he couldn't afford it and returned, disheartened, to Cedar Rapids.

Grant's mother was also destitute at this point, having used up the small savings Maryville had left her. She was soon to be evicted from her home. Grant's brothers Jack and Frank had moved elsewhere, and Hattie's welfare was now his responsibility. Together Grant and his mother found a small cabin out by Indian Creek next to one owned by Paul Hanson. They lived on simple fare: elderberries, gooseberries and blackberries found in the neighborhood.

Grant's sister Nan occasionally came to visit or stayed with her maiden aunt, Sarah Wood, in Cedar Rapids. Grant slept on a cot, painted genre scenes of nearby locales and relished his one meal a day which consisted mainly of fried potatoes.

At 24, Grant Wood was a relatively innocent young man who did not smoke or drink and rarely spoke of women. Teaming up again with Hanson, he began construction on a pair of houses in Grove Court at Kenwood Park in Cedar Rapids. His paintings, like *The Dutchman's Old House with Tree Shadows* of 1916, reflected his interest in vernacular, Iowan architecture. He made a succession of sketches of indigenous trees and flowers, presenting Nan with *Quivering Aspen* for her 17th birthday. Though he struck up a friendship with Paul Hanson's wife's sister, Dawn Hatter, it never developed into a serious relationship.

Beginning in 1917, Wood received several assignments from Henry Ely, a Cedar Rapids realtor who was promoting his developer's homes. Wood was commissioned to make doll-sized models of these houses with lacquered sponges for trees. His pleasure in creating these tiny residences is evident by their reappearance in his regional landscape scenes. Their diagrammatic, stylized foliage and petite dwellings are akin to those seen on architects' plans.

For Ely, Wood also devised assorted pamphlets and programs. His lettering for Ely's advertisements was more interesting than their corny copy, which claimed "Every Bird and Bee That Lights, Finds a Home in Vernon Heights".

When World War I broke out, Grant Wood enlisted as a private in the Army and was stationed at Camp Dodge outside Des Moines. His artistic talent entertained his compatriots and he sold portraits to the privates for 25¢ and to officers for $1.00 a piece. He soon contracted anthrax and nearly died. After recovering, Wood was transferred to Washington, D.C., and assigned to paint camouflage for cannons and artillery pieces and to sculpt clay models of field-gun positions. He returned home on Christmas Eve, 1918.

Despite Grant's shyness and social foibles (including a slow speaking manner partly due to thyroid medication), the principal at Jackson High School, Francis Prescott, approved his application for a position as an art teacher. With a Special Subject Certificate to be a part-time instructor, Grant arrived at school on his first day, in the fall of 1919, wearing his army coat and campaign hat. He earned only $900 his first year, and taught in uniform to save money.

In October 1919, Wood and his high school friend, Marvin Cone, had a two-man exhibit at Killian's Department Store in downtown Cedar Rapids. Cone was teaching French and Art at Coe College, a small liberal arts institution on the outskirts of the city. Wood displayed 23 panels of his work, oil on composition board landscapes with a conventional, picturesque approach. His brushwork was fluffy and impressionistic with a busy, animated textural surface. Significantly, eleven of these panels featured outbuildings of farms and small cabins not unlike the one in which he lived. The best of these – *Old Stone Barn, Old Sexton's Place* and *Feeding the Chickens* – disclose an interest in clapboard patterns, rooflines and corner interstices that prefigures the singular structure in *American Gothic*.

Grant Wood selected settings and climatic conditions that conveyed warmth and composure in *Yellow Shed and Leaning Trees* and *Horse Traders*. These were unremarkable perspectives of quiet scenes that revered a simple life with few luxuries and nothing extreme or extraordinary. Storms, tragedies and dramatic characters never appear in Grant's early canvases.

Wood was thought to be rather eccentric by Cedar Rapids standards, keeping strange hours, painting at night and making odd sculptural pieces out of junk metal that he called *Lilies of the Alley*. He was very orderly, never amassing any memorabilia but he was also absent-minded. Though naturally serious and fairly introverted, he loved costume parties. One of his quirkier inventions was a left-hand turn signal for his car, a wooden hand with its index finger pointed in that direction.

In the summer of 1920, Grant Wood sailed to Europe with Marvin Cone for his first exposure to foreign culture. He was a typical tourist, visiting well-known monuments and cathedrals and sketching quick, plein-air oil compositions of quaint cobblestone streets and pretty fountains along the way.

Wood and Cone stayed in a boardinghouse whose landlady, Madame Betat, was one of their few French contacts other than a nearby café's proprietor and various food peddlers. The Iowans took no classes and spoke very little French other than the simplest phrases, and spent their days wandering the streets in search of picturesque venues for their paintings. Light operas performed by local troupes were their source of entertainment.

Grant Wood's small oil sketches on composition board were city vignettes of peasant folk that would be special attractions to residents of Cedar Rapids. They are similar in subject and mood to the leisurely reveries he sketched of barns, fields and farming people back in Iowa.

His impressionistic brushwork in 1920 seems closest to that of Utrillo, Bonnard and Vuillard but at this stage in his career

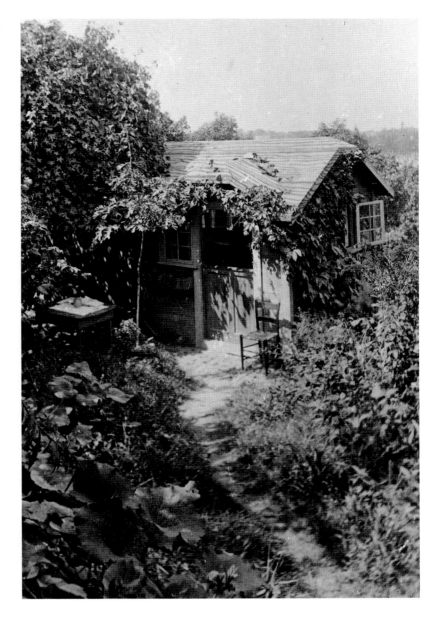

Above: In 1916 Grant Wood and his mother lived together in this small, rustic cabin near Indian Creek in Cedar Rapids.

Below: Grant Wood created this sculpture, *Lilies of the Alley*, with junk metal and found objects, in the mid-twenties. (The Cedar Rapids Museum of Art, Cedar Rapids, IA)

he had had few opportunities to study painting techniques and his style was not particularly well-defined. When he left at the end of the summer, he was determined to return to Paris and enroll at the Académie Julien. His most obvious French affectation was the goatee and mustache he grew while abroad which so ill-suited him that he was promptly urged to shave them off back in the Midwest.

Francis Prescott transferred from Jackson to McKinley High School and brought Grant Wood along with her as an art instructor. He was a patient, flexible and inspiring teacher. True to his Arts and Crafts background, he used natural materials and found objects to furnish decorative, well-designed handmade items. His students coated paper with paraffin to make lampshades and they perforated metal cans with lively patterns for tin tile flooring. Grant provided program covers for school events and involved his pupils in model production and mural painting. One of his students won a $100 prize for a poster. Grant endeared himself to Miss Prescott by carving a "Mourner's Bench" for a spot outside her office with the warning: "The Way Of The Trangressor Is Hard."

Grant's most interesting and ambitious art project with his ninth-grade class was a huge, fanciful frieze called *Imagination Isles*. It was filled with billowing skies, purple mountains, vast ships and mother-of-pearl palaces. In his descriptive address to parents of the students, Wood focused on the value of dreams: "It is difficult to find people who can produce the material of dreams. Almost all of us have some dreampower in our childhood, but without encouragement it leaves us and we become bored and tired and ordinary . . . we are apt to forget the dream spirit that is born in us."

The invocation of the unconscious was a modernist idea embraced by such Symbolist poets and painters in the late nineteenth century as Charles Baudelaire and Albert Pinkham Ryder. In fact, many of Grant Wood's mature regional canvases seem to linger in a somnolent state, bathed and becalmed in a surreal, rarefied light. For an artist whose work so often centered on his hometown, perhaps this yearning for a journey into a different realm was wishful thinking.

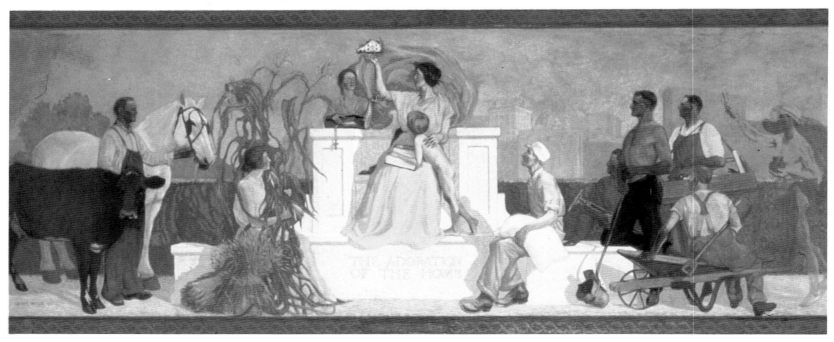

Above left: Grant Wood (middle left) sailed to France in the summer of 1920.

Below left: Grant Wood depicted local themes and values in his 1921 mural, *Cedar Rapids* or *Adoration of the Home*. (The Cedar Rapids Museum of Art, Cedar Rapids, IA).

Right: Grant Wood and his ninth-grade students at McKinley Junior High School work on a fanciful frieze called *Imagination Isles*, 1924.

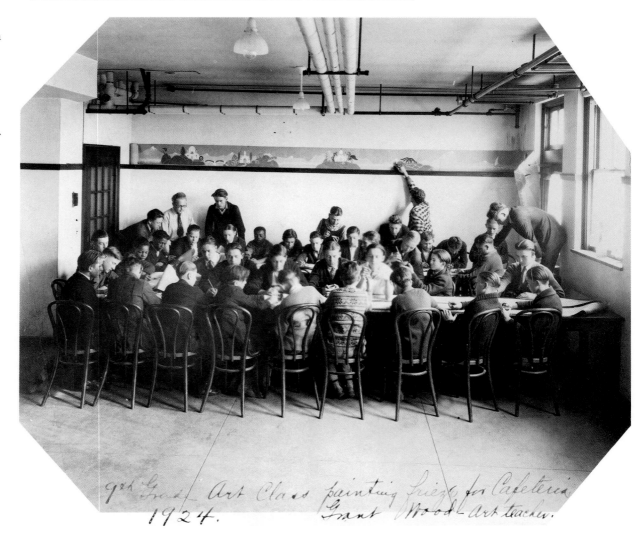

9th Grade Art Class painting frieze for Cafeteria 1924. Grant Wood art teacher.

By gradual increments Wood's salary increased to $1,700 by his fourth year at McKinley. He earned additional income by painting an outdoor advertising mural for Henry Ely in 1921 entitled *Adoration of the Home*. This was a large canvas glued to a wood panel. It contained allegorical characters as icons of regional goals and enterprises. Different figures represented education, religion, animal husbandry and commerce, among other themes. Wood posed his friend Paul Hanson as a carpenter in the mural, and local types fulfilled the other roles.

In 1923 the artist applied for and received a year's leave of absence from teaching and set off again for Paris. He spent 14 months in Europe this time, beginning with life study classes at the Académie Julien on the Rue du Dragon. His classmates nicknamed him Tete de Bois, or Wooden-head, a play on his last name and a reflection on his inability to speak their language.

Grant's attendance was irregular and few studies remain from his time at the Académie with the exception of *The Spotted Man*, a stiffly posed nude man he decorated with red blotches to call attention to his work. The background is soft and blurred in the impressionist manner but the model's sturdy, realistically rendered limbs are closer to the style of Thomas Eakins than of any French master.

Grant had a studio off the Boulevard Raspail and as in 1920, his small paintings capture postcard images of friendly, familiar settings in the quiet squares and parks that surrounded him. These sketches were a visual diary of his journeys. His craftsman's eye is noticeable in the construction details of *Fountain of the Medici* and *Doorway, Perigeux*. Medieval stone portals and gothic archways were drawn so often that a psychological quest on Wood's part may be suggested by these paintings, a search for artistic passage. A highlight of his stay in Paris was dressing as a fish-in-a-net for Quat-z-Arts costume ball.

Wood abandoned his cold, wintry Paris flat in late 1923 for Sorrento, Italy, on the Bay of Naples. His headquarters there was the Hotel Coccumello, a former monastery that offered its lobby to him as a site to exhibit his paintings of Italian farmyards and village habitués. He sold several of these to townspeople to support his visit in the sunny climes. The following spring he set off for a rambling tour of Palermo, Bordeaux, Brittany and Belgium before landing back in Paris.

Grant was once more short of funds and ready to return to Iowa, but he made arrangements for a future exhibit with the Galeria Carmine in Paris before his voyage home. Back in Cedar Rapids, Grant discovered his favorite sibling, Nan, had married Edward Graham and his mother, now 66 years old, was grateful for his company. He went back to teaching at McKinley for a brief time but soon struck up a friendship with the owner of a local funeral parlor, David Turner, the man who would become his most dedicated patron and enthusiastic ally.

Turner provided the artist with rent-free living quarters in a stable loft behind his mortuary. Wood fashioned an eclectic studio space for himself and his mother, who tended snake plants, begonias, petunias, geraniums and ferns in window-boxes and a small garden plot. Grant's furnishings were inventive, including a dining table that folded up and cots that

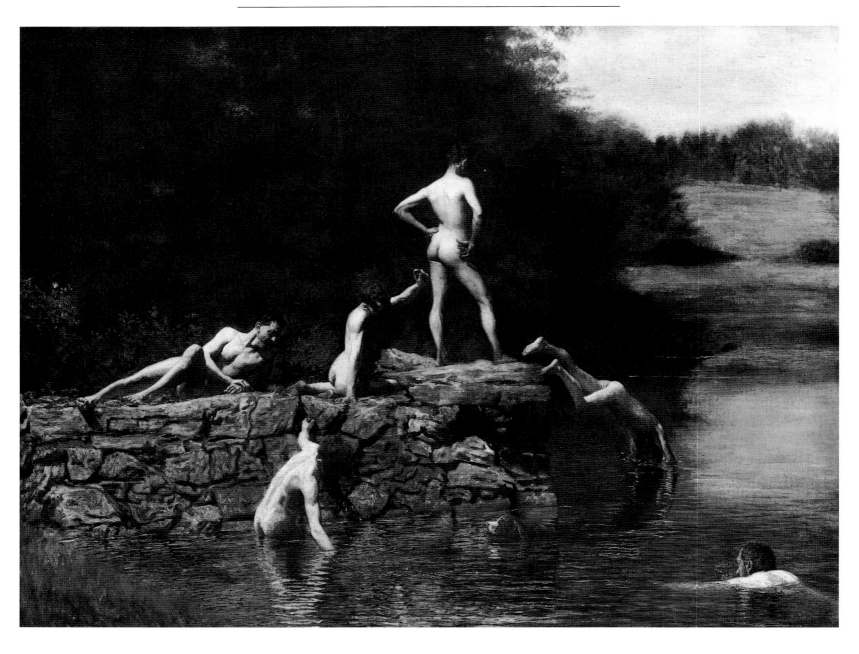

slid away out of sight when not in use. In the bathroom, a tub was lowered into the floor for shower space. Wood's easel stood prominently in one corner and he hung heavy drapes along the back wall to convert the studio into a community theater. The former livery became a novel attraction in Cedar Rapids and a welcome outpost for local writers and artists.

Wood's financial arrangement with Turner made it possible for him to abandon teaching at McKinley in favor of painting and decorating assignments for regional businessmen. In the late 1920s Grant began to receive recognition as a native son artist. He painted a series of workingmen portraits for the J. G. Cherry factory in the summer of 1925, as well as a canvas of the dairy equipment plant itself. David Turner hired Wood to decorate the interior of his funeral parlor, and hung his landscape canvases there for sale. Turner advertised Wood's talents in a January 1926 issue of the *Cedar Rapids Gazette*: "In Grant Wood, Cedar Rapids has an artist whose work is bringing fame to the city and whose artistic influence is being felt in many ways which tend to beautify the city." Turner also arranged a contract for Wood to supply a design for letterhead and chinaware to the Cedar Rapids Chamber of Commerce, whose offices the artist decorated.

In the spring of 1926 Wood borrowed $1,000 from Henry Ely to return to France for his gallery show at 51 Rue de Seine in

Paris. He displayed 47 canvases and panels of French scenes at the Galerie Carmine, a small but well-respected establishment. Although praised by the French press, few of the works sold and Wood received no attention from American critics. Pope Pius XI wrote and asked for reproductions but despite this honor, Wood lost money on his venture and was sorely discouraged about his prospects. He did manage to attend the Quat-z-Arts Ball once again, this time in the improbable costume of a ballet dancer, but his interests in France and continental culture flagged and he sailed for home.

A variety of commissions awaited Wood upon his arrival back in Cedar Rapids. He painted murals of corn shocks for a restaurant in the Hotel Montrose, one of a chain of Midwestern inns that belonged to Eugene Eppley. Wood also limned a village scene called *Kanesville* at Eppley's Hotel Chieftain in Council Bluffs. This mural combined a number of elements that would evolve into Wood's mature style. The subject was historical and Wood referred to old maps, engravings and primitive images of Kanesville for his design scheme. These eight-foot high canvases with a bird's-eye view and naif folk style owed a debt to Iowa's past and predicted Grant Wood's future.

Another patron was John Reid, president of the National Oats Company, who purchased several canvases from Wood and gave him badly needed advice about monetary matters.

Armstrong's Department Store in downtown Cedar Rapids employed the artist to outfit its display windows and interior showcases. In partnership with Bruce McKay, a builder and general contractor, Wood helped design and decorate homes for David Turner, Robert Armstrong and Herbert Stamats, a prominent publisher.

Wood and McKay adapted their plans to the owners' desires, constructing neocolonial houses for Turner and Armstrong and a late 19th-century styled Iowan house for Stamats. They rarely used progressive designs, preferring historical details such as hand-painted flowers to resemble stencils and colonial lanterns in the hallways. Wood furnished the interior of a home belonging to Van Vechten Shaffer, a Cedar Rapids banker, and painted Early American portraits of his two little girls, Susan and Mary, for which the artist received $150 each.

Cedar Rapids in the late 1920s was a burgeoning city on the Cedar River whose avenues of transportation and hydropower

made it an ideal processing center for Midwestern agricultural products. It featured a pork-packing house, a flour mill, a corn syrup and corn derivatives company and an oatmeal producer. The entrepreneurs and manufacturing chiefs of Cedar Rapids encouraged Wood to reflect and preserve local atmosphere and pursuits in his work.

Wood was considered an artist sympathetic to the city's commercial needs and a conduit for its cultural development and discourse. Support for the arts and intellectual endeavors was growing at the Cedar Rapids Art Association, founded in 1905, and at Coe College, a small liberal arts institution on the border of the city limits. By 1921 the city had its own symphony orchestra.

In 1928 the American Federation of the Arts selected Cedar Rapids to be "an experimental art station" with monies provided by the Carnegie Foundation. With its bequest the Little Gallery in Cedar Rapids was formed. Its director, Edward Rowan, had a master's degree in fine arts from Harvard, and he strongly encouraged Grant to display his canvases at the annual Iowa State Fair and in juried exhibits at the Art Institute of Chicago.

The Little Gallery initially occupied only a storefront area but soon expanded and moved into a Victorian house.

Left: The blend of impressionism and realism of Thomas Eakins's *The Swimming Hole* can be compared to the style of Grant Wood's early work. (Amon Carter Museum, Fort Worth, Texas)

Below: No. 5 Turner Alley was a studio and living space in Cedar Rapids provided to Grant Wood and his mother rent-free by the artist's patron, David Turner.

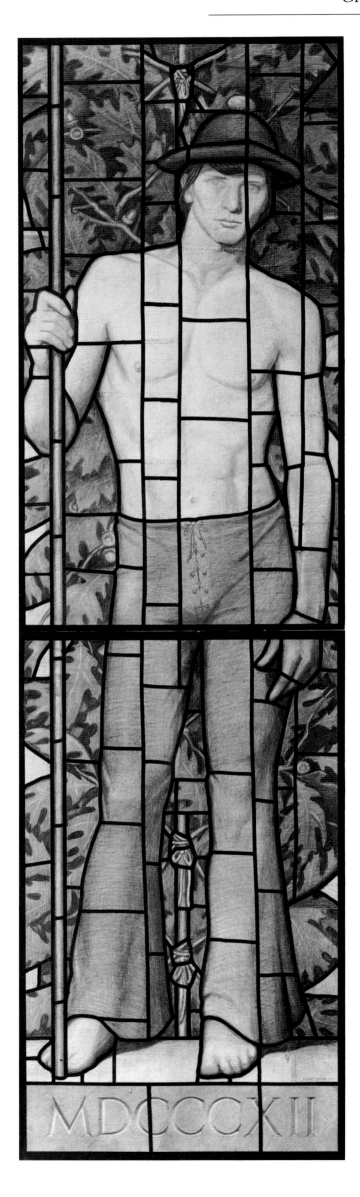

Although avant-garde books were available in its shop, its shows were representational in nature. Rowan championed the works of artists like Edward Hopper, Charles Burchfield, Charles Hawthorne and members of the American Impressionist movement.

In addition, a cultural center sponsored by the Fine Arts Studio Group was established at Hobby House, a three-story home that once belonged to Edward Mansfield. Its floors were occupied by a gift shop, a music studio, the art school of the Cedar Rapids Arts Association, the editor's office of the *Cedar Rapids Republican*, and the atelier of Edgar Britton, another local artist. Wood was a frequent visitor.

Wood also initiated the Garlic Club at this time, Cedar Rapids' equivalent of a salon. Its devotees were a coterie of corporate magnates, literary lights, members of the press and assorted aspiring artists. Wood's closest friends were writers, particularly those like Jay Sigmund, Ruth Suckow and William Shirer, who championed Midwestern values and characters.

Suckow was frustrated by the public perception that Midwesterners were "intellectual poor relations to the Eastern States." She wrote perceptively about her region, "Until the last few years it has been accepted almost without question that its young intellectuals must go away – preferably to New York but at least away! – in order to find something 'interesting' to write about."

When the *New Yorker* magazine was founded in 1925, its editor proclaimed that its pages were "not edited for the old lady in Dubuque." Grant Wood and his associates labored assiduously to counteract this kind of attitude toward Iowa's citizens.

Wood was awarded a significant municipal commission in 1927 with the design of a memorial stained-glass window for the Veteran's Memorial Building. Located on an isle in the Cedar River, the Veteran's Building was an imposing citadel encompassing the town hall, chamber of commerce and a civic auditorium that housed a $35,000 pipe organ.

Wood enlisted the aid of a St. Louis stained-glass artisan, Emil Frei, for the project and the two men traveled to Munich, Germany, to supervise a team of ten skilled craftsmen in the memorial's production. Its format would feature six soldiers as symbols of the men who died in America's six wars.

The main figure was a saint-like female presiding over the veterans as an allegory of a beneficent republic. She dwelled in romantic clouds while the footsoldiers were banked against a dense forest of earthy oak leaves. Their expressions were somber and subdued. No hint of tragedy, struggle, victory or ascen-

Left: Grant Wood's 1927 study in pencil and ink, *Soldier in the War of 1812*, for the Cedar Rapids Veteran's Memorial Building stained glass window. (Davenport Art Gallery, Davenport, IA)

Right: While in Germany working on the memorial stained glass window, Grant Wood spent time studying work of the old German and Flemish masters, including Albrecht Dürer's *Self-Portrait*. (Alte Pinakothek, Munich, Germany)

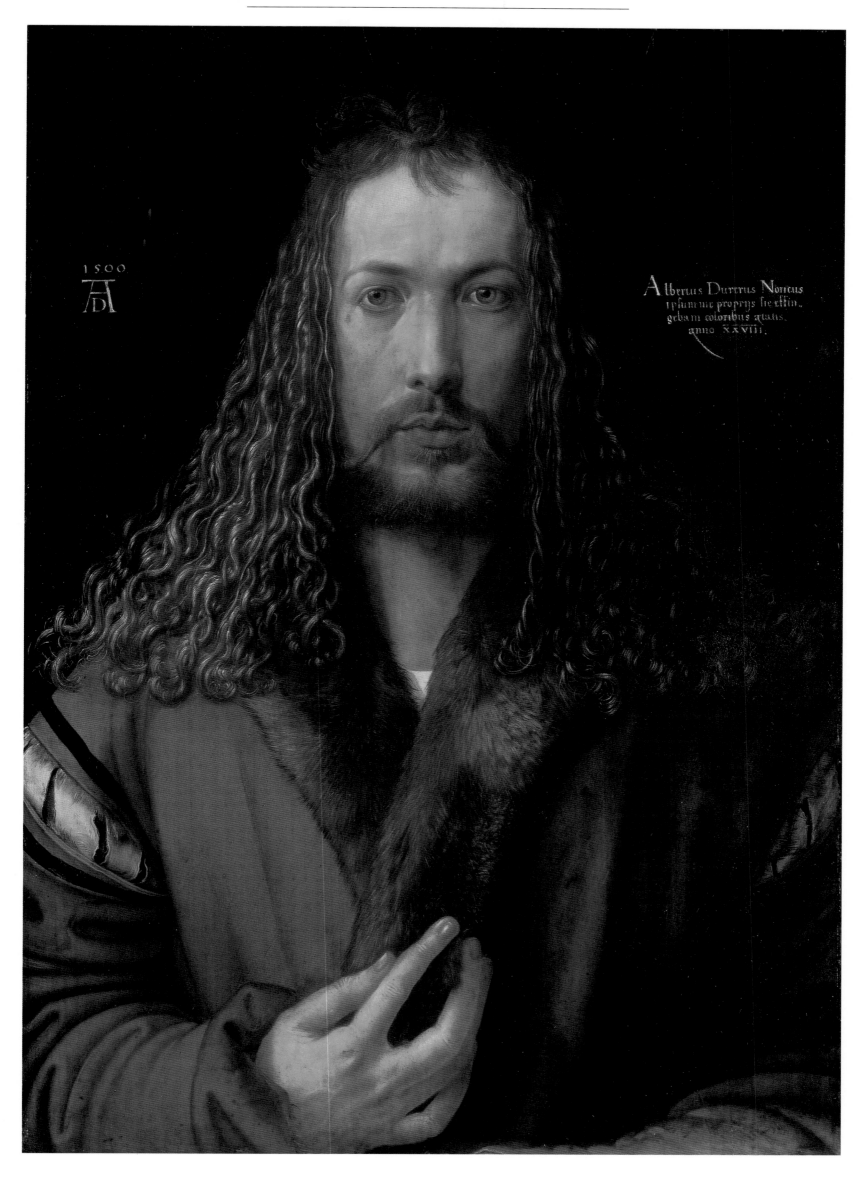

sion is suggested by their strict horizontal arrangement and stiff, academic poses.

Wood rarely gave rein to any emotional volatility in his work and this stained-glass memorial, for which restraint was appropriate, is no exception. The German glassmakers were more accustomed to fashioning portraits of religious figures than soldiers. They required Grant's guidance to make the physiques and features less beatific and more American. Wood did the staining of all of the faces himself, except for the World War I soldier which was finished by Frei. Wood never learned to speak German and for more than two years of work on the project (1927-1929), earned less than $800.

The most far-reaching effect of Wood's visit to Germany was derived from his forays to the Alte Pinakothek, the art museum in Munich. Here Grant studied portraits and landscapes by German and Flemish masters of the fifteenth and sixteenth centuries and watched a copyist apply glazes in the manner of these artists. Works by Albrecht Durer, Hans Holbein and Hans Memling especially caught his attention. He admired

their use of severe poses, inscrutable expressions and decorative patterns in clothing and landscapes. The appeal of Memling's Gothic period would soon blossom in Grant Wood's paintings.

Unfortunately, the stained-glass memorial fostered dissension rather than unity in Cedar Rapids, and brought Grant unexpected and unwarranted criticism. The Cedar Rapids chapter of the Daughters of the American Revolution and local members of the American Legion loudly opposed its assembly on foreign soil, particularly that of a former enemy. There was no acknowledgement of the window's rich color, Wood's thoughtful compositional scheme or its fine construction – only self-righteous provincial comments were voiced by these groups. No dedication ceremony was ever scheduled and to this day, there is no inscription on the central stone. At Wood's insistence, the best the local government would offer was a resolution that the artist "completed a satisfactory installation."

Grant Wood's patrons were loyal, however, and continued to boost his spirits and revenues with portrait commissions and interior design activities. David Turner requested a portrait of his father and Wood obliged with a memorable image in 1929 entitled *Portrait of John B. Turner, Pioneer*. Wood posed the 71-year-old former funeral director before a unique backdrop – a map of Linn County, Iowa. The shapes and seams formed by the county lines match the contours of Turner's bald pate and the creases of his purposeful gaze and determined mouth.

Left: *St. George* by Hans Memling. Memling's influence can be seen in Wood's work after his visit to Germany. (Alte Pinakothek, Munich, Germany)

Below: The landscape of the J. W. Richardson homestead in Jackson, Iowa, provided inspiration for Grant Wood's *Stone City.*

John Turner called his portrait "two old maps" and it was a resounding success. Wood submitted it to the arts competition at the Iowa State Fair where it won the portrait and sweepstakes prizes. The judge, Chicago critic Oskar Gross, remarked, "I haven't seen anything like this since the old Dutch masters. Surely a young man could not have painted it." Wood was 38 years old and at a transition point in his career.

The artist's next venture was a portrait of his mother. Rather than a sentimental reverie, Grant devised a cool, objective and intriguing vision. Its title, *Woman With Plants*, reflects his desire to distance himself somewhat from the painting. Mrs. Wood donned a plain black dress topped by a simple green apron with yellow rickrack that added decorative patterns typical of a farm woman's costume. Several aspects – including

the placement of the rural landscape beneath her form and the country road that zigzags through it – were borrowed from the *Mona Lisa*. Here was Wood's first deliberate attempt at a neo-Flemish painting and he used glazes to achieve old master effects.

Woman With Plants epitomized the soul of the Midwest in a way that struck a chord with local critics and distant jurors. It

was Grant's first painting to be accepted at the annual exhibition of American painting at the Art Institute of Chicago where it went on view in the fall of 1929. The Cedar Rapids Art Association bought the picture for $300.

A landscape of Stone City, a once vibrant town built around a limestone quarry later eclipsed by cement manufacturing, was depicted by Wood in 1930. The ingredients of its style soon became a Grant Wood formula. Its layout, with a perspective far above the town, was based on a topographical map from an old atlas. Every flaw was removed from *Stone City* until the surface was as smooth and hard-edged as the home model settings Wood built for Henry Ely.

The light was warm and inviting, each plant, tree and barn regimentally conformed to an ideal, and an aura of pastoral contentment prevailed. Wood included a windmill in the center of the composition, an icon of Iowa that became his logo. After capturing the top landscape award at the 1930 Iowa State Fair, the painting was bought by the Omaha Society of Liberal Arts and displayed there in the Joslyn Memorial Museum.

Grant Wood painted *American Gothic* at a propitious time. The United States was reeling from the stock market crash of 1929 and entering the Depression era, ready to leave behind the champagne and heedless consumption glorified in F. Scott Fitzgerald's *The Great Gatsby*.

Wood's image of a homely Iowan farmer and his unmarried daughter standing protectively before their provincial Gothic cottage must have seemed to critics and the public alike to be a moral lesson for the times.

The canvas changed the course of Grant's career and the unbridled acclaim it attracted, wholly out of character with the probity of its spirit, would carry him into a limelight for which he was largely unprepared.

Based on tintypes from his family's old photograph albums, the figures in *American Gothic* were mythic agrarian characters. He arranged their forms to echo the narrow vertical lines of the Gothic window placed above them in the composition. His sister, Nan, put her hair up in a bun so that she resembled an ancestor from an earlier era. The stern, protective, paternal quality Wood painted into the local dentist's features was inspired by the father he knew briefly as a child.

There is little sense of welcome or warmth in the picture, yet it distills the integrity and hard-bitten independence represented by the small-town Iowan farmer.

Left: Reminiscent of the figures and house in *American Gothic*, this 1886 photograph depicts pioneer John Curry and his wife in front of their sod house near West Union in Custer County, Nebraska.

Pages 20-21: Grant Wood's sister, Nan, and the local dentist, Dr. B. H. McKeeby, pose in 1942 before *American Gothic*, for which they modeled.

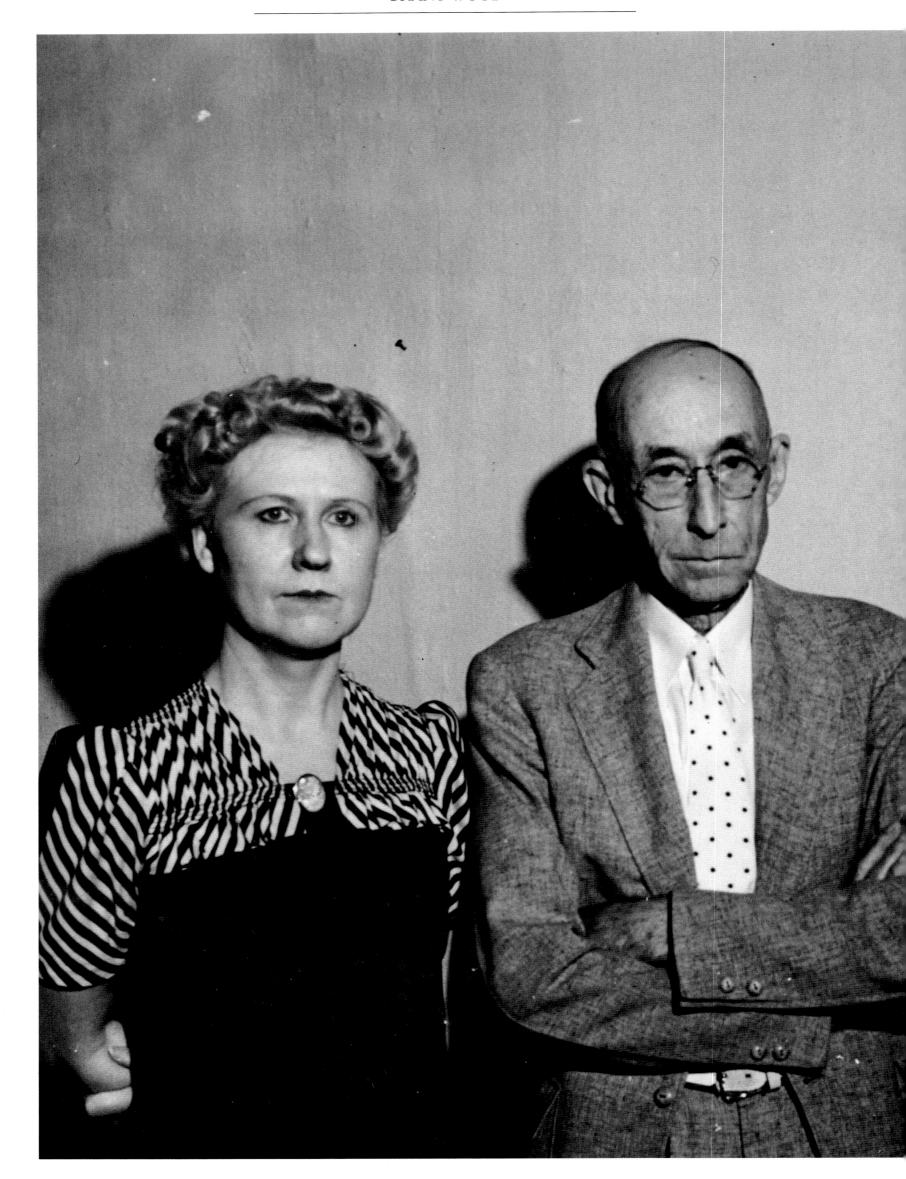

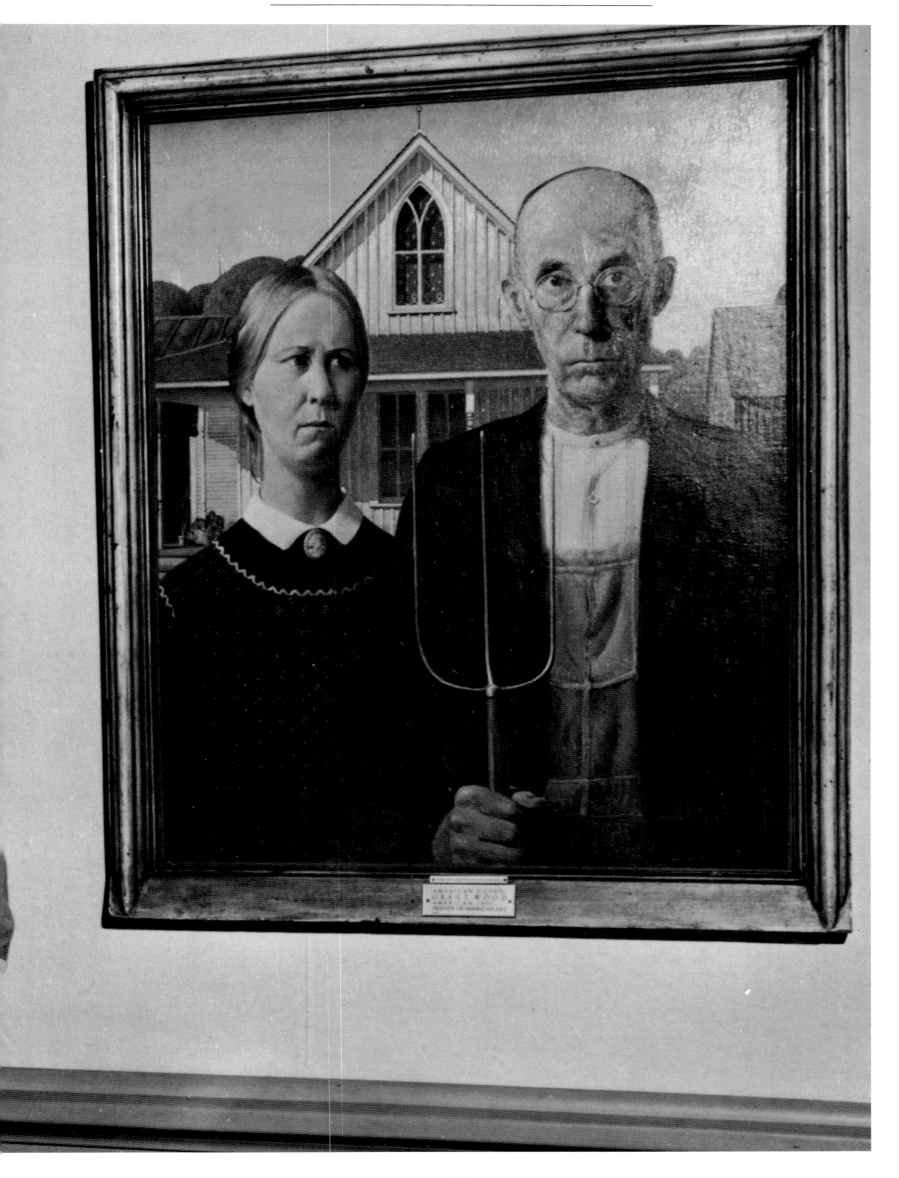

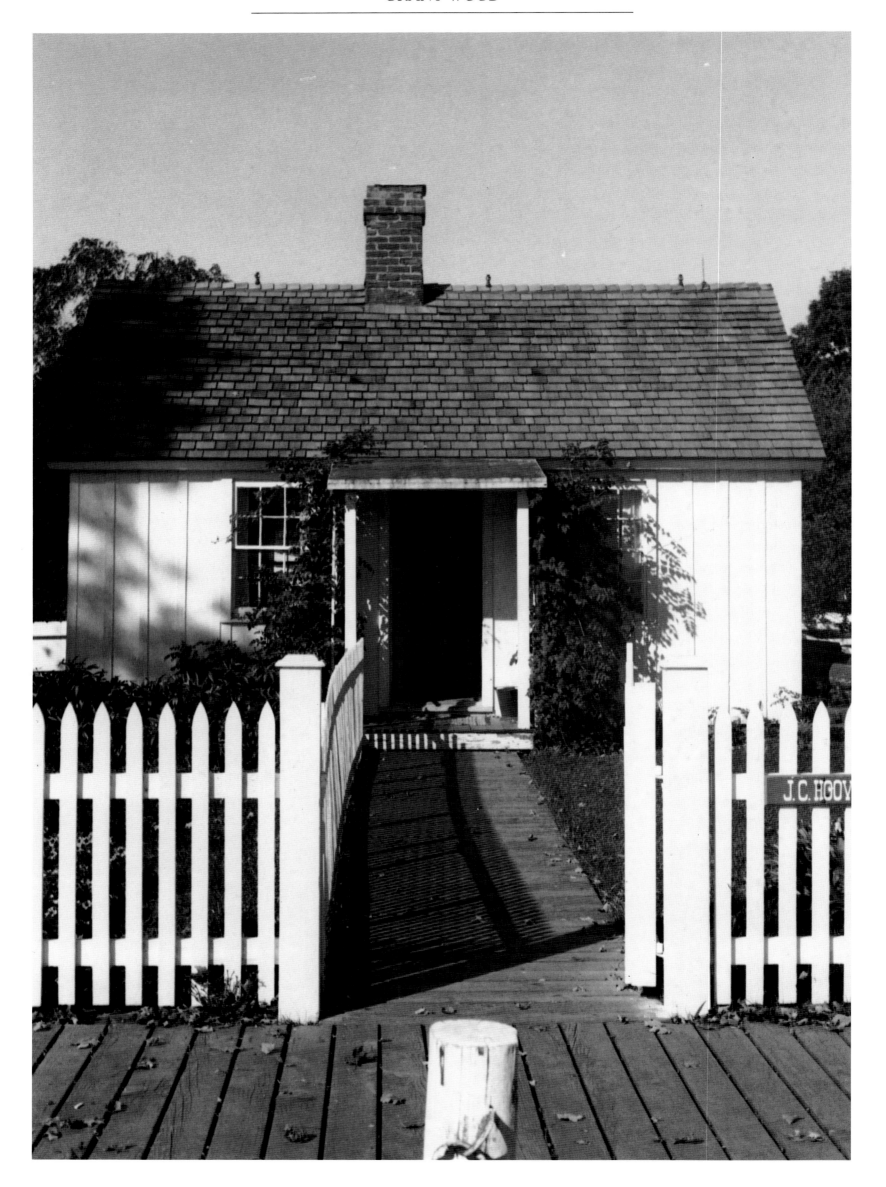

Wood planned the painting quite precisely from the outset. The final canvas, measuring 25″ × 30″, is little different from a thumbnail sketch the size of a postcard he first drew for it. Critics from other parts of the country considered it a work of social satire but reviewers from America's heartland were more sympathetic. Marquis Childs, a Midwesterner, called it "Iowa, grim, bleak, angular with a touch of humor and a heart of gold."

American Gothic won the Harris Bronze Medal at the Art Institute of Chicago's annual exhibit of American painting in the fall of 1930. This was just the beginning of its fame. The public was fascinated by the painting and photographs of it appeared in newspapers across the country. The Art Institute of Chicago purchased the painting for $300, the first museum to buy a work by Grant Wood. The artist's mentor Ed Rowan of the Little Gallery was so pleased with its success he arranged a reception for Grant after the exhibition and over 600 people attended.

Wood was entering the most fertile and active period in his career. His portrait, *The Appraisal*, depicting a young farm woman with a hen meeting a city matron dripping in minks, won first prize for oil paintings at the 1931 Iowa State Fair. It barely disguises Wood's antipathy for wealthy, urban visitors to the Midwestern scene – even the plump hen is more prettily patterned than the old dowager.

The Birthplace of Herbert Hoover followed in 1931, when Iowa's best-known citizen and first president of the United States was in his third year of office. Grant Wood's rise to prominence and facility at promoting his region's artistic values coincided with a time when a fellow statesman led the country. Hoover's election brought recognition to West Branch, Iowa, and Grant Wood capitalized on it.

The absolute symmetry and fit of every neatly clipped bush, hedge, tree, and evenly planed home are a linchpin of Wood's 1930s' method. The rhythmic design scheme of Hoover's neighborhood is emphasized more than the little cottage where he was born.

In the same year, Wood also completed *The Midnight Ride of Paul Revere*, *Young Corn*, *Fall Plowing*, *Victorian Survival* and *Portrait of Nan*. Wood kept his sister's portrait thoughout his life, but the other paintings were quickly acquired by collectors around the country.

Fall Plowing won the Landscape Prize at the 1932 Iowa State Fair and was bought by Marshall Field III, heir to the Chicago department store fortune. The Dubuque Art Association purchased both *The Appraisal* and *Victorian Survival*. *Young Corn* was sold to the Woodrow Wilson High School in Cedar Rapids. There was a steady market for Wood's artwork and its

domain was growing. *American Gothic* was taken to London in 1931 for display, a token of Wood's international renown.

Wood's satirical 1932 canvas, *Daughters of Revolution* appeared at the Carnegie International Exhibit in Pittsburgh and the first Biennial Exhibit at the Whitney Museum in New York. After the public criticism of his memorial window by the Cedar Rapids D.A.R., Wood was not inclined to paint a favorable image of ladies whom he called "those Tory gals." Their homely faces look accordingly mean-spirited and undemocratic. The actor Edward G. Robinson bought the painting because it amused him. Postcards of the portrait were a popular souvenir item in Pittsburgh.

For the Hotel Montrose in Cedar Rapids, Wood painted five decorative murals in 1932 called *Fruits of Iowa*. These livened the coffee-shop walls with generic farm characters busy with traditional activities: milking the cow, tending to chickens, carrying bushels of corn and carving slices of watermelon. Their faces all feature plump cheeks, snub noses, thin lips and round contours – playful spoofs of a common folk type of Iowa.

Wood called his 1932 paean to two Iowan elementary school teachers *Arbor Day*. It featured a tiny, pristine white schoolhouse like the one he attended in Anamosa. This painting was purchased by another Hollywood denizen, the director King Vidor, who would acquire a small collection of Wood canvases over the next decade.

In the early 1930s Grant Wood developed a regionalist theory to elucidate his artistic principles. In the summer of 1932, along with Ed Rowan and Adrian Dornbush, an instructor at the Little Gallery, Grant devised an experimental art colony at Stone City to disseminate his ideas and encourage the arts in Iowa and Midwestern towns. His goal was to emulate similar communities that had prospered in Taos, New Mexico, and Woodstock, New York, by establishing a small group of artists in a remote territory. One of Wood's idols, William Morris, the leader of the Arts and Crafts Movement in England in the late 1800s, had also envisioned a utopian brotherhood of artists with shared aesthetic ideals.

Supported by limited financing from the Iowa Artists Club, the Little Gallery and Coe College, Wood organized a group of volunteer teachers, sent out a brochure mailing to prospective students and converted the old Green mansion in Stone City that had formerly belonged to the quarry owner into dormitories and classrooms.

The icehouse on the property became a gallery and frame shop, and Wood and several of the painting instructors lived like gypsies in ice wagons that dotted the grounds. Wood painted the side of his temporary summer residence with a grand Hudson river scene replete with Catskill details: soaring blue-green mountains, a huge stag perched on a rocky tor and an Indian brave on a mount beyond him.

Students could enroll at Stone City for periods ranging from one to eight weeks, and received credit from Coe College for their coursework. The teachers, who included Wood's old friends Marvin Cone and Arnold Pyle, received no salaries. In

Left: The cottage in West Branch, Iowa, in which Herbert Hoover was born, is but one element in Grant Wood's symmetrical landscape, *The Birthplace of Herbert Hoover*, painted in 1931.

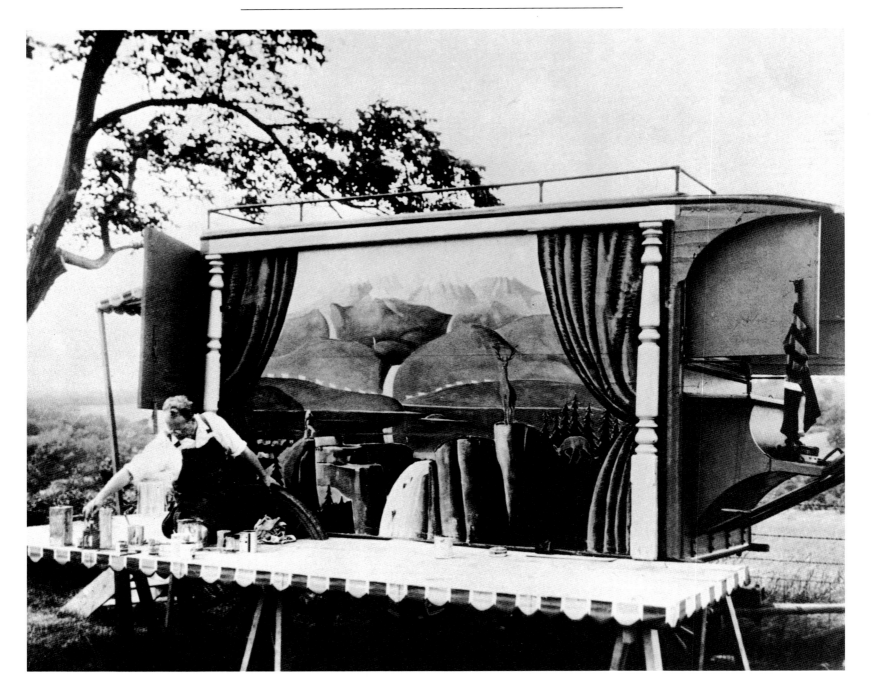

the promotional pamphlets the artistic emphasis was on "a subtle quality that extends over a large but quite homogenous area, and that manifests itself in a thousand elusive but significant ways." They also stated that techniques "conservative . . . eclectic . . . or radical" were acceptable but in actual practice realistic representations of actual settings in the Iowan landscape were strongly preferred.

The art instructors' costumes of farmers' overalls and lederhosen reflect a certain artifice and appropriation of folk dress and farm life. The evening entertainment was often provided by Jay Sigmund's poetry readings filled with glowing imagery of Iowa's beauty.

The Stone City Art Colony lasted only two summers before going into debt and being disbanded but it was a fine effort to foster cultural interests in America's midland. Wood's concept of regional art centers whose rivalries would produce a better quality of art was based on his observation that "Gothic architecture grew out of competition between different French towns as to which could build the largest and finest cathedrals." Following the demise of the Stone City enterprise, Wood's theories would soon find additional support with the New Deal venture known as the Public Works of Art Project (PWAP).

Ed Rowan, the former director of the Little Gallery, became the assistant director of the PWAP office in Washington in 1934 and Wood was appointed the state director in Iowa. The purpose of the PWAP was to give relief and encouragement to artists buffeted by the Depression by granting them salaries of $26.50 a week to furnish murals in public buildings, offices, libraries and universities.

The guidelines for their work depicting the contemporaneous American scene were quite broad, accepting "any type of landscape, urban or rural; any industrial activity, in the field or in the factory; or any interpretive work having social significance." The ideals of democracy would be painted in cooperative harmony and a national identity would emerge through a kaleidoscope of lenses focused on regional phenomena and enterprises.

Abstraction was not particularly desirable or encouraged by the PWAP philosophy. Wood's interpretation of regionalist goals is reflected in this statement quoted by the *Cedar Rapids Gazette*: "The story of American life of this period can be told in a very realistic manner."

When the PWAP offices moved from Cedar Rapids to Iowa City, Grant went with them to the University of Iowa and

automatically became a member of the art department faculty there in June of 1934. He was appointed to a three-year term as an associate professor and supervised the production of library murals at the university's campus in Ames. He was approaching the apogee of his fame as an artist and of his influence as a proponent of regionalism.

Wood's three-part tempera painting, *Dinner for Threshers*, was voted the third most popular work at the Carnegie International Show in Pittsburgh. When he traveled to New York in the fall of 1934, his visit was highlighted by special luncheons and dinners given in his honor. He met a fellow Midwestern artist, Thomas Hart Benton, at an afternoon tea where museum officials, influential art critics and writers had gathered to make his acquaintance.

The December 24, 1934 issue of *Time* magazine lavished praise on Grant Wood, calling him "the chief philosopher and greatest teacher of representational U.S. art." It also discounted trends in abstraction as "the crazy parade of Cubism, Futurism, Dadaism, Surrealism" which its writers condemned as "outlandish art." A self-portrait by Thomas Hart Benton was featured on the cover and a triumvirate of Midwestern artists – John Steuart Curry, Thomas Hart Benton and Grant Wood – were ordained as the leaders of regionalism.

The arts in a variety of media were emphasizing America's

Left: Grant Wood painted the side of his ice wagon residence at the Stone City Art Colony with a grand Hudson River scene.

Right: Grant Wood and Thomas Hart Benton pose in a spoof of an old-fashioned portrait.

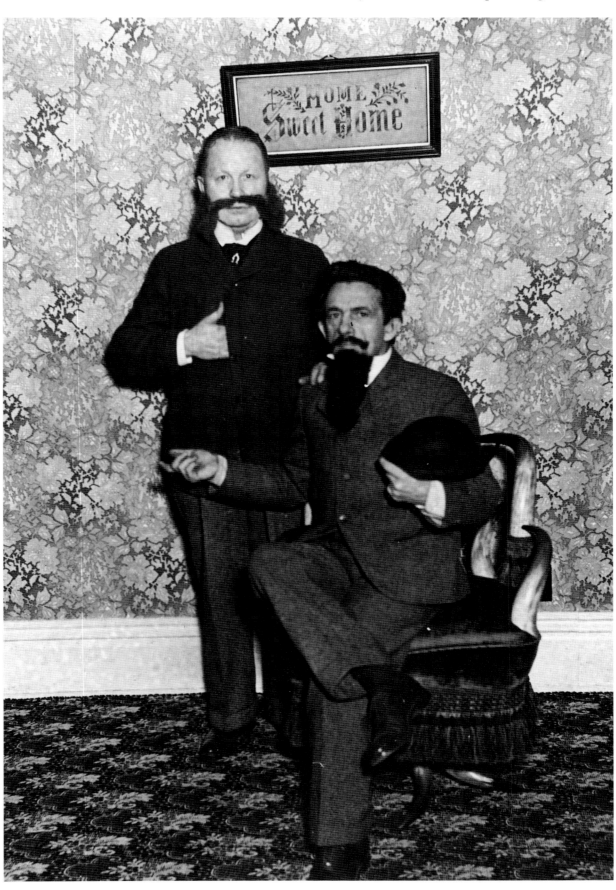

Pages 26-27: Grant Wood's Midwestern colleague and fellow leader in regionalism, Thomas Hart Benton, painted *Threshing Wheat* in 1939. (Sheldon Swope Art Museum, Terre Haute, IN)

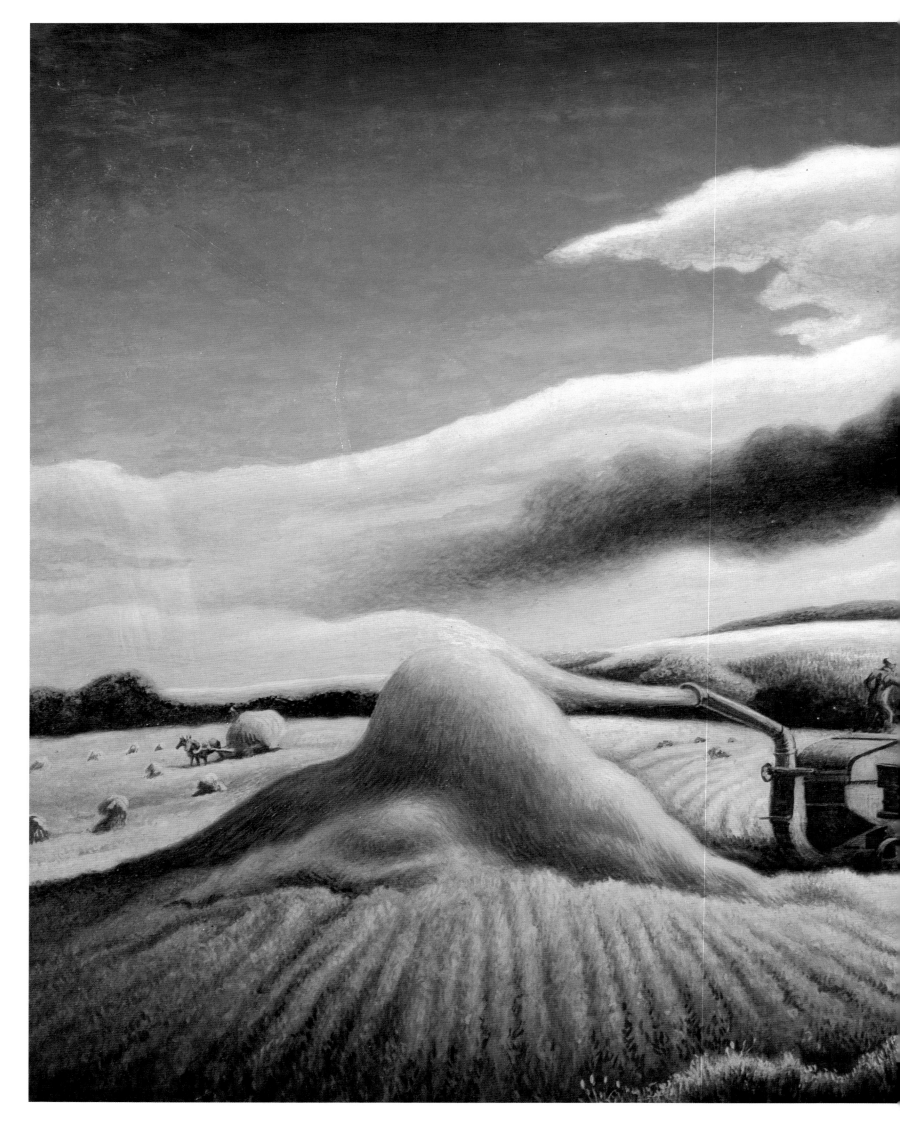

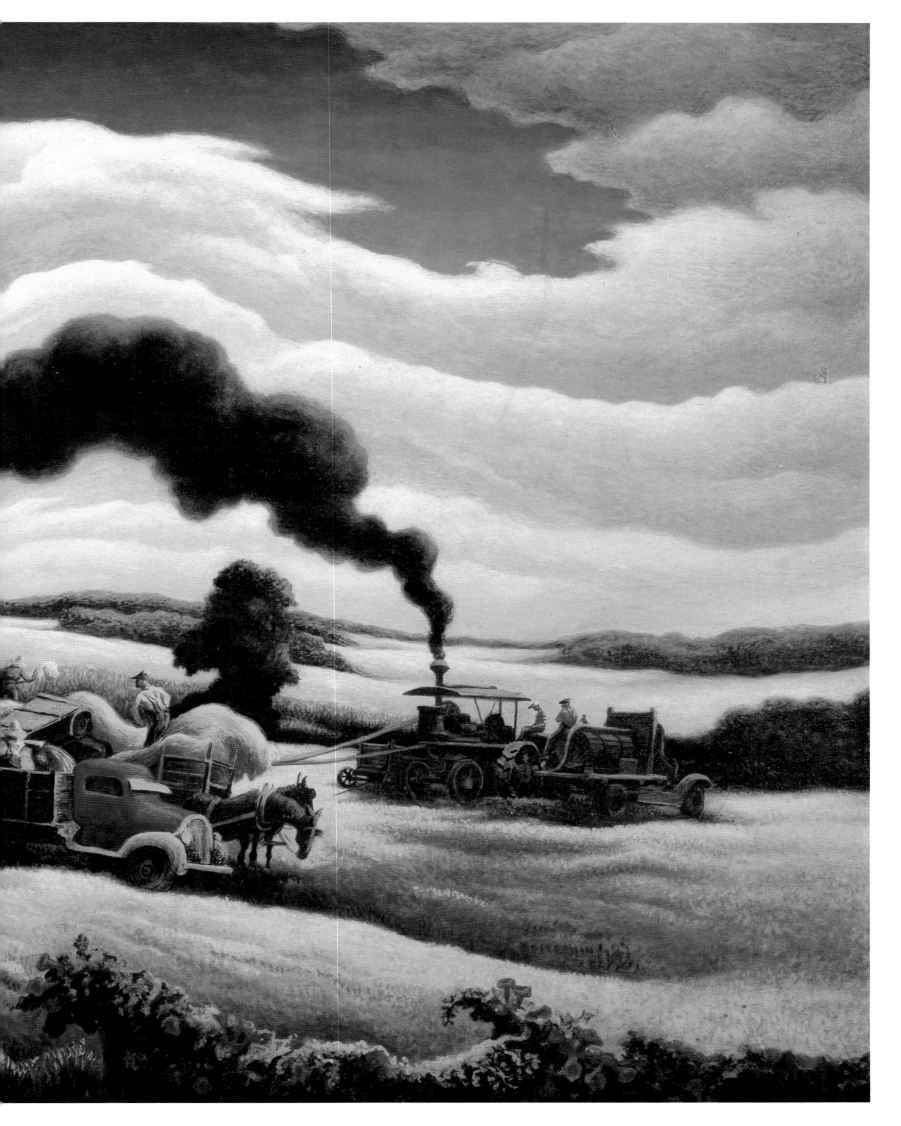

roots. Historical sagas like *Gone with the Wind* published in 1936, were enormously popular. Thornton Wilder's play about a small village called Grover's Corner, New Hampshire, better known as *Our Town*, was first performed in 1939. A little girl named Dorothy got lost in a cornfield fantasy in *The Wizard of Oz*, also produced in 1939. Cole Porter wrote a song called "Farming" with the lyrics: "Farming, that's the fashion. . . . Makes 'em feel glamorous and gay." An important work-relief project sponsored by the federal government catalogued 22,000 pieces of American folk art. A literary critic exclaimed of the 1930s, ". . . never before did a nation seem so hungry for news of itself."

Regionalism promoted artists' interest in American subject matter during the 1930s. Positive images of farm workers and industrial employees depicted by the PWAP muralists were intended as an antidote to the severe economic hardships of the

Left: John Steuart Curry's *Kansas Cornfield*, 1933. Curry shared Wood's regionalist vision, celebrating in his art the values and folklore of rural America. (Wichita Art Museum, Wichita, Kansas)

Right: Grant Wood and John Steuart Curry. Wood lured Curry to the Midwest from Westport, Connecticut, securing him an art department post at the University of Wisconsin.

Depression era. These visions were people-oriented and documentary in nature, and often celebrated the values and folklore of earlier times with a special fondness. Wood related this sentiment to his favorite locale.

In a 1935 speech he wrote entitled "Revolt From the City," he claimed:

> The Great Depression has taught us many things, and not the least of them is self-reliance. . . . It has sent men and women back to the land; it has caused us to rediscover some of the old frontier values. I think the alarming nature of the Depression and the general economic unrest have had much to do in producing this wistful nostalgia for the Midwest. . . . This region has always stood as the great conservative section of the country. Now, during boom times, conservatism is a thing to be ridiculed, but under unsettled conditions it becomes a virtue.

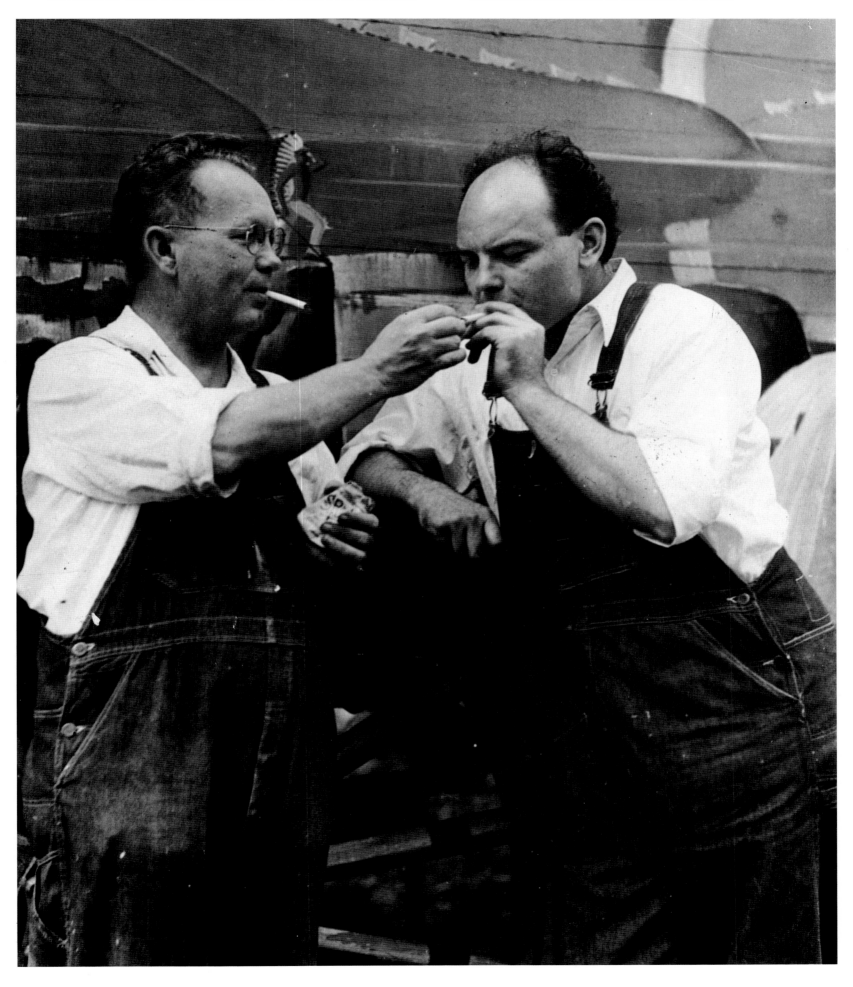

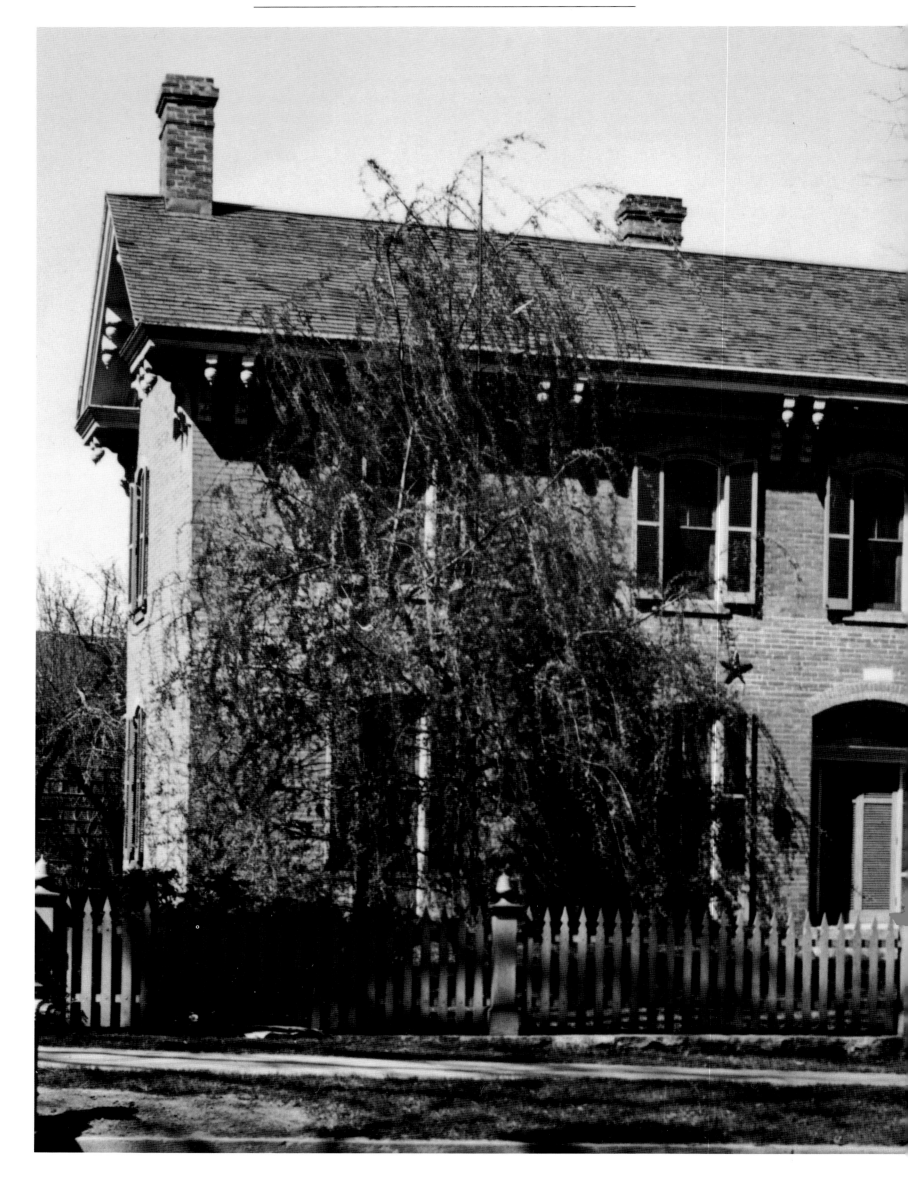

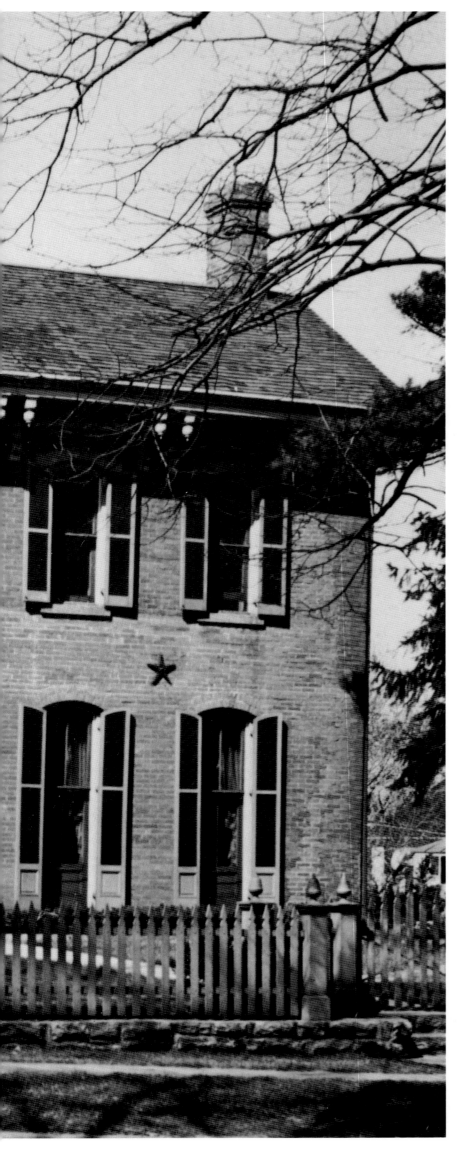

Despite the fact that farmers were in as desperate straits as were members of the urban population, Wood painted images of extraordinary abundance, peace and orderly beauty. While dairymen carried out strikes by pouring their milk into ditches, and farm union members blocked roadways with spiked logs and stormed jails where picketers were held, Wood continued with his unblemished scenes of serenity. The almost effortless fertility, comfort and promise implied by canvases like *Spring Turning* in 1936 and *New Road* in 1939 were more fictional than he ever revealed in his persistently optimistic writings and speeches.

A significant tenet of the theories espoused by Wood and his cohorts was its suppression of any European influence or contact. He stated that regionalism "has been aided by such factors as the rejection of French domination, a growing consciousness of the art materials in the distinctively rural districts of America, and the system of PWAP at work."

Peyton Boswell, the editor of *Art Digest* and author of *Modern American Painting*, echoed Wood's sentiments in this reflection on art in the 1930s: ". . . the native painter had succeeded in dropping his last chains of French serfdom. The decks were swept clear, as the American discovered in some Midwestern tank town or New England textile mill the same powerful urge to create that Gauguin sought in exotic Tahiti and poor, mad Van Gogh found in windswept Arles. The American artist had come home."

By luring them with teaching assignments and painting commissions, Wood convinced his two fellow regionalists, John Steuart Curry, who lived in Westport, Connecticut, and Thomas Hart Benton, a New Yorker, to accompany him to the Midwest to assist him in his cause. He secured an art department post at the University of Wisconsin for Curry. Benton was drawn back to his native Missouri with a public mural project at the state capitol building in Jefferson City and a professorship at the Kansas City Art Institute.

Wood's social life was in a period of upheaval. He brought his mother with him to Iowa City but she was ailing and died at 77 in October 1935. Wood had met a singer and actress, Sara Maxon, in late 1934. Against the objections of his friends and patrons, he married her on March 2, 1935. When they met, Maxon was a soloist on tour in the operetta of *Robin Hood* and sang lieder in the East. She was flashy, silver-haired, older than Grant by five years and already a grandmother. In addition, she was extroverted, convivial and extravagant while he was introspective and reserved.

Together they set up a whirlwind lifestyle of entertaining that exceeded Wood's income and no doubt, his inclinations. They purchased an 1858 brick house at 1142 East Court Street

Left: The house at 1142 East Court Street in Iowa City where Grant Wood and his wife, Sara Maxon Wood, lavishly entertained writers and artists during their brief marriage.

in Iowa City. It was decorated with fine antiques and a special armchair Wood later patented and tried to mass-produce. Despite limited resources, Grant restored the home in an exemplary fashion and it became a popular meeting place for local and visiting writers and artists.

The library was filled with first editions, including autographed volumes of John Dewey, Robert Penn Warren, Carl Sandburg and Wood's fellow Iowan, Ruth Suckow. An English author, Eric Knight, rented the second floor apartment while he taught at the University of Iowa's writers' workshop.

Soon after his marriage, Grant was elected to the National Academy of Design and later became a member of the National Society of Mural Painters. He was inundated with invitations to lecture and to participate in juried shows. Although he painted farm scenes and small-town Midwesterners, he traveled widely and frequently on the lecture circuit and spent extended periods of time in cities.

His agent in New York, Lee Keedick, arranged speaking engagements in the Midwest, the South and California. Juried exhibits and gallery shows took him to Chicago, Philadelphia and New York on numerous occasions. Two Manhattan dealers, the Walker Galleries and the Ferargil Galleries, represented and promoted his paintings across the country.

In June of 1936 the artist who had flunked the Iowa teacher's

Above: *Fruits* (1938) was one of 19 hand-colored lithographs produced by Grant Wood for the Associated American Artists in New York, a company that marketed the prints through its mail-order catalogue. (Davenport Museum of Art, Davenport, IA)

Right: *Tame Flowers*, a hand-colored lithograph produced by Wood in 1938. (Davenport Museum of Art, Davenport, IA)

examination in 1912 received his first honorary degree, a Doctor of Letters from the University of Wisconsin. Others would follow, including a Master of Arts from Wesleyan University and a Doctor of Fine Arts from both Lawrence College and Northwestern University. He later made a lithograph called *Honorary Degree*, a self-caricature that deflated pompous ceremony from these events.

Wood pictured himself as a short, squat fellow between two tall, thin academicians who resemble executioners. They appear to hold a hangman's noose rather than an emblem of tribute over his head. He slyly designed the hood to resemble a Gothic window, aware that much of his fame was attributable to *American Gothic*.

Wood painted very few canvases during his marriage to Sara Maxon. His illustration skills were adapted to book covers, posters and lithographs. He designed jackets for Thomas Duncan's *O'Chautauqua* and Sterling North's *Plowing on Sunday*,

32

and provided drawings for a children's book *Farm on the Hill* by Madeline Horn that included homespun images executed in colored pencil of figures like *Grandma Mending* and *Grandpa Eating Popcorn*.

Grant's satirical talents and his familiarity with Midwestern stereotypes were put to use creating inventive illustrations for a special edition of Sinclair Lewis's 1925 novel *Main Street*. The 1,500 copies that were published displayed Wood's memorable interpretations of *The Perfectionist, Sentimental Yearner, Booster, The Good Influence, The Radical, Practical Idealist* and *General Practitioner*.

Although Lewis's narrative disparages the conformity, narrow-mindedness and ennui he found in America's small towns, Wood admired the writer for he drew attention to the world Wood so lovingly portrayed in his landscapes. Grant asked friends to pose for him to flesh out the story's descriptions. He then added details like the Masonic ring, Moose pin and American flag in *Booster* to make his characters come to life.

Between 1937 and 1941, Wood produced 19 lithographs for Associated American Artists in New York, whose mail-order catalogues advertised prints for $5 each, or 6 for $25. The company considered itself an extension of New Deal relief, offering a source of income to artists and marketing inexpensive art to the masses. Grant's lithograph subjects mirrored those of his paintings: farming, the seasons and small-town life. He began a series with a calendar theme, but supplied only *January, February, March, July 15* and *December Afternoon*. These were powerful, simplified scenes that approached abstraction, especially in the mechanized patterns of his *January* cornshocks.

Wood burnished his lithographs on an old pulpit he had redeemed from an abandoned church, an ancestral link with his Christian forebears. The monies the prints earned were necessary to rescue Grant from debt. He and Sara Maxon had entertained too lavishly. On one homecoming weekend, Grant had hired a bus to bring 16 guests to his house for a gala of parties. They had live-in household domestics, rare on a professor's salary.

Moreover, Maxon had been responsible for keeping track of Grant's business affairs and had failed to file income tax reports for three years beginning in 1935. The Internal Revenue Service demanded repayment. The marriage collapsed in 1938 and the couple separated. The divorce settlement a year later cost Wood an additional $6,000 and Maxon was forbidden to use his name.

Grant Wood was frequently proffered portrait commissions but he usually declined these, preferring his mural projects, home restoration and lithographs. He did, however, spend a week in Kalamazoo, Michigan, at the home of a banker he would portray stiffly in a golfing pose for *The American Golfer, Charles Campbell*. Wood's signature garnish of oak leaves appears incongruously in the horizon.

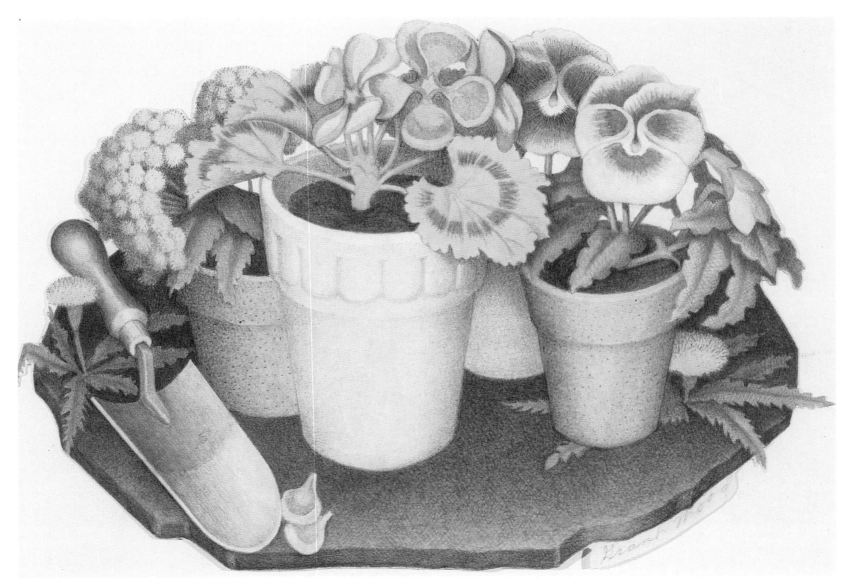

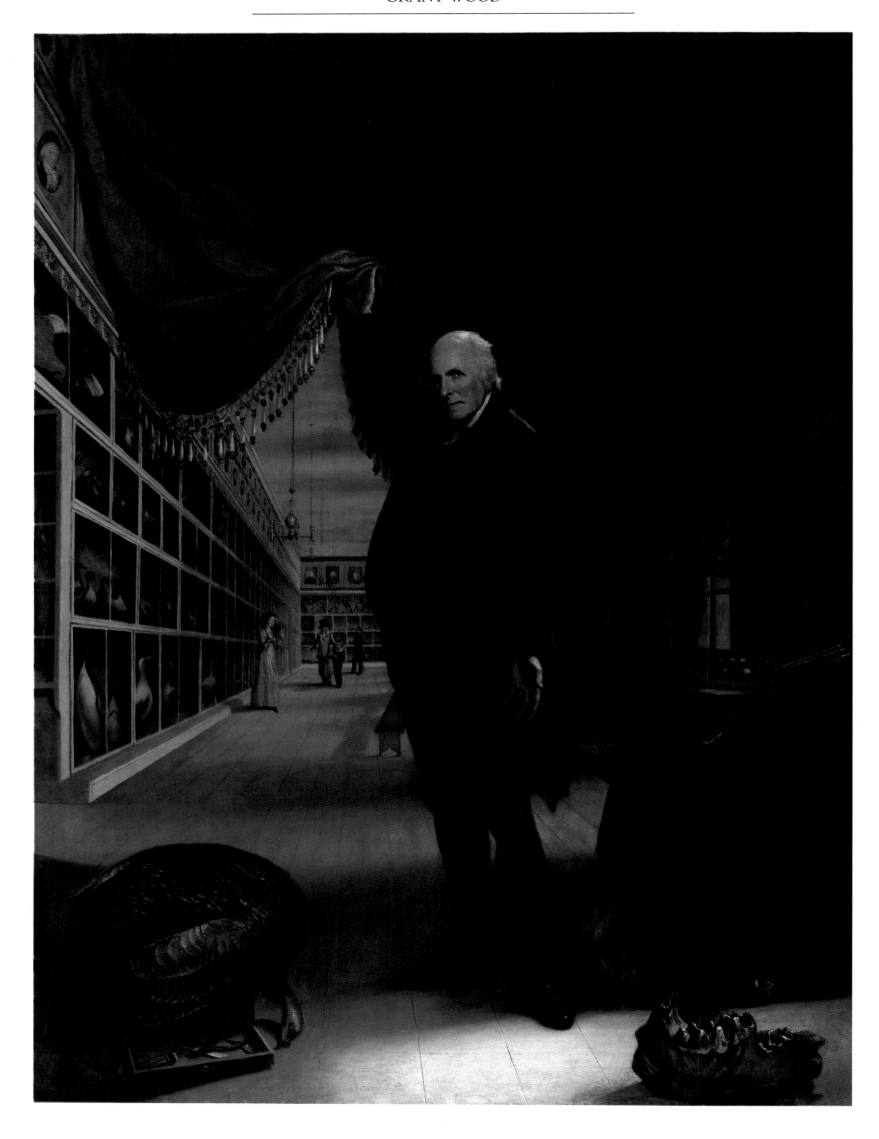

A more successful portrait of Henry Wallace, the Secretary of Agriculture under Harding and Vice President under Roosevelt, was featured on *Time* magazine's cover for its September 23, 1940 issue. In addition, Associated Artists found commercial patrons for Wood. Following his divorce, Wood began painting again and he sold a marvelous rendering of a trio of chickens called *Adolescence* to Abbott Laboratories in Chicago.

He secured a particularly lucrative project in Hollywood in 1939. Nine artists were assembled to design a group of pictures about the filming of Eugene O'Neill's novel *The Long Voyage Home*. Wood's image, entitled *Sentimental Ballad*, shows a group of sailors on leave overindulging in spirits and nostalgic reverie. The tall figure in a checkered jacket is John Wayne. For this work Wood received the handsome sum of $10,000, which helped alleviate some of his financial difficulties at the time.

Wood was one of the first artists who not only copyrighted his paintings for reproduction purposes but demanded a resale clause in his purchase agreements to receive a percentage of his paintings' appreciation as they passed from one owner to the next. When he produced a whimsical oil entitled *Parson Weem's Fable* alluding to George Washington's childhood morality tale, he demanded 50 percent of the increase in its value if it was resold at a profit.

The 1939 painting had some oddly amusing inconsistencies: the six-year-old George resembles his formal presidential portrait by Gilbert Stuart; the colonial house is Wood's thoroughly modernized Iowa City residence; and the hewn cherry tree looks like a huge ball of string with red fringe. The painting sold the day after its arrival in New York to John Marquand, the novelist and short-story writer, for $7,500. Wood was pleased by this and retracted his resale clause, but it was a shrewd business concept for an artist in the 1930s.

In 1939 Grant was still receiving accolades from the mainstream American press for his regional philosophy and teaching methods. In its June 5, 1939 issue, *Life* magazine praised Wood's "learn by doing" projects, finding them more constructive than the emphasis on history and theory noted at Yale University where "students never paint at all." However, Grant was encountering problems and resistance from other members of the staff at Iowa City, especially Lester Longwood, an art historian and the chairman of his department.

They resented his fame, his popularity with the media, his freedom to travel and to lecture at whim. And they were interested in themes that had international meaning, notably abstraction and modernism.

H. W. Janson was a member of the Department of Graphic and Plastic Arts at the University of Iowa who later achieved renown with his tome *The History of Art*. He was often at ideological odds with Wood and when he was fired from the staff for taking a group of students to Chicago to visit a Picasso exhibit, he felt Wood had had a part in his dismissal. Although later reinstated, Janson went so far in his condemnation of Grant Wood as to align his representational painting style with the official state art approved by the Nazi regime in Germany.

Many of Wood's colleagues were interested in contemporary European artists and found Grant's nationalistic furor antiprogressive and outdated. Wood had indeed become a pedagogue for regionalism but even he felt the term was too limited and confining in matters of technique and inspiration.

Wood was also severely criticized for employing photographs and mechanical devices in his work. Claims that he could not draw or teach draftsmanship developed into another bitter battle within the arts faculty, and administration officials were in a quandary to determine a fair settlement.

Finally, Grant applied for and received a year's leave of absence from 1940 to 1941 and upon his return would be honored with a special chair as a University Professor of Fine Arts, separate from the Graphic and Plastic Arts Department. In many respects, Wood's subject matter can be seen as isolationist in tenor. There is little doubt that social circumstances in America during the 1930s favored regionalism and that its heyday was eclipsed by the peril of Fascism in the 1940s. Freer modes of expression and psychological exploration seemed more relevant to the crises of the forties and world events beyond the realm of Iowa.

Grant Wood never returned to his new post at the University. In the fall of 1941 he began suffering from acute stomach pain and was diagnosed with inoperable cancer of the liver. His last lithograph was fittingly called *Family Doctor* and featured his physician, Dr. Bennett, who was close to his side until the end. What canvases he completed were sold almost immediately. *Spring in Town* of 1941 was acquired by the Sheldon Swope Gallery in Terre Haute, Indiana, and *Spring in the Country* was purchased by Cornelius Vanderbilt Whitney in New York.

His estate did not amount to much and the few assets he possessed he left to his devoted sister, Nan. Grant Wood died on February 2, 1942, and was buried next to his mother in the Weaver cemetery plot, preferring its plain headstone to the lion in the Wood plot next to it.

His first museum exhibition was a posthumous one held nine months later at the Art Institute of Chicago. Some critics' remarks had a sharp edge. Charles Bulliet of the *Chicago Daily News* commented on Wood's "shrewd sense of showmanship and a sort of pictorial demagoguery." A kinder reflection of the artist was written in the *Saturday Evening Post*'s April 18, 1942 issue and carefully added to the family scrapbooks. It described Grant's painting as "the picture of a country rich in the arts of

Left: Grant Wood borrowed ideas from the arrangement of Charles Wilson Peale's *The Artist in His Museum* (1822) when he painted *Parson Weem's Fable* in 1939. (The Pennsylvania Academy of the Fine Arts, Philadelphia, PA)

Below: Grant Wood created *The Good Influence* as one of many memorable illustrations for the novel *Main Street* by Sinclair Lewis. (The Pennsylvania Academy of Fine Arts, Philadelphia, PA)

Right: The foremost pioneer of regional art, Grant Wood founded his art on his heritage, what he termed "an honest reliance by the artist upon subject matter he can best interpret because he knows it best."

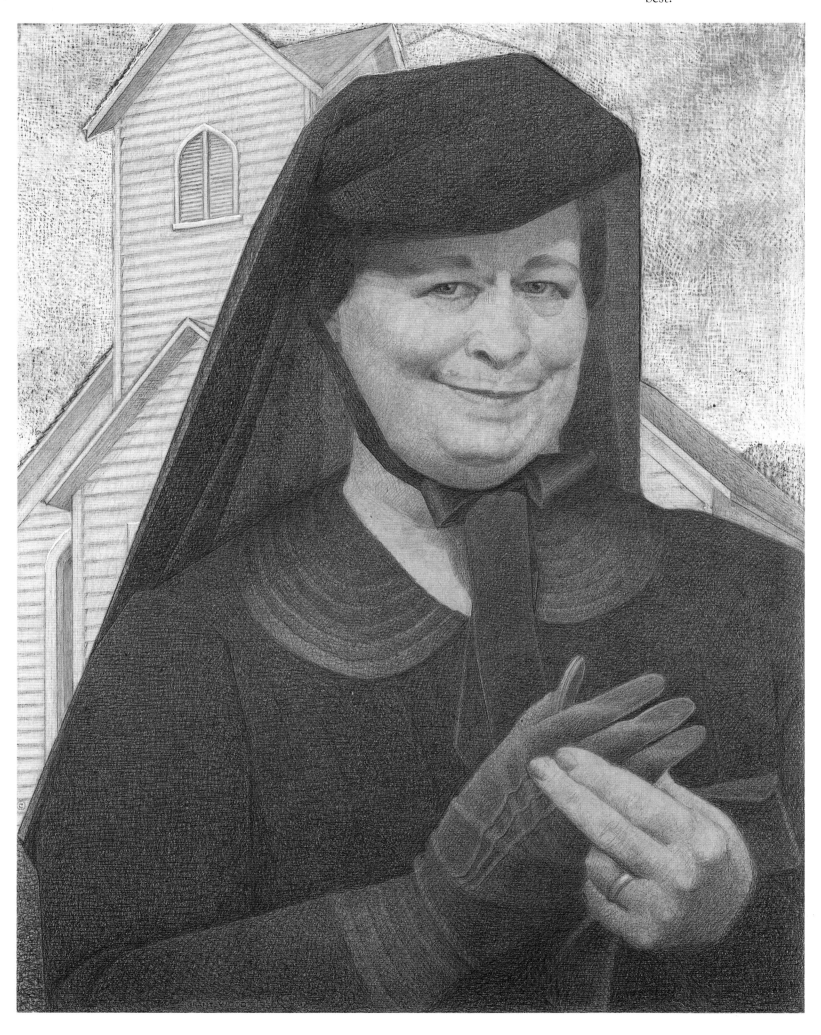

peace; a homely, lovable nation, infinitely worth any sacrifice necessary to its preservation."

The legacy of the regionalists may only merit a paragraph or two in art history, particularly in light of the progression and popularity of modern art. The influence of regional art and its relationship to legendary modern painters such as Georgia O'Keeffe is often disregarded, yet O'Keeffe's communion with and absorption in the Western territories is part of a continuum with Grant Wood's philosophy.

The mysterious and inexplicable appeal of *American Gothic* is undisputed. It has been reproduced many times over, and has even been featured as a commemorative postage stamp for the emirate of Sharjah, Trucial Oman (now the United Arab Emirates). It has attained the status of an American myth and will no doubt be replicated and inventively reinterpreted for many years into the future. As its creator and the foremost pioneer of new vision of regional art, Grant Wood takes his place in American art history.

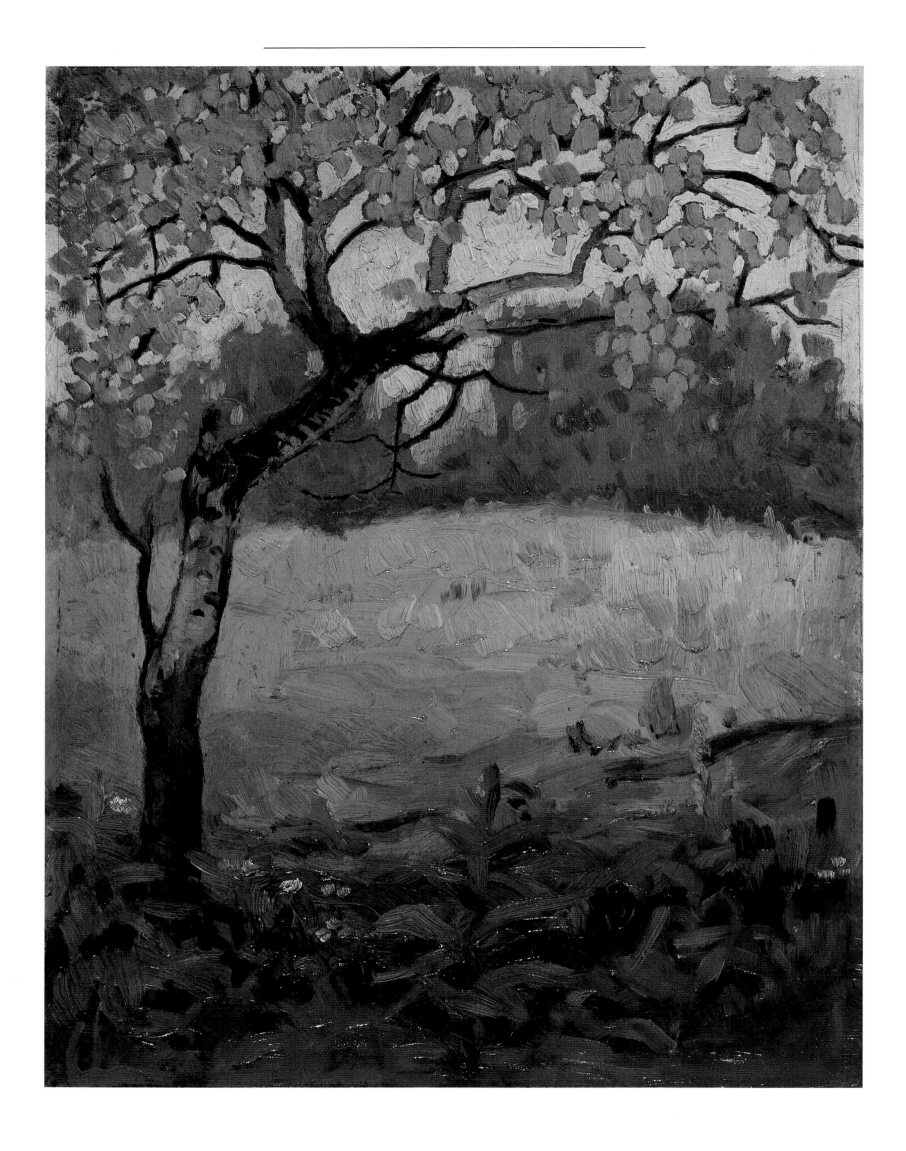

EARLY YEARS

As a young boy living on a farm in Anamosa, Iowa, Grant Wood sketched chickens with charred sticks on brown wrapping paper. After his father died prematurely of a heart attack and the Wood family moved to Cedar Rapids, Grant had few recreational opportunities to draw. He excelled at art in school, however, and won first prize in a national contest for his drawing of oak leaves. In his mature canvases, both chickens and oak leaves would be featured as symbols of his rural upbringing. Wood considered his early childhood in idyllic terms and felt that its influence superseded all others in his work.

The simple shacks he rendered in *Old Sexton's Place, Feeding the Chickens* and *The Dutchman's Old House with Tree Shadows* were not very different from the rustic cottage where he lived with his mother near Indian Creek in Cedar Rapids. His loose, active brushwork reflected the popular style encouraged by his teachers rather than his personal predilections, which were more defined and resolute in form. The 23 panels he exhibited at Killian's Department Store in 1919 were conventional, picturesque landscapes that possessed a romantic quality common to late nineteenth-century canvases.

Two important elements in his compositions were his interest in wood patterns and his arrangement of them to create undisturbed oases in backyard settings. His fascination for the fit of rooflines and barnsiding as well as decorative patterns would continue throughout his career.

Grant began to receive recognition from local businessmen while in his twenties and early thirties. Henry Ely, a Cedar Rapids home developer, commissioned Wood to paint an outdoor mural advertising his company. The result was *Adoration of the Home*, a horizontal menagerie of genre figures of the Midwest plains. As a group they seem incongruous, but Wood is exceedingly thorough in including the city's sources of hometown pride: education, industry and farming.

Grant also provided factory murals of the J. G. Cherry plant, a dairy equipment manufacturer in Cedar Springs. He portrayed several of the workingmen in addition to an exterior view of the plant.

Eugene Eppley, the owner of a chain of hotels in Iowa, was another patron. Wood's murals of cornshocks painted for the Hotel Montrose restaurant are so commanding that the dining areas are now called "corn rooms." The subjects are fulsome stalks vividly daubed in pale yellow brushstrokes.

The most important commission Wood received in the 1920s was a large-scale, stained-glass memorial window for the Cedar Rapids Veteran's Memorial Building. Wood labored from 1927 to 1929 to complete the project and traveled to Munich, Germany, to oversee skilled craftsmen involved with its construction.

The window was 24 feet high and commemorated soldiers slain in battle during America's six wars. An amalgam of styles incorporating neoclassicism, realism and modern design were synthesized in the finished memorial, an imposing work of art. A huge, female figure in classical drapery presides over the men as a high priestess of the Republic. The billowing clouds and mountain tors that surround her are captured in flat patterns of an almost abstract nature. Although she stands in strict profile like an Egyptian hieroglyph, the soldiers are conveyed with fuller dimensions.

What is notable about their faces is an utter lack of discernable emotion. Taciturn expressions would become a metaphor for the Midwestern personality in Wood's later canvases. The soldiers are banked in a profusion of oak leaves, Wood's signature symbol of honor.

The window is especially pleasing for its rich color harmonies. It caused inforeseen controversy, however, because Wood employed foreign workers in its making. The artist was never offered a public ceremony for its dedication. Yet Wood's trip to Munich, occasioned by the memorial window, would usher in a new style and vision in his artwork.

Quivering Aspen
1917, oil on wood panel, 14 × 10⅞ in.
Collection of the Davenport Museum of Art, Davenport, IA (65.2)

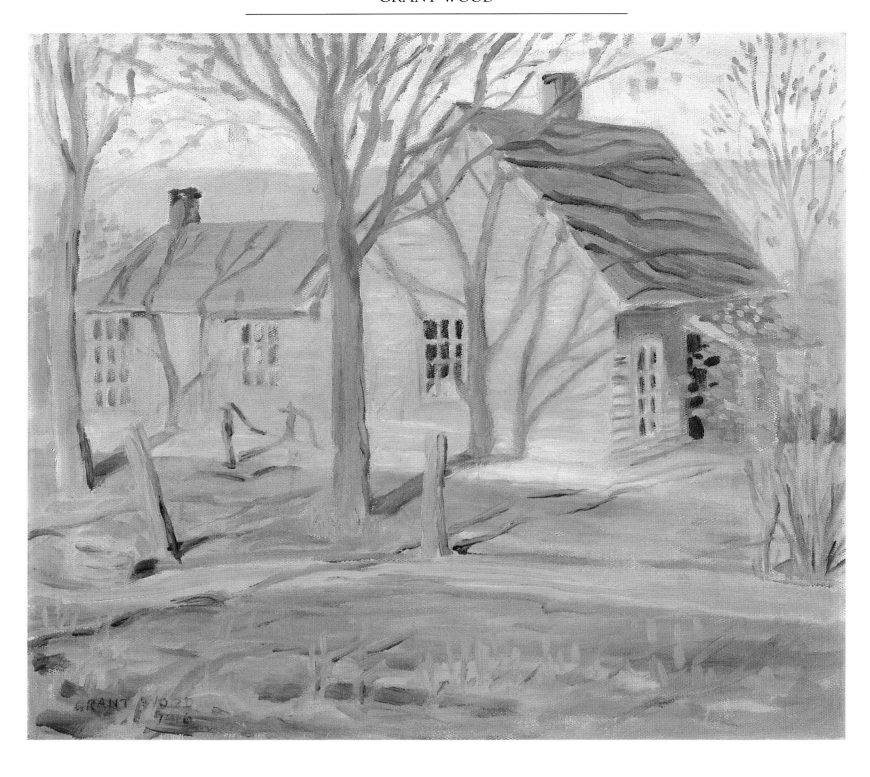

Old House with Tree Shadows
1916, oil on composition board, 13 × 15 in.
Gift of Happy Young and John B. Turner II,
Cedar Rapids Museum of Art, IA (72.12.47)

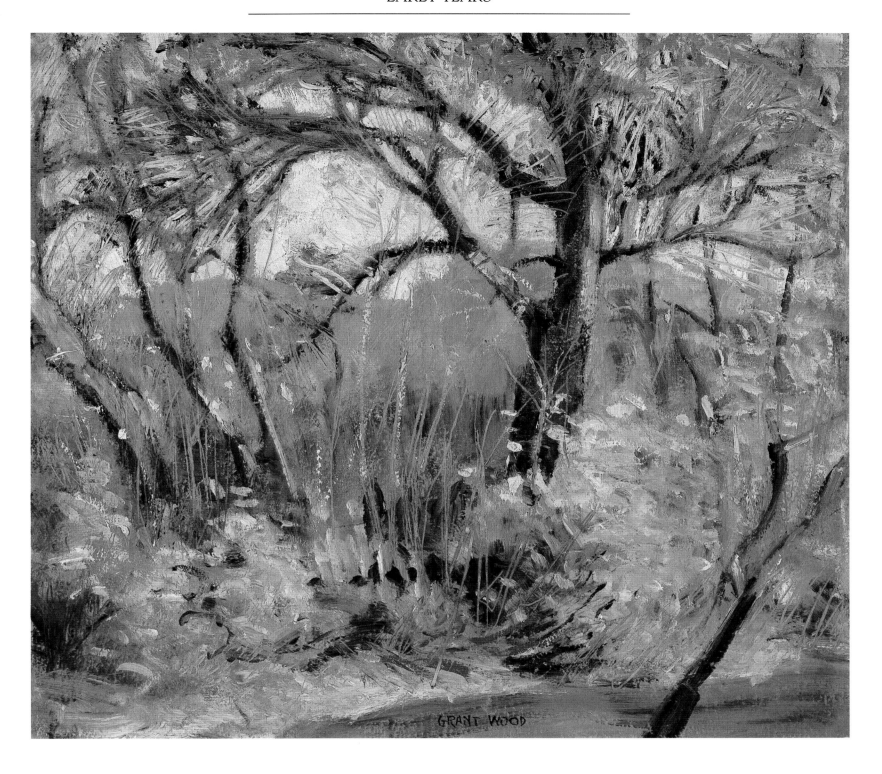

Fall Landscape
1924, oil on composition board, 13⅛ × 15 in.
Gift of Happy Young and John B. Turner II,
Cedar Rapids Museum of Art, IA (72.12.17)

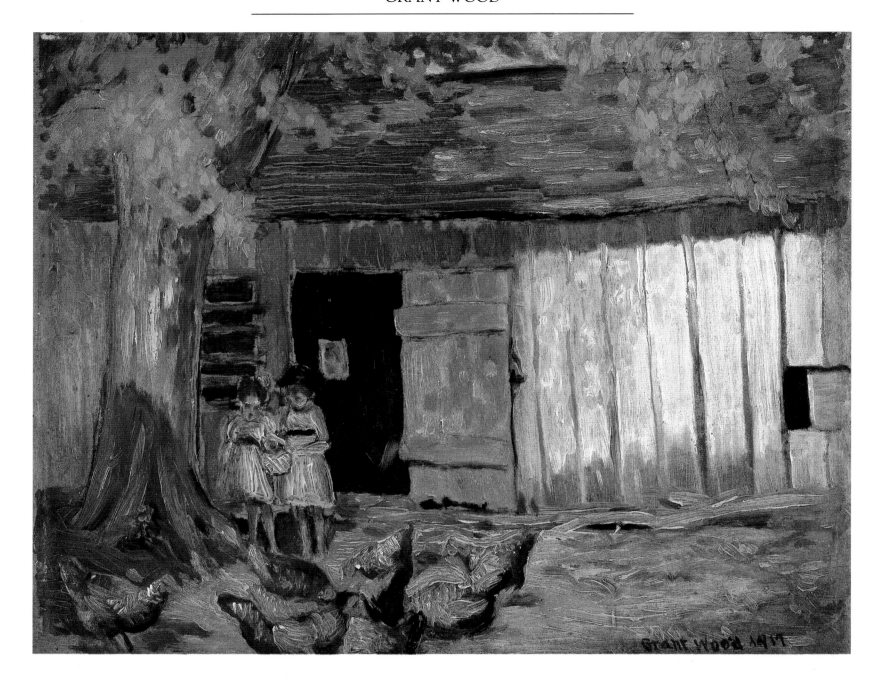

Feeding the Chickens
1917, oil on composition board, 11 × 14 in.
Gift of Happy Young and John B. Turner II,
Cedar Rapids Museum of Art, IA (72.12.20)

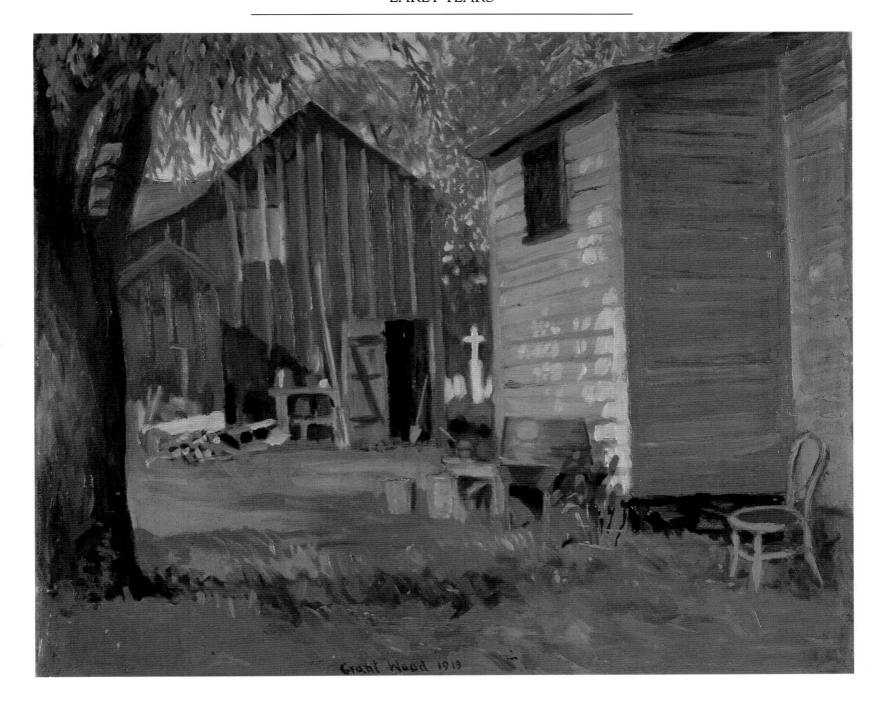

Old Sexton's Place
1919, oil on composition board, 15 × 18⅛ in.
Gift of Happy Young and John B. Turner II,
Cedar Rapids Museum of Art, IA (72.12.48)

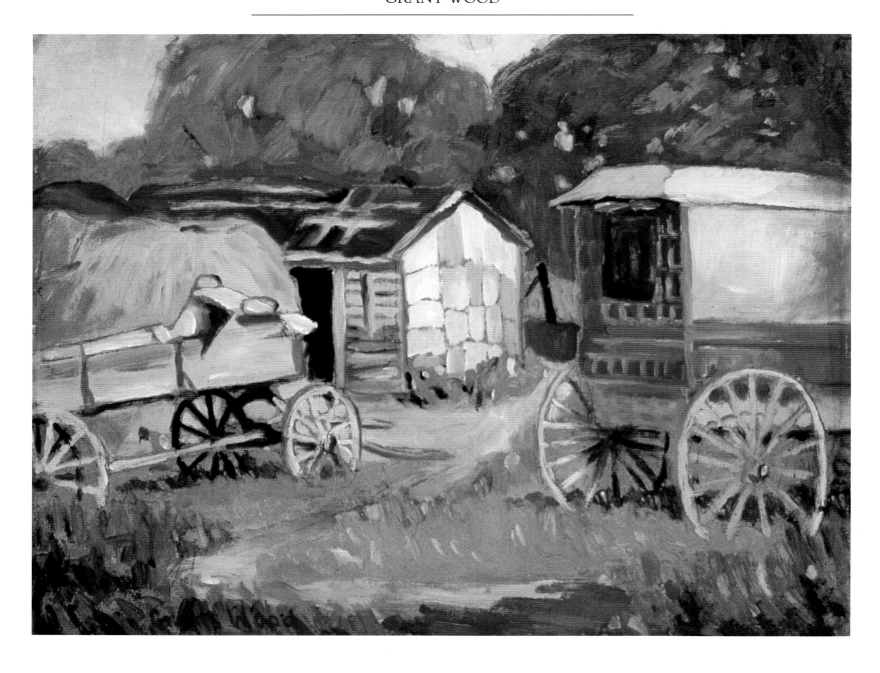

The Horsetraders
1917-18, oil on composition board, 11 × 14 in.
Gift of Happy Young and John B. Turner II,
Cedar Rapids Museum of Art, IA (72.12.28)

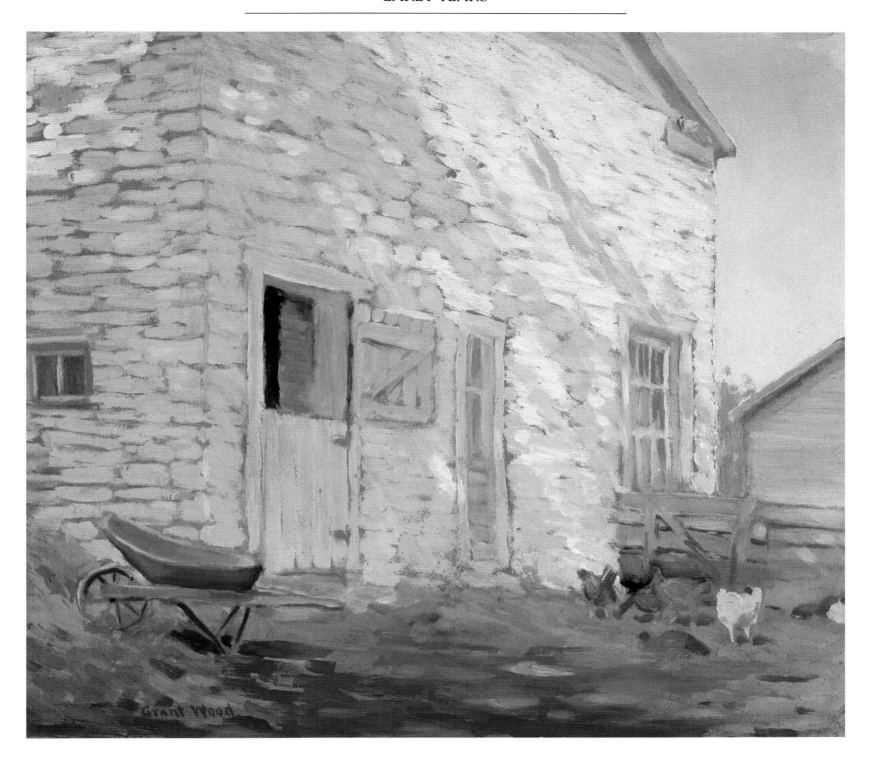

Old Stone Barn
1919, oil on composition board, 14¾ × 17⅞ in.
Gift of Happy Young and John B. Turner II,
Cedar Rapids Museum of Art, IA (72.12.50)

45

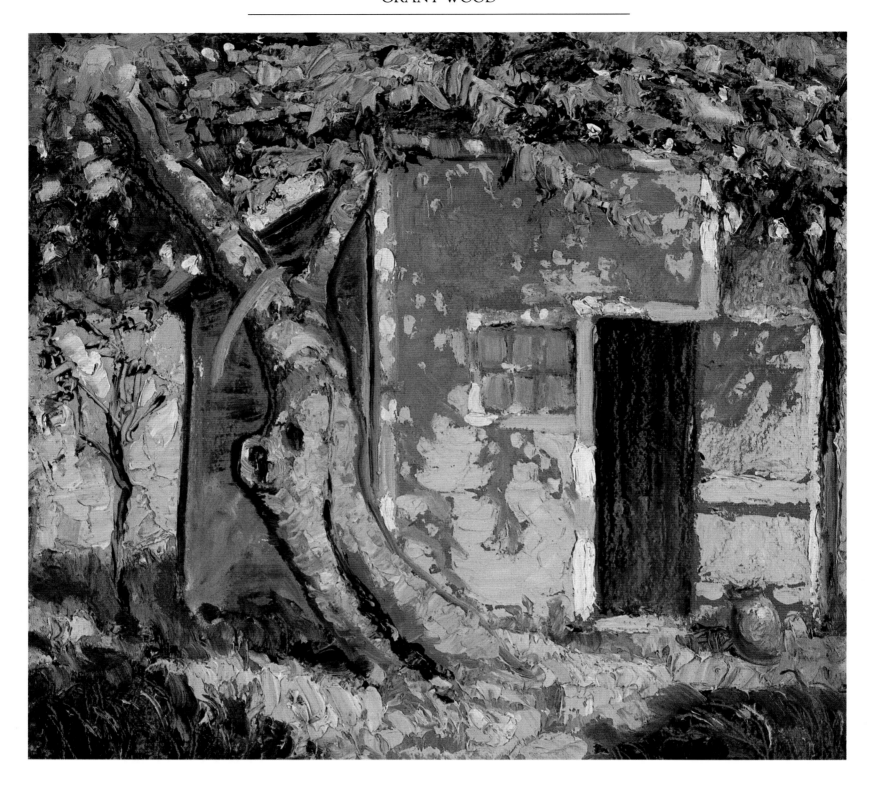

Van Antwerp Place
1922-23, oil on composition board, 12⅞ × 14⅞ in.
Gift of Happy Young and John B. Turner II,
Cedar Rapids Museum of Art, IA (72.12.78)

Basket Willows
1920, oil on composition board, 12¾ × 14½ in.
Gift of Happy Young and John B. Turner II,
Cedar Rapids Museum of Art, IA (72.12.35)

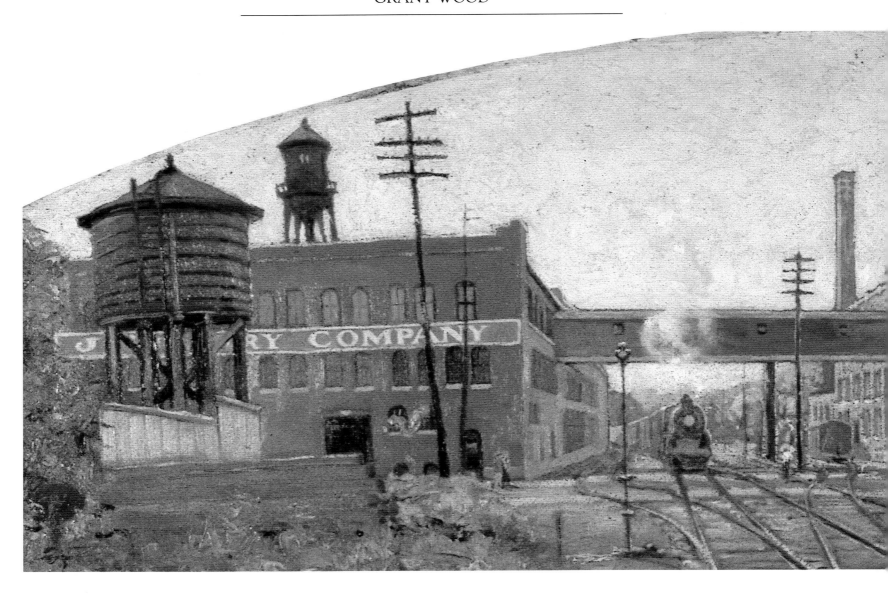

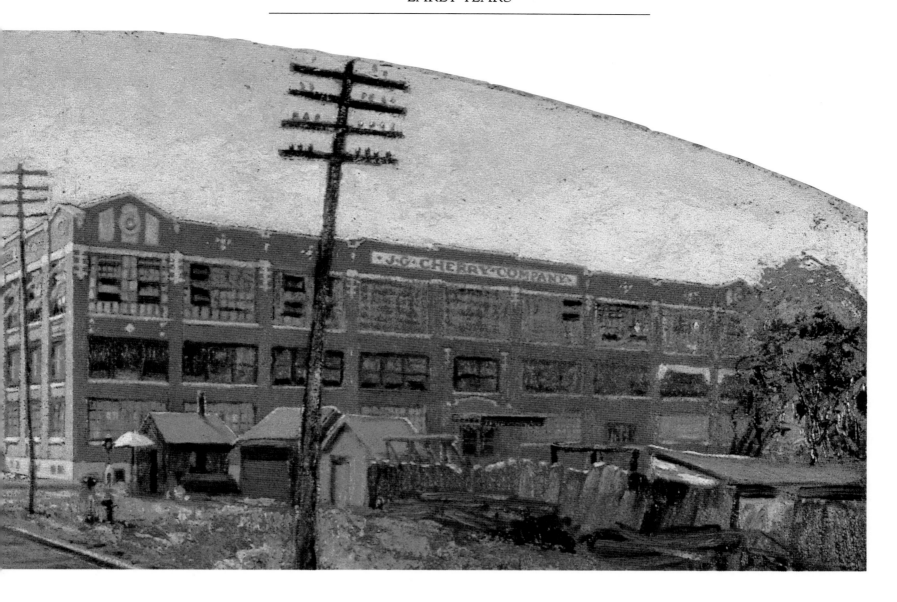

The Old J.G. Cherry Plant
1925, oil on composition board, 13¼ × 40¾ in.
Cherry Burrell Charitable Foundation Collection,
Cedar Rapids Museum of Art, IA (74.5.4)

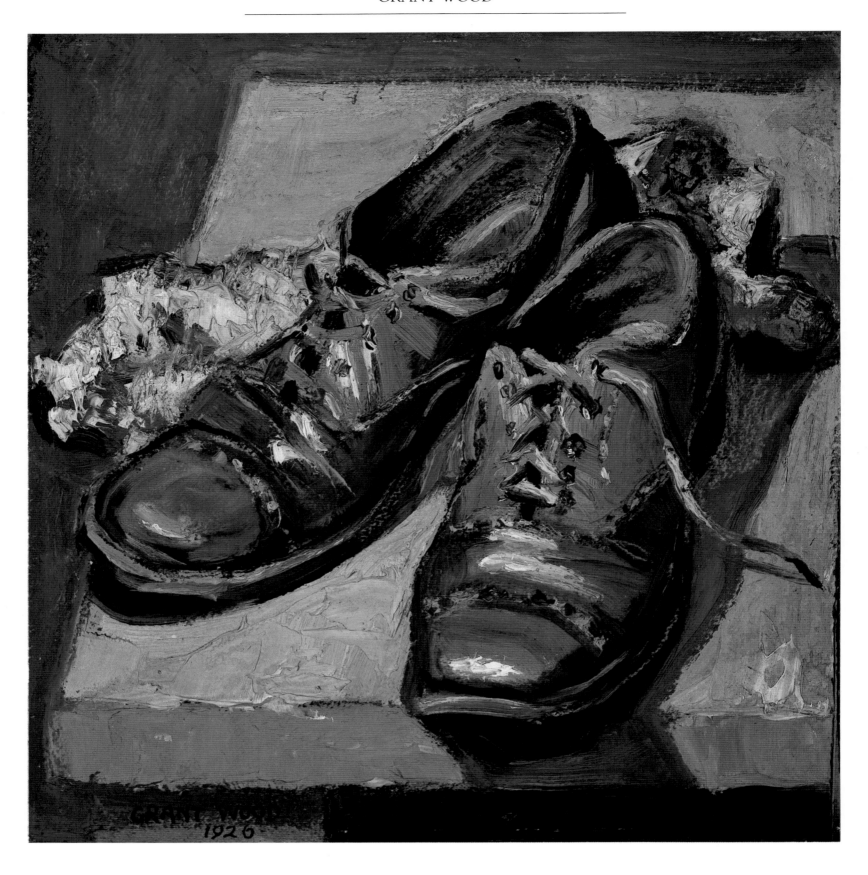

Old Shoes
1926, oil on composition board, 9¾ × 10 in.
Gift of Happy Young and John B. Turner II,
Cedar Rapids Museum of Art, IA (76.2.3)

Right:
Iowa Corn Room Murals, Montrose Hotel (detail)
1925, oil on canvas, 80 × 49 in.
Gift of Happy Young and John B. Turner II,
Cedar Rapids Museum of Art, IA (81.17.1)

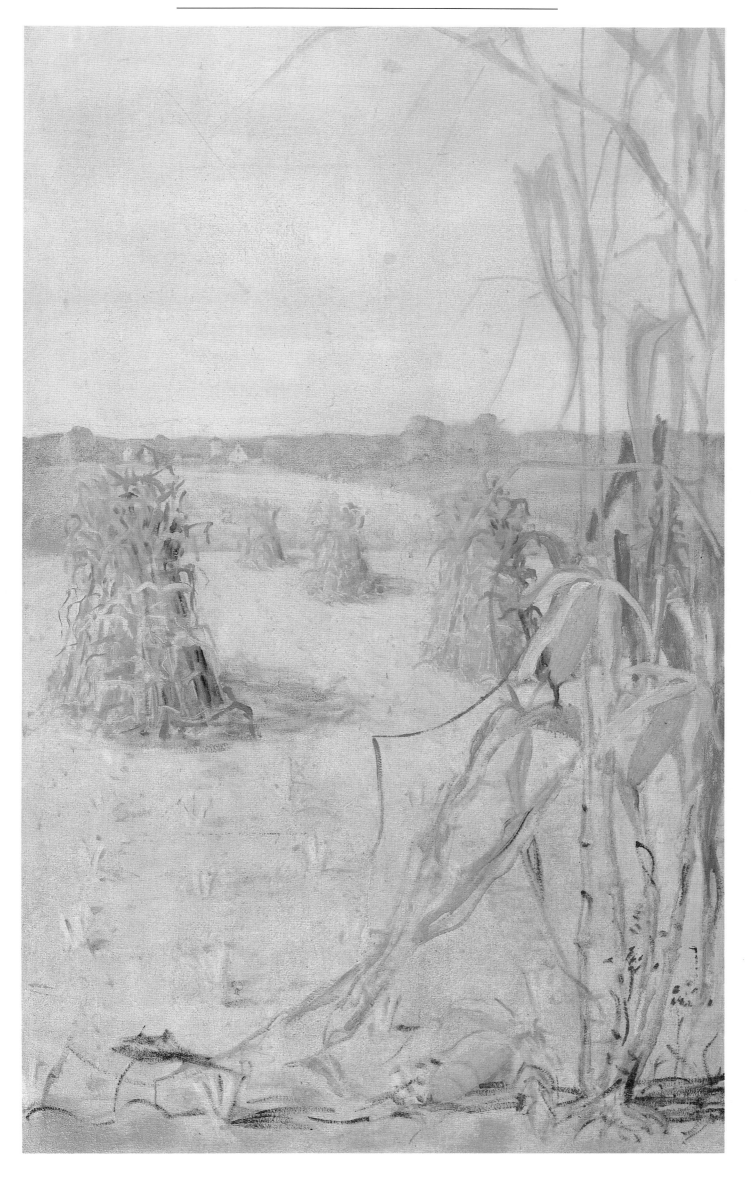

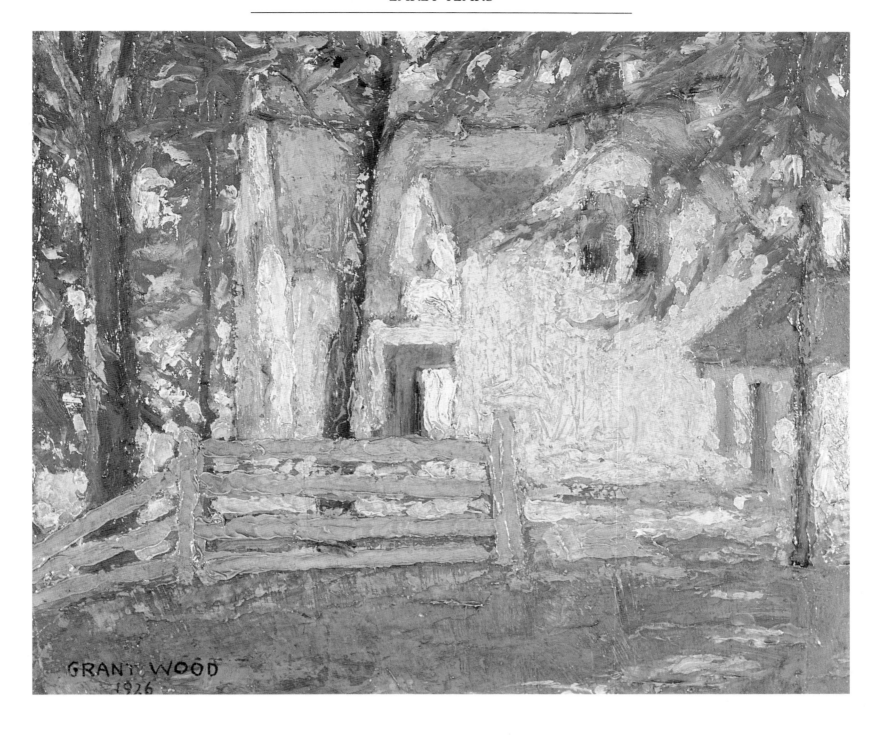

Left:
Indian Creek
1929, oil on canvas, 22 × 17¾ in.
Chamber of Commerce Collection,
Cedar Rapids Museum of Art, IA (82.22.1b)

Grandma Wood's House
1926, oil on wood panel, 8⅜ × 10½ in.
Collection of the Davenport Museum of Art,
Davenport, IA (72.14)

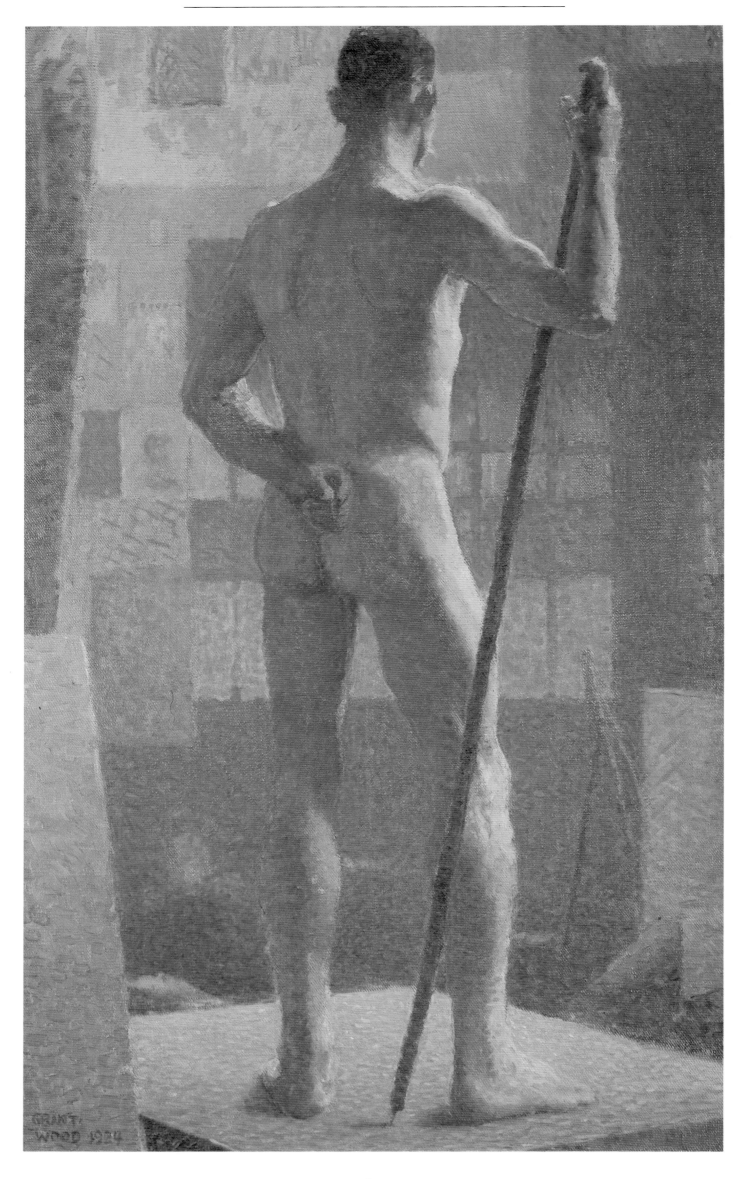

TRAVELS

Grant Wood went to Europe on four occasions: to Paris for the summer of 1920; to Paris for fourteen months in 1923 and 1924 with visits to Sorrento and Palermo, Italy, as well as Bordeaux, Brittany and Belgium; to prepare and display an exhibit of his works at the Galerie Carmine in Paris in 1926; and to oversee the construction of a stained-glass memorial window in Munich, Germany, in the fall of 1928.

Wood's visits to France were diverting, leisurely encounters with a foreign culture yet they had little influence upon his painting style. His composition board sketches of quaint village scenes and cobblestone streets were picturesque and impressionistic. He worked quickly, completing plein-air pieces in a few hours and finishing several a day on occasion. These genre paintings were not very different from the backyard views and farmspeople he chose to depict in Iowa.

The arabesques of fountains and heroic public sculpture find expression in several 1920 paintings, including *The Runners, Luxembourg Gardens; Tuileries Gate and Obelisk;* and *Fountain of Voltaire, Chatenay*. These unusual tourist sites would entertain Wood's captive audience upon his return to Cedar Rapids.

The stucco buildings Wood limned in quiet Paris squares and back streets bear a resemblance to similar subjects by Maurice Utrillo. Wood's *Paris Street Scene with Café* of 1920, *Italian Farmyard* of 1924, and *House with Blue Pole, Paris* of 1924 reveal an interest in local architecture and convey a sense of enclosure and protection.

Although Wood's technique is often dappled and fluffy, the artist showed none of the interest in pure atmospheric effects that marked the work of Monet. The composition never dissolves into color fragments or flattens into planes as in the canvases of Seurat and Cezanne. Wood's sketches maintain a firm grounding in realism and a deliberate preference for plain folk and slow-paced thoroughfares.

Wood's interest in Gothic designs and medieval portals was inspired by his ramblings in the neighborhoods of Paris. Oil paintings such as *Street Scene through Gate, Roman Arch* of 1920; *Yellow Doorway, Church Portal, St. Emilion* of 1927 and *Doorway, Périgueux* of 1927 uncover an interest for solid forms with historical resonance. Doorways seemed to offer a symbolic passage to a new realm in Wood's artistic adventure. A palette knife accretion of paint on the composition board surface gave these pictures a frosted appearance.

The only memento from Wood's life study class at the Académie Julien is a strange male nude entitled *Spotted Man*. Wood dotted it with red to attract attention from his classmates, but later overpainted the flesh tones. The pose looks stiff and awkward against the soft, flecked background and bears stronger resemblance to a Thomas Eakins portrait than to the work of any French master or contemporary artist.

Wood exhibited 47 of his travel paintings at the Galerie Carmine in 1926. Though well-received in the European press and though Pope Pius XI wrote for reproductions of the works, Wood did not sell enough paintings to finance his trip and the show was ignored by American critics. He left Europe disheartened. The most significant effect of this journey was the epiphany he experienced upon his return to Iowa. He remarked, "I did return from my third trip to France to see, like a revelation, my neighbors in Cedar Rapids, their clothes, their homes, their tablecloths and curtains, the tools that they used. I suddenly saw all this commonplace stuff as material for art – wonderful material."

Wood's sole objective during his 1928 stay in Munich was the direction of his Veteran's Building stained-glass memorial window project by German artisans. He did not paint local venues on this trip, but visits to the Alte Pinokothek museum were essential to his artistic development. He absorbed the decorative patterns used by Flemish painters of the fifteenth and sixteenth centuries, particularly Hans Memling, Albrecht Durer and Hans Holbein. Their solidly contoured, sober portraits appealed to his staid Midwestern personality. Wood resolved to apply their glazing techniques and somber realism to his portraits of Iowan characters.

The Spotted Man
1924, oil on canvas, 32 × 20 in.
Collection of the Davenport Museum of Art,
Davenport, IA (75.14)

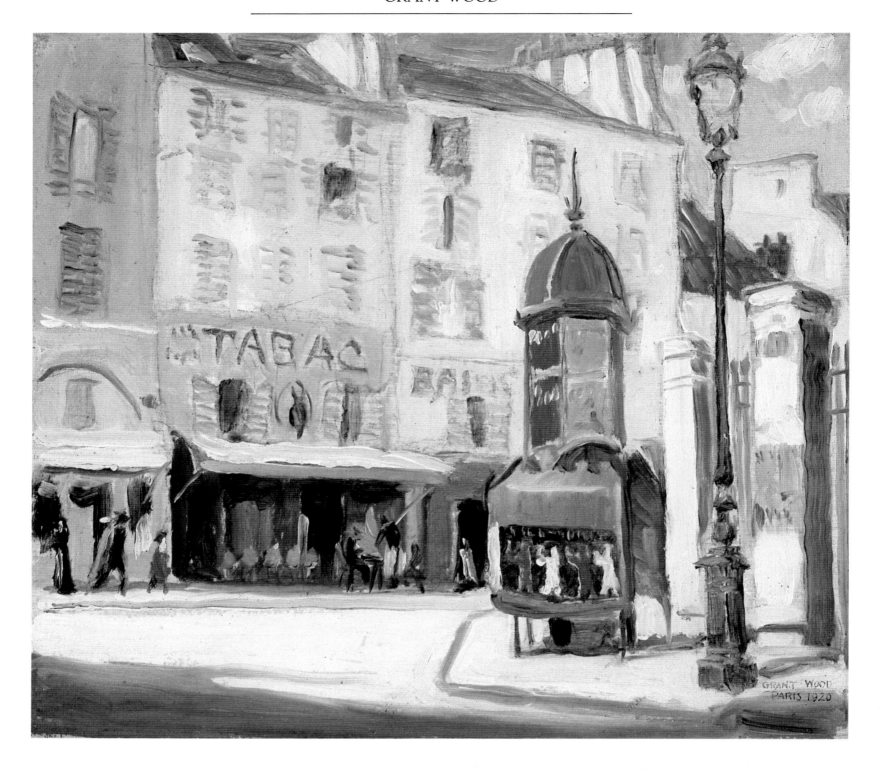

Avenue of Chestnuts
1920, oil on composition board, 13 × 15 in.
Gift of Happy Young and John B. Turner II,
Cedar Rapids Museum of Art, IA (72.12.52)

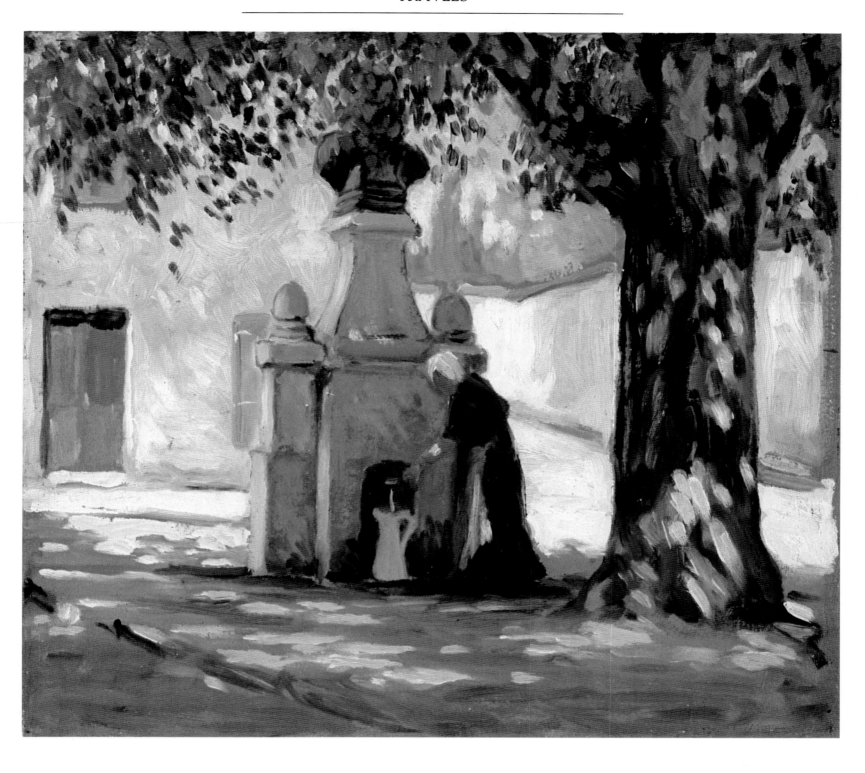

Fountain of Voltaire, Chatenay
1920, oil on composition board, 13 × 15 in.
Gift of Happy Young and John B. Turner II,
Cedar Rapids Museum of Art, IA (72.12.23)

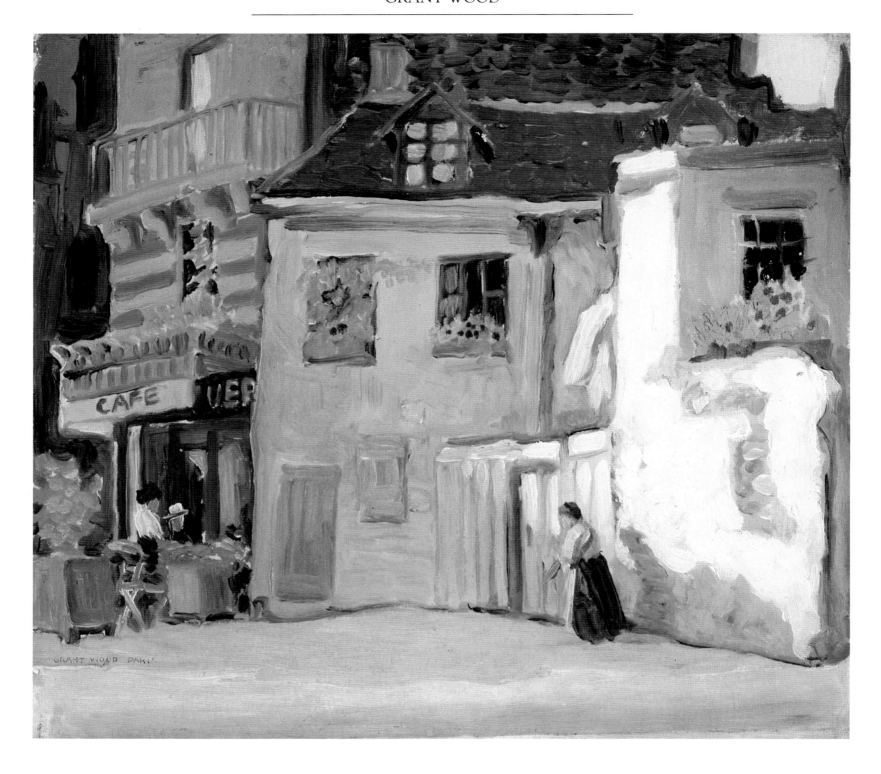

Old and New
1920, oil on composition board, 13 × 15 in.
Gift of Happy Young and John B. Turner II,
Cedar Rapids Museum of Art, IA (72.12.10)

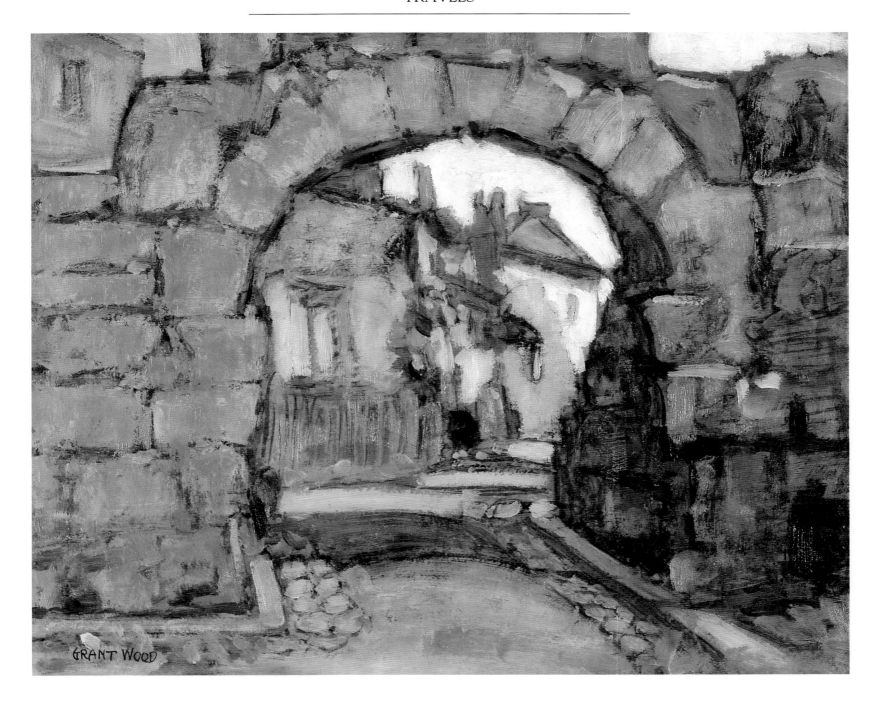

The Gate in the Wall
1920, oil on composition board, 12⅞ × 16⅛ in.
Gift of Happy Young and John B. Turner II,
Cedar Rapids Museum of Art, IA (72.12.66)

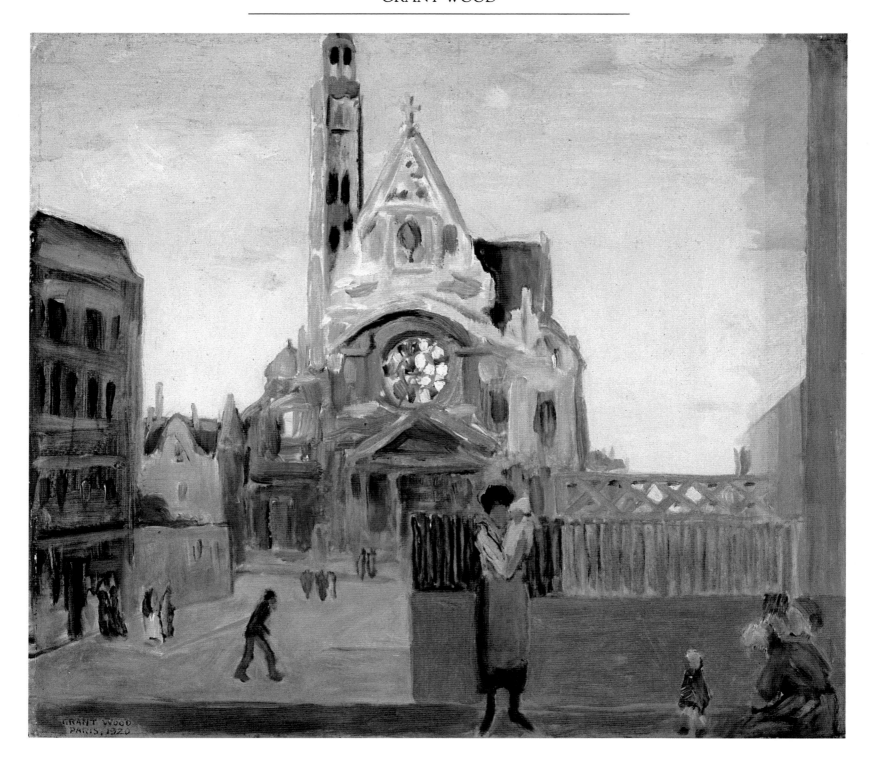

St. Etienne du Mont
1920, oil on composition board, 13 × 15 in.
Gift of Happy Young and John B. Turner II,
Cedar Rapids Museum of Art, IA (72.12.9)

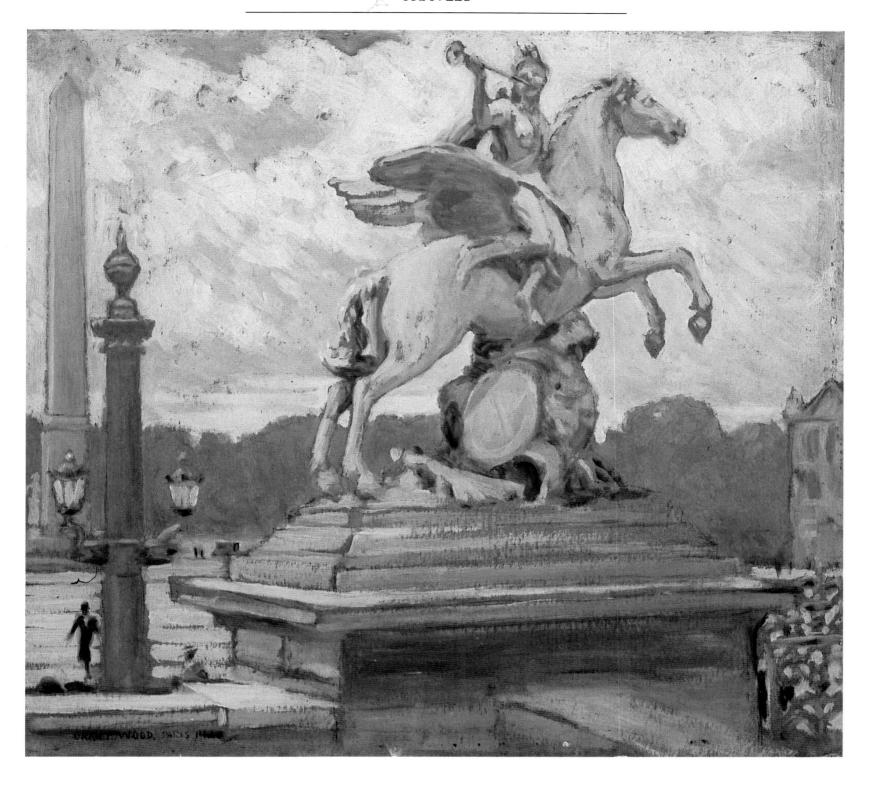

Place de la Concorde
1920, oil on composition board, 13 × 15 in.
Gift of Happy Young and John B. Turner II,
Cedar Rapids Museum of Art, IA (72.12.69)

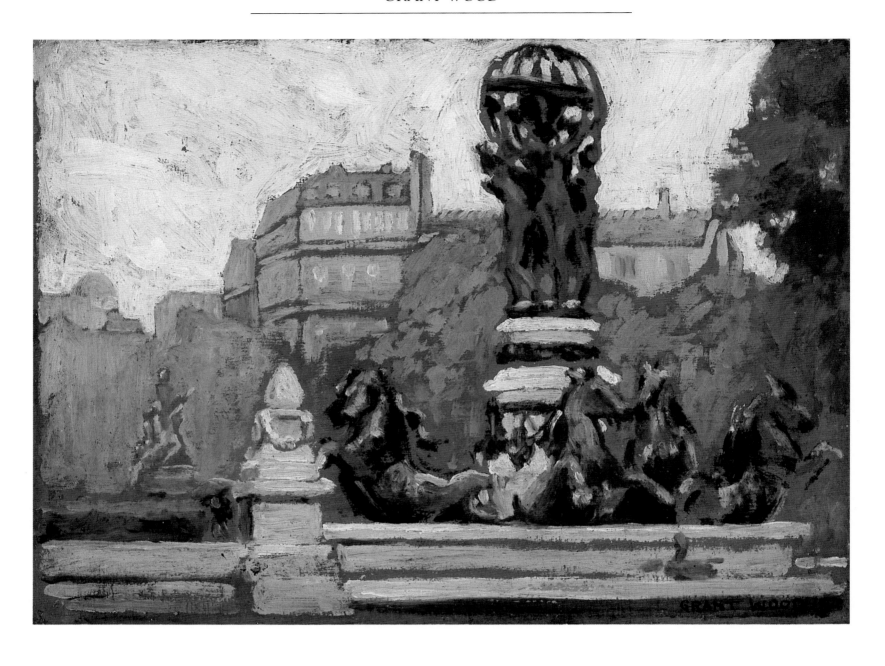

Right:
The Runners, Luxembourg Gardens, Paris
1924, oil on composition board, 15⅝ × 12½ in.
Bequest of Miss Nell Cherry,
Cedar Rapids Museum of Art, IA (69.4.1)

Misty Day, Fountain of the Observatory, Paris
1920, oil on composition board, 7⅛ × 10 in.
Gift of Happy Young and John B. Turner II,
Cedar Rapids Museum of Art, IA (72.12.43)

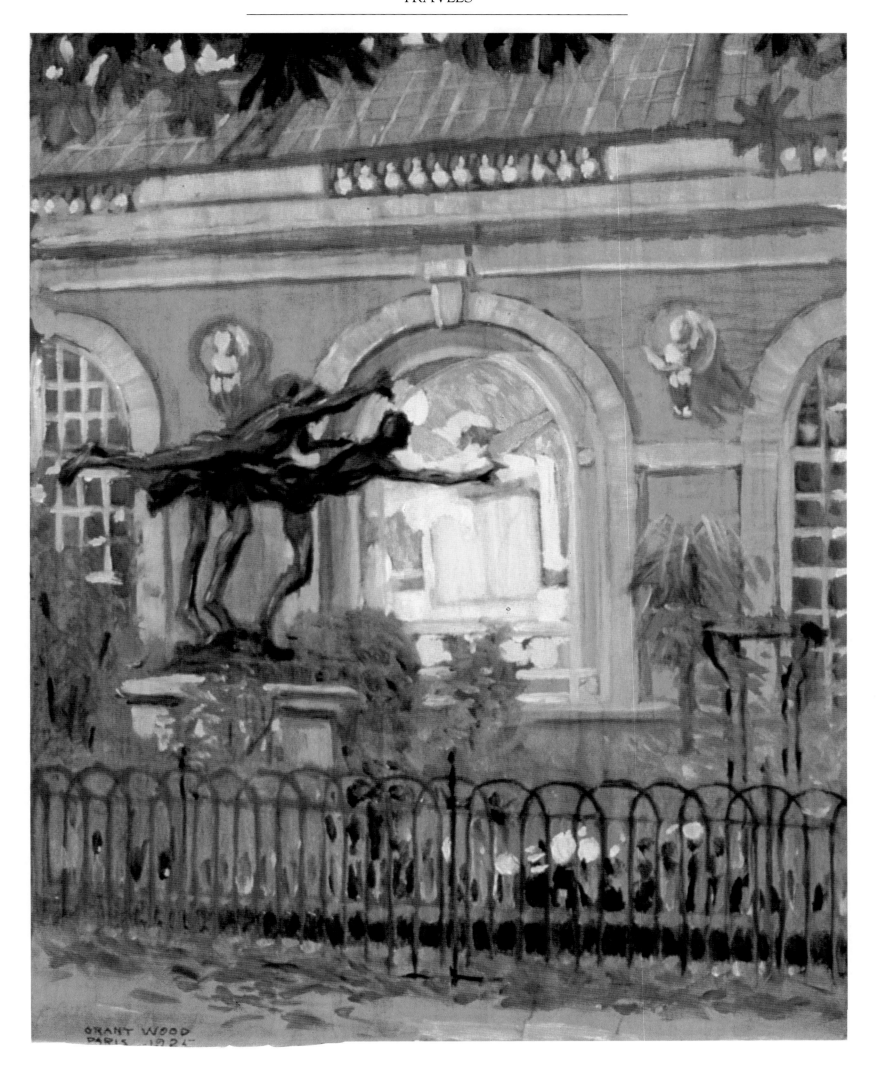

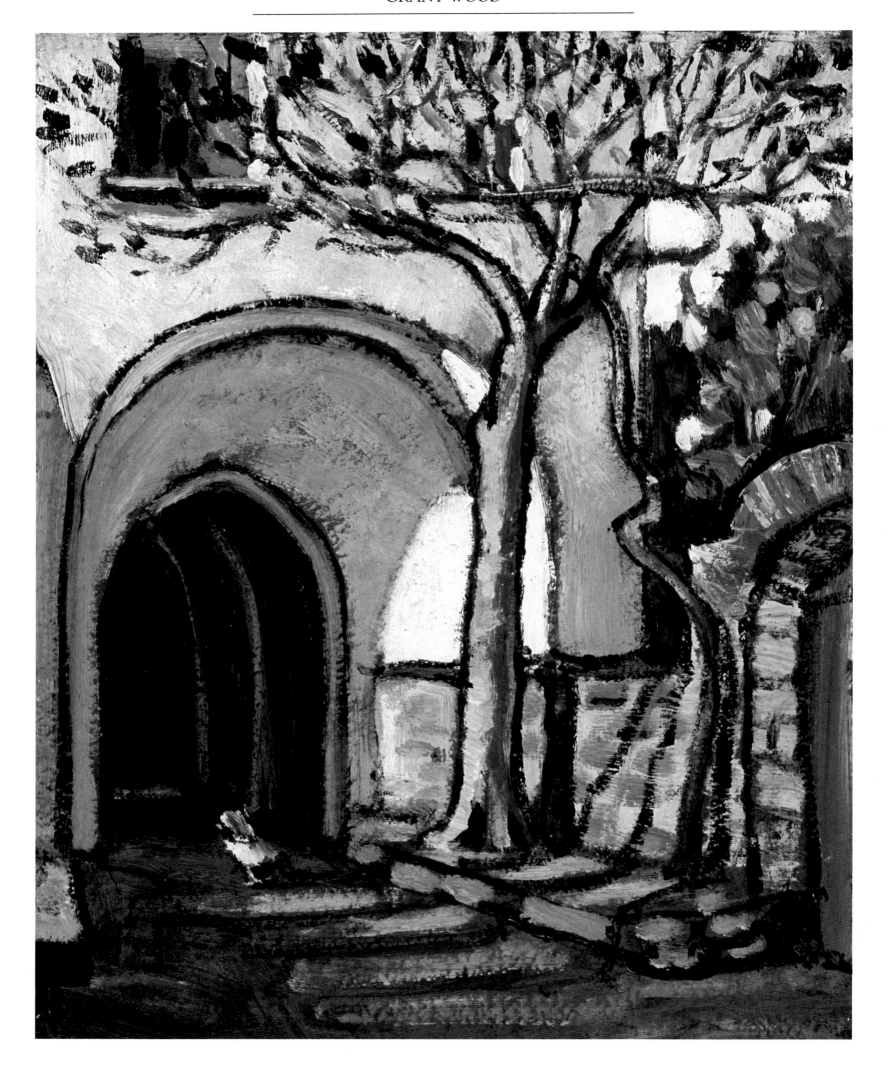

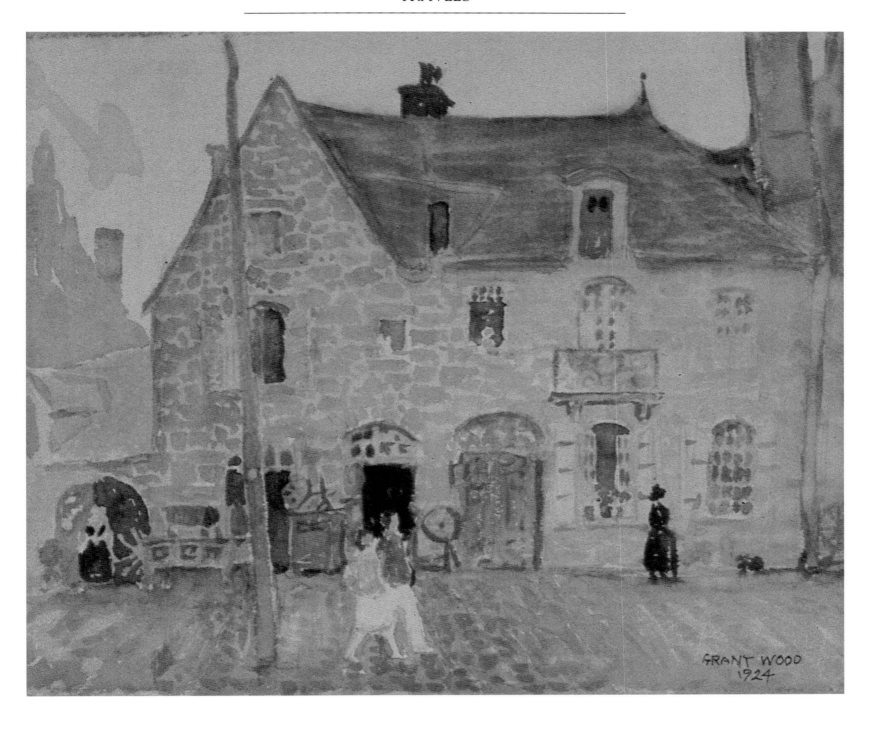

Left:
Italian Farmyard
1924, oil on composition board, 10 × 8 in.
Gift of Happy Young and John B. Turner II,
Cedar Rapids Museum of Art, IA (72.12.32)

House with Blue Pole
1924, watercolor on paper, 9 × 11 in.
Gift of Happy Young and John B. Turner II,
Cedar Rapids Museum of Art, IA (72.12.29)

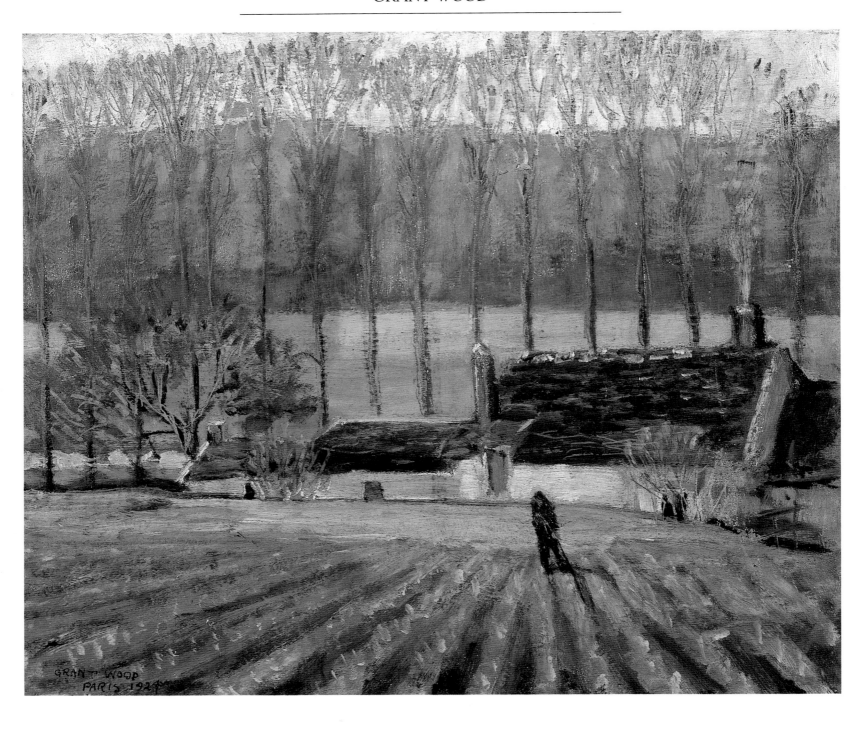

Truck Garden, Moret
1924, oil on masonite panel, 12½ × 15⅜ in.
Collection of the Davenport Museum of Art,
Davenport, IA (65.3)

At Ville d'Avray, Paris
1920, oil on canvas, 23¼ × 27¼ in.
Gift of Happy Young and John B. Turner II,
Cedar Rapids Museum of Art, IA (76.2.4)

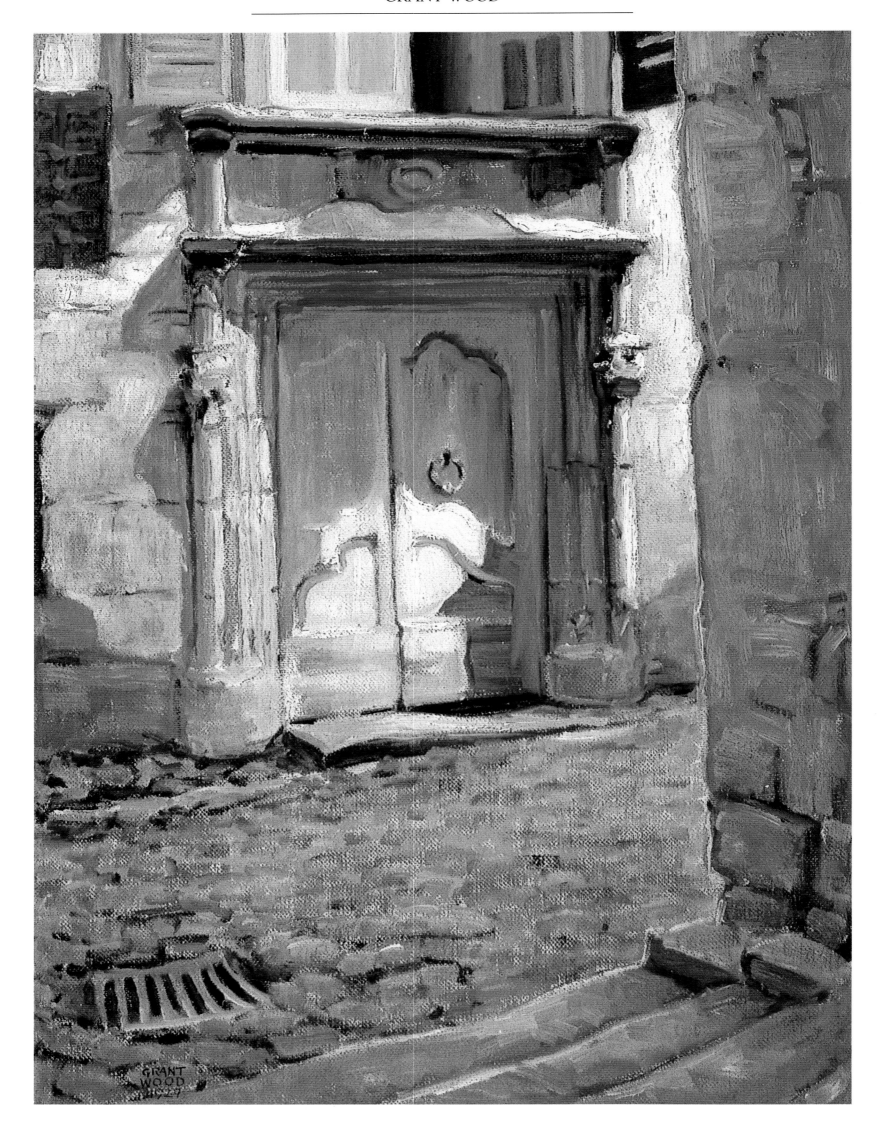

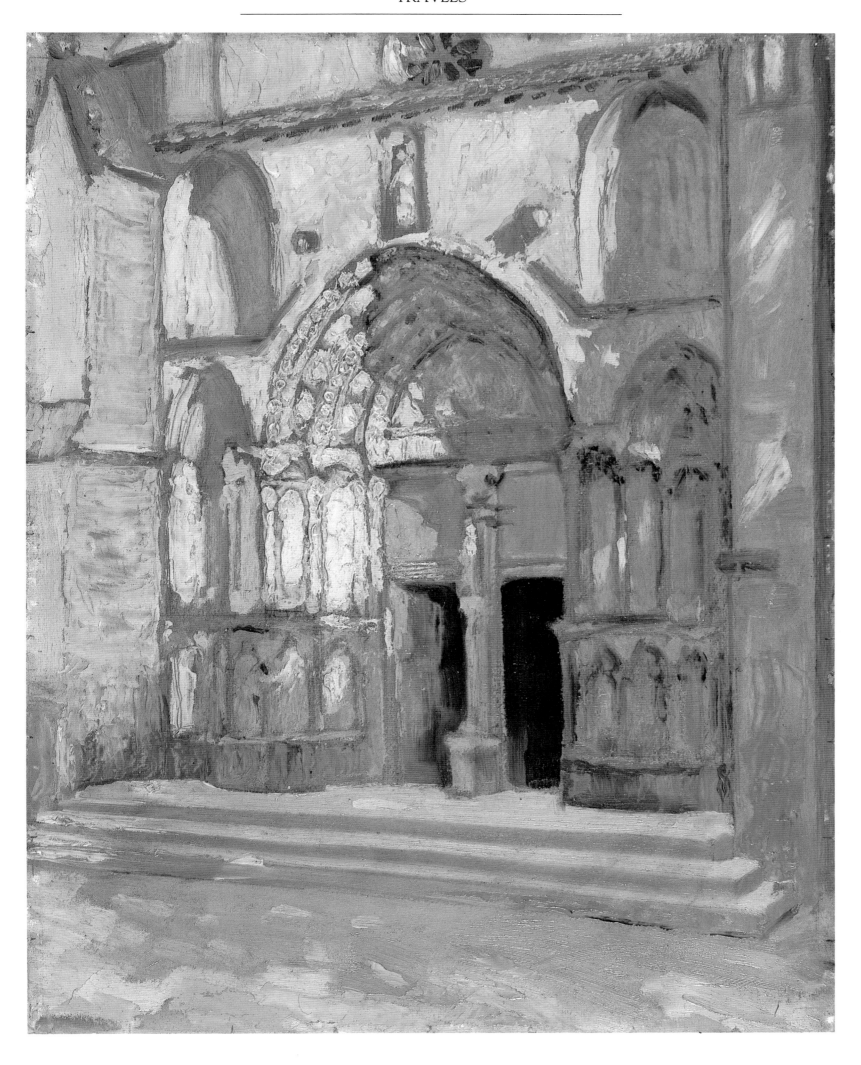

Left:
The Doorway, Perigueux
1926, oil on canvas, 24½ × 18¼ in.
Art Association Purchase,
Cedar Rapids Museum of Art, IA (32.2)

Yellow Doorway, St. Emilion
1926, oil on composition board, 16½ × 13 in.
Gift of Happy Young and John B. Turner II,
Cedar Rapids Museum of Art, IA (72.12.8)

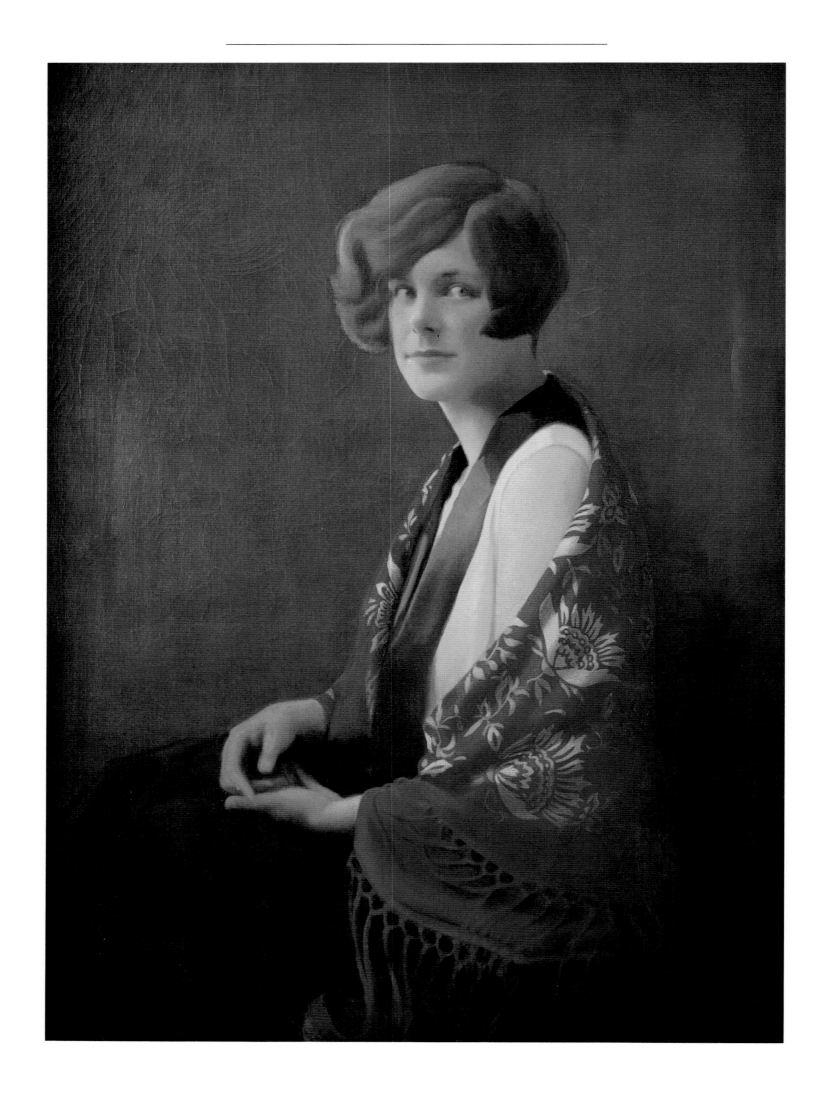

Portrait of Frances Fiske Marshall
1929, oil on canvas, 40⅜ × 30 in.
Gift of Frances Marshall Lash, Patricia Marshall Sheehy,
Barbara Marshall Hoffman, and Jeanne Marshall Byers,
Cedar Rapids Museum of Art, IA (81.11)

PORTRAITS

With an eye for detail and careful draftsmanship dedicated to preserving Midwestern values of thrift and conservatism, Grant Wood was a natural portraitist for the Iowan farmspeople. His best known figures were painted from the late 1920s to 1940, a decade that brought him both fame and turmoil. He turned down many portrait commissions from far afield, preferring images of his family, friends and personages of a tenor and temperament that aligned with his own.

After a sojourn in France at the Academie Julien, Wood was hired to paint images of factory workers at the J. G. Cherry Plant in Cedar Rapids, a dairy equipment manufacturer, in 1925. His oil on masonite portraits were notable for the concentration and manual dexterity he conveyed in these skilled craftsmen, who included a coil welder, cover maker, coopersmith, painter and shop inspector.

David Turner was Grant Wood's primary patron and guardian angel, providing the artist with rent-free living quarters, display space in his mortuary, subsidized advertising in the local press and contracts with Cedar Rapids' municipal government. Wood's portrait of David's father, *John B. Turner, Pioneer*, placed the 71-year-old gentleman against a background of an 1869 map of Linn County, Iowa.

The pink hues of Turner's skin and steel grey eyes match the map's subdivisions and its plat lines meld into his facial expression. He looks more like a banker than a pioneer but there is a physical energy and tenacity in his mien born of years on the plains.

John B. Turner, Pioneer was one of Grant's first portraits in his stricter, neo-Flemish style, with harder shapes, limited detail and a specific reference to place in the vista beyond the sitter. John Turner called the painting "two old maps" and it won the portrait and sweepstakes prizes at the 1929 Iowa State Fair.

In his mother's portrait of 1929 entitled *Woman with Plants* Wood avoided personal, intimate flourishes and refinement in favor of an archetypal pioneer woman. Her hair is pulled up into a bun, her face is plain and square-boned, and her appeal is homespun. She wears a green apron with yellow rickrack over a somber black dress. Like the hardy snake plant she holds, Mrs. Wood is an enduring species. The farmscape behind her is as simple as her clothing, adorned only with Wood's trademark windmill. The canvas portrait was his first accepted at the Art Institute of Chicago's annual exhibit of American painting in the fall of 1929.

The dramatic success of Grant Wood's most famous portrait, *American Gothic*, seemed the result of shifting cultural patterns following the Stock Market Crash of 1929. Extravagance and urbane charm no longer appealed to the public as social or artistic virtues, and sentiment was ripe for the straightlaced lines of *American Gothic*, painted in 1930.

To prepare for the painting, Wood took a photograph of a small farmhouse in nearby Eldon, Iowa, whose prim, white clapboard front featured a Gothic window of the type he had often sketched in Paris and studied in German museums. He matched its long, narrow lines to the faces of his sister, Nan, and a Cedar Rapids dentist, Dr. B. H. McKeeby, the central figures in the composition. McKeeby wore overalls over a plain-collared white shirt and frock coat, as if he were both a farmer and preacher. Wood's own father was a supervisor of the Anamosa Sunday school when he had met Grant's mother, Hattie Weaver, the organist.

The pitchfork McKeeby held was a multifaceted symbol. Although traditionally the devil's trident, here it keeps Lucifer at bay. The portrait was intended to be a farmer and his unmarried daughter, so a protective weapon is implied. Wood wittily repeats the pitchfork's tines in the seams of the farmer's overalls as if his trade has somehow permeated his being. (Wood wore overalls everywhere and was considered a bit reactionary in his attire). Grant bought his sister's decorative apron from a mail-order catalogue so that she, like his mother, would exemplify the rural past.

Indeed, one of the artist's early champions, Henry Ely, remarked that Wood "never bartered his birthright for a one-way ticket to any hot bed of culture but had the courage, confidence and common sense to stick to his native Iowa." Grant found an enthusiastic audience for *American Gothic* at the Art Institute of Chicago's 1930 fall show, where it won the Harris Prize and was bought by the museum for $300.

The public was enthralled by the image although critics occasionally misinterpreted the somber mien of the couple as a slyly satirical caricature. The pair look cramped within the pictorial plane, perhaps an oblique reference to the Midwestern narrowmindedness described in Sinclair Lewis's novels of the 1920s. Wood was an admirer of Lewis and would later illustrate his novel *Main Street*. However, it may also suggest they are pinched by poverty, a state with which Grant Wood was quite familiar.

American Gothic was a declaration of the artist's mature style. Its positive reception would propel him on to the lecture circuit, assuring invitations to juried shows across the nation and offers of teaching posts at Iowan universities. It has been amusingly parodied by cartoonists such as Charles Addaams, and revised on numerous magazine covers, particularly during the 1960s when communal ventures and grassroots organizations shared an odd kinship with the *American Gothic* farm couple.

Grant Wood displayed a rare revenge in his 1932 portrait *Daughters of Revolution*. Some local members of the Daughters of the American Revolution had earlier stirred up public antipathy to his memorial stained-glass window because it was assembled abroad, and he was merciless in this caricature of them as bloodless spinster types. He depicts them as near-

sighted, with squinting eyes or wearing thick-lensed glasses. They are prim, tight-lipped and almost masculine in their plainness – the woman pictured at left is a ringer for George Washington, whose birthday bicentennial was held in 1932.

Washington Crossing the Delaware by Emanuel Leutze is centrally featured in *Daughters of Revolution*. Leutze was a German immigrant who painted the canvas while living in Dusseldorf, a fact not lost on Wood, whose German associations caused such furor with the Daughters of the American Revolution. Wood explicitly omitted the word "American" from the painting's title. He tagged it "those Tory gals" to express his distaste for "people who are trying to set up an aristocracy of birth in a Republic." One critic remarked: "This picture will create a great deal of talk and a great deal of hard feelings – but not enough."

Wood's self-portrait won a first award at the Iowa's Federation of Women's Clubs in 1932 but the artist was not satisfied with it. He continued working on the image for several years, changing the overalls for an open-necked shirt. It has the kind of dispassionate, unflinching appraisal more recently seen in work by photorealists such as Chuck Close. Even in his forties, Grant had the plump features and blond crewcut of an Iowan farmboy, yet his extraordinarily steady gaze discloses his profession. More importantly, the figure has dominion over the sunny farm landscape in the distance, complete with his windmill logo.

Henry A. Wallace was the secretary of agriculture during the Harding Administration and vice president under Franklin D. Roosevelt from 1941 to 1945. Wallace implemented the Agricultural Adjustment Act to create stability between production and consumption of farmers' crops and livestock. Funds were alotted to restrict livestock and lay fields fallow, and farmers could borrow from banks with their crops as collateral. Grant Wood openly admired Henry Wallace and his feelings are reflected in the flattering, confident portrait he limned for a *Time* magazine cover in 1940.

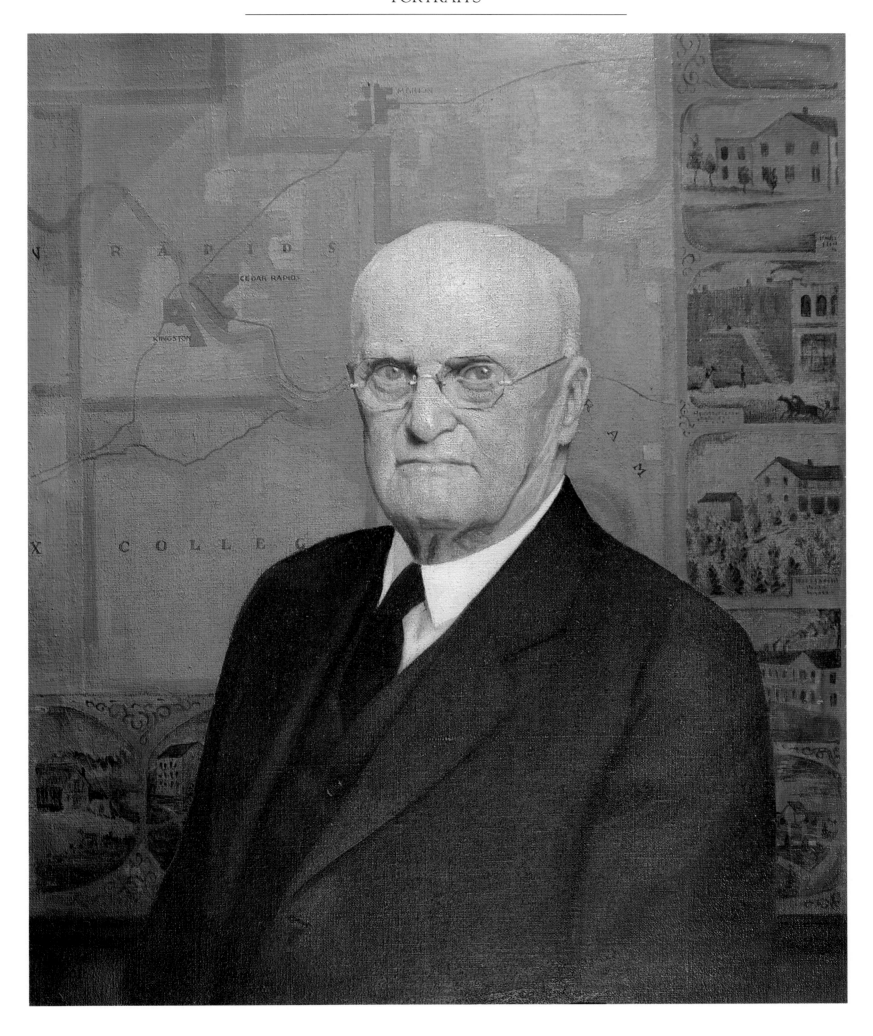

Left:
The Coil Welder
1925, oil on canvas, 18¼ × 22 in.
Cherry Burrell Charitable Foundation Collection,
Cedar Rapids Museum of Art, IA (74.5.2)

Portrait of John B. Turner, Pioneer
1928-30, oil on canvas, 30¼ × 25½ in.
Gift of Happy Young and John B. Turner II,
Cedar Rapids Museum of Art, IA (76.2.2)

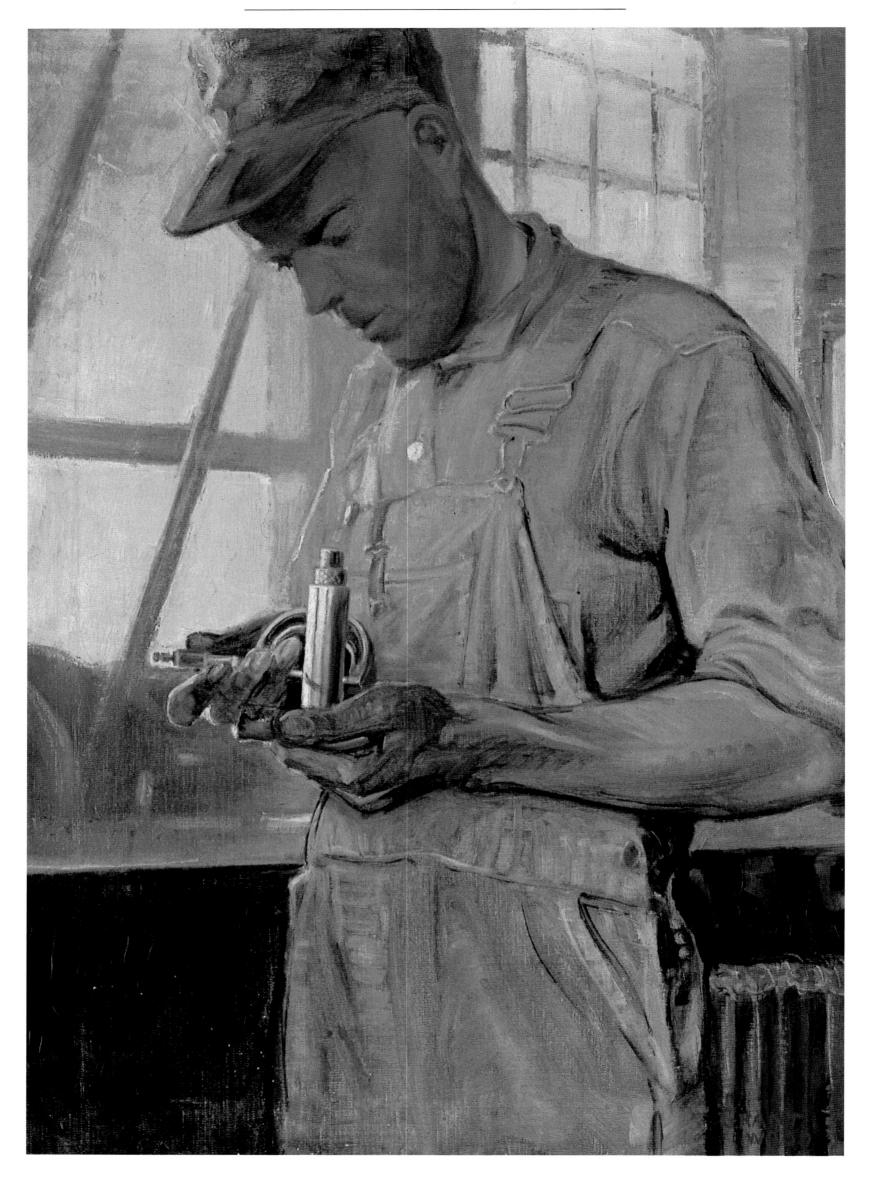

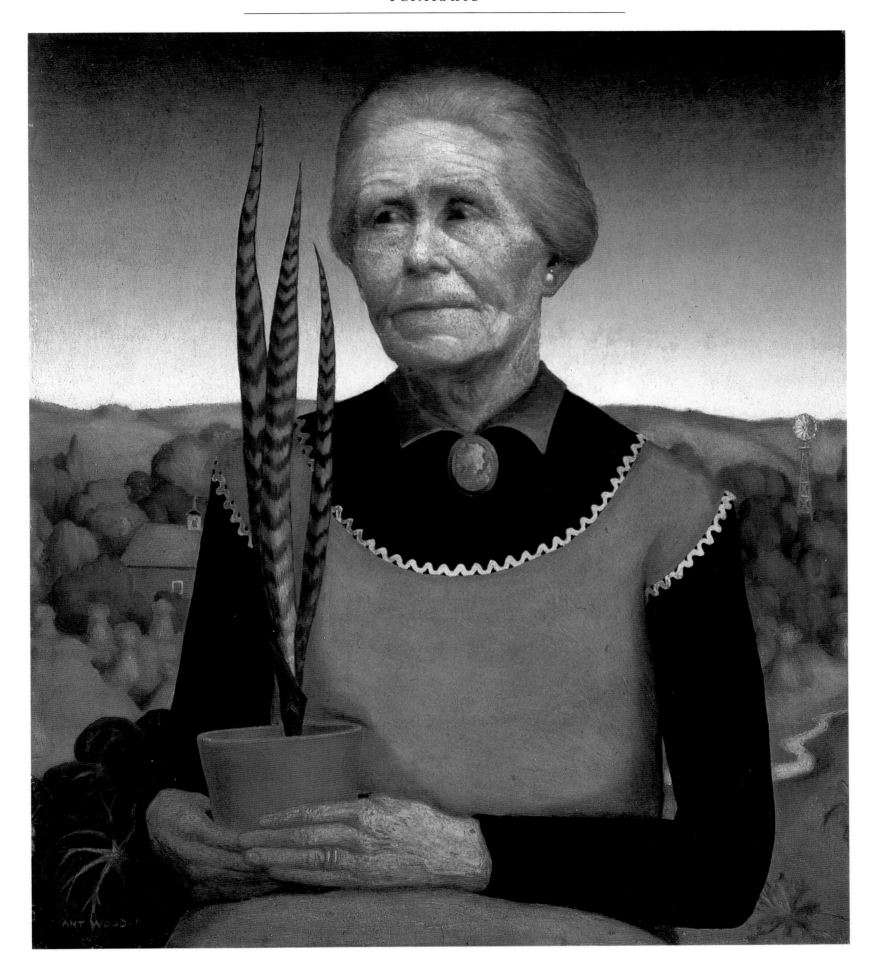

Left:
The Shop Inspector
1925, oil on canvas, 24 × 18 in.
Cherry Burrell Charitable Foundation Collection,
Cedar Rapids Museum of Art, IA (74.5.6)

Woman with Plant(s)
1929, oil on upsom board, 20½ × 17⅞ in.
Art Association Purchase,
Cedar Rapids Museum of Art, IA (31.1)

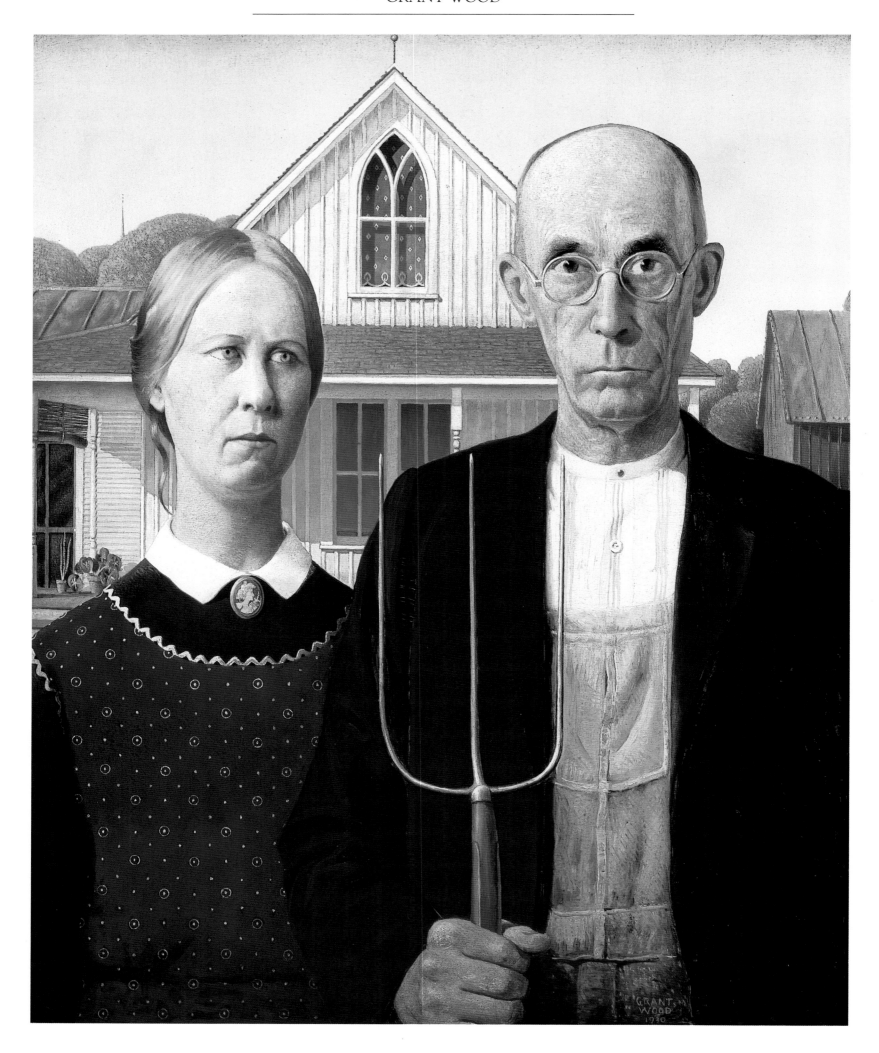

American Gothic
1930, oil on beaver board, 30 × 25 in.
Friends of American Art Collection,
photograph © 1993, The Art Institute of Chicago,
Chicago, IL, All Rights Reserved (1930.934)

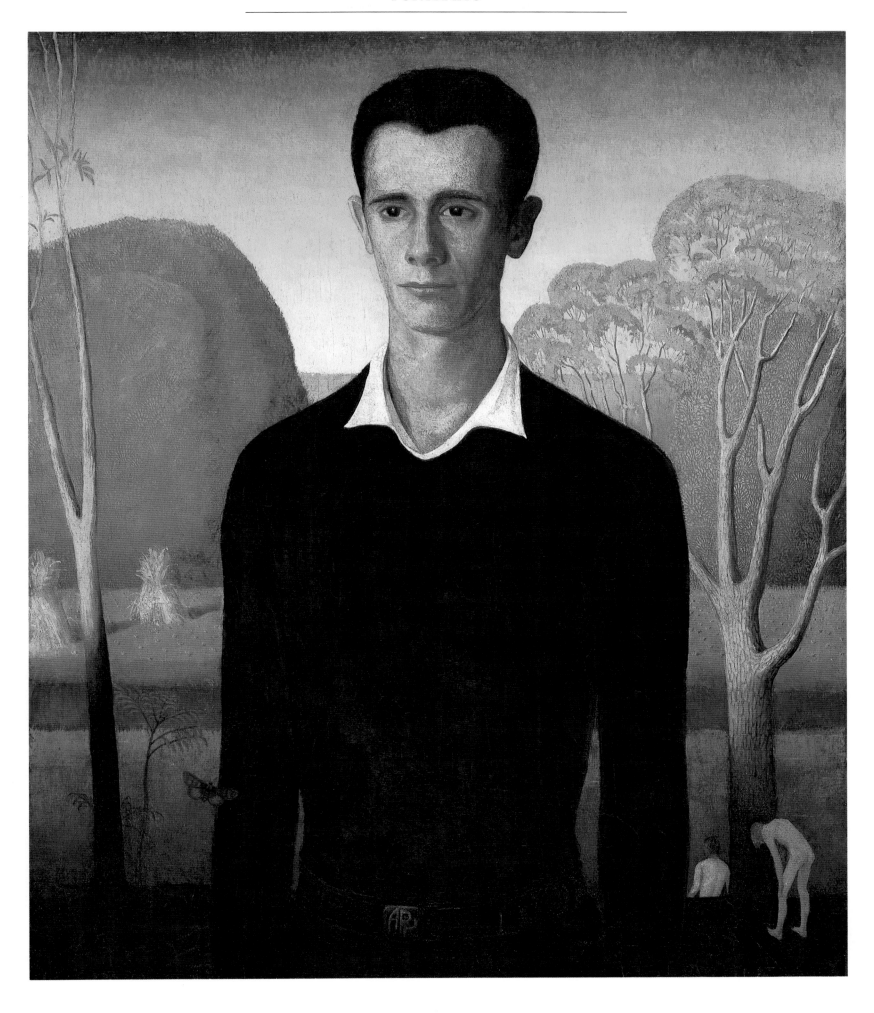

Arnold Comes of Age
1930, oil on composition board, 26¾ × 23 in.
NAA Collection, Sheldon Memorial Art Gallery,
University of Nebraska, Lincoln, NE (1931.N-38)

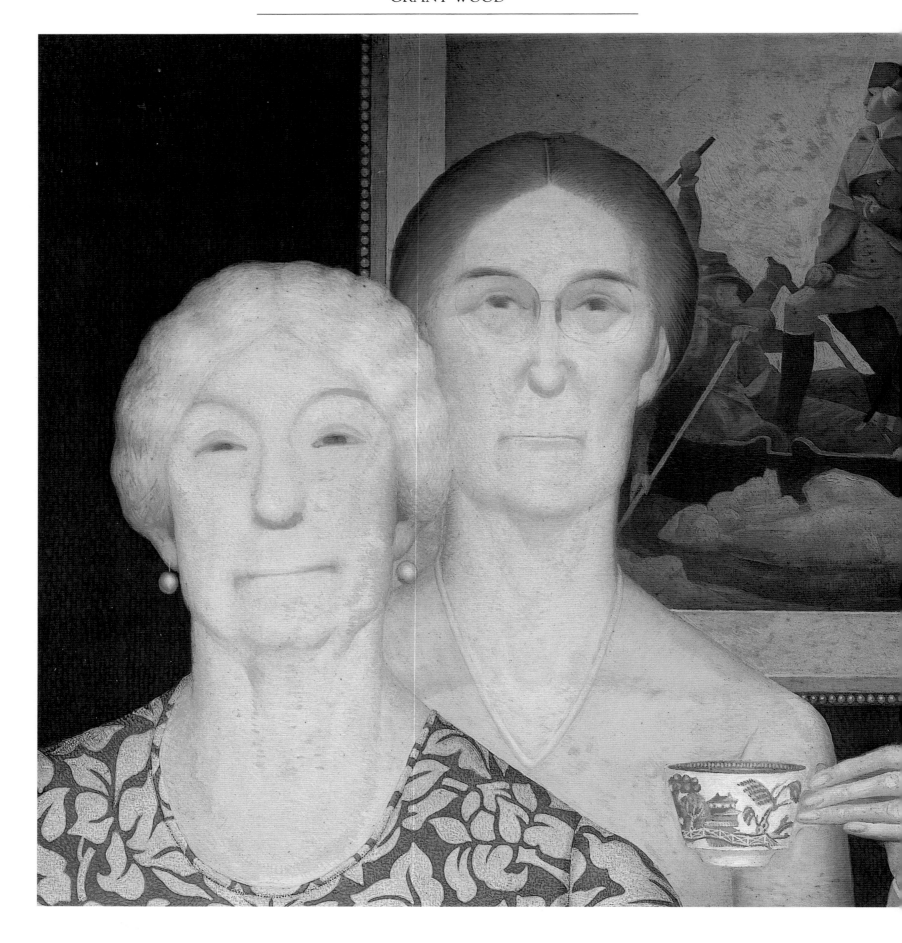

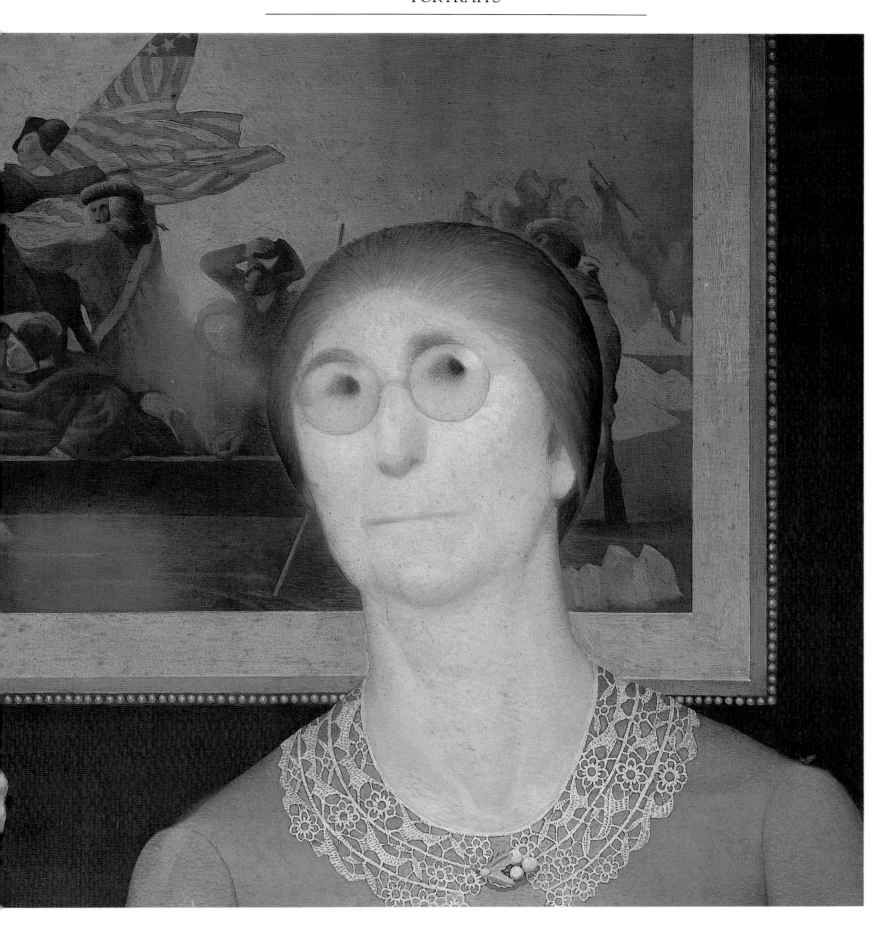

Daughters of Revolution
1932, oil on masonite, 20 × 40 in.
The Edwin and Virginia Irwin Memorial,
Cincinnati Art Museum, Cincinnati, OH (1959.46)

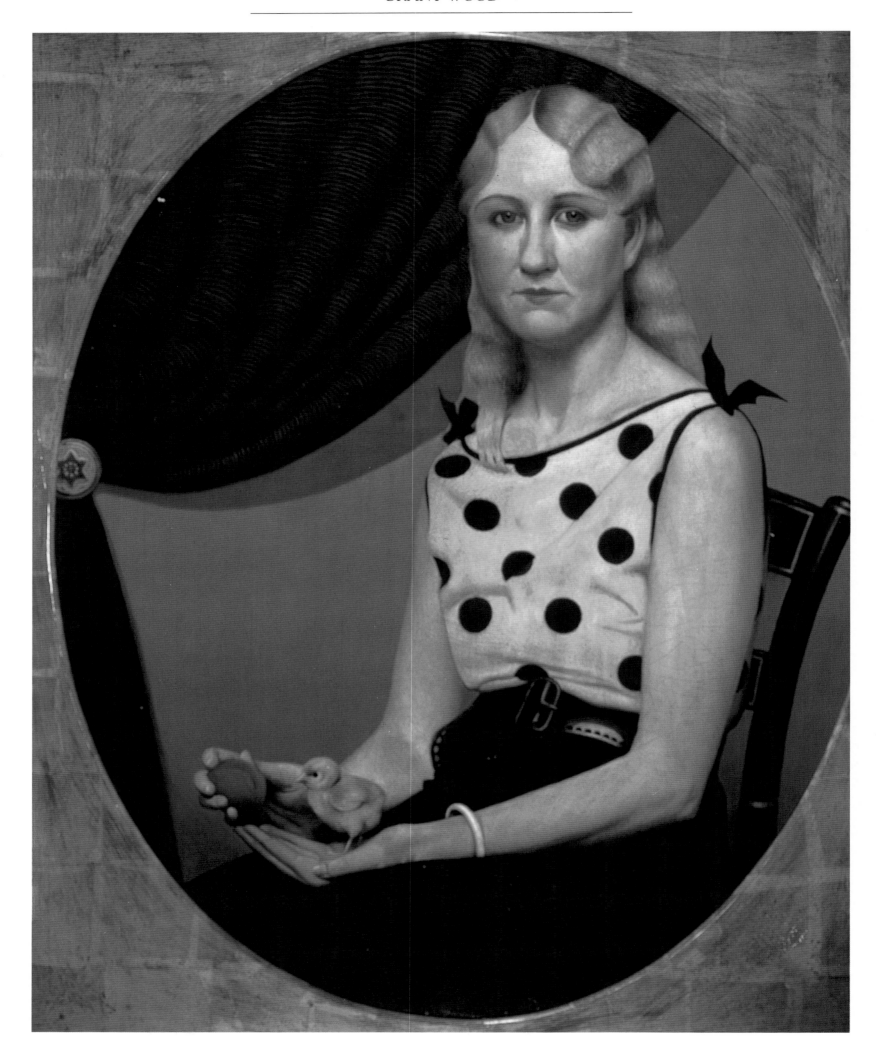

Portrait of Nan
1933, oil on masonite panel, 40 × 30 in. (oval)
Anonymous Loan, Elvehjem Museum of Art,
University of Wisconsin, Madison, WI

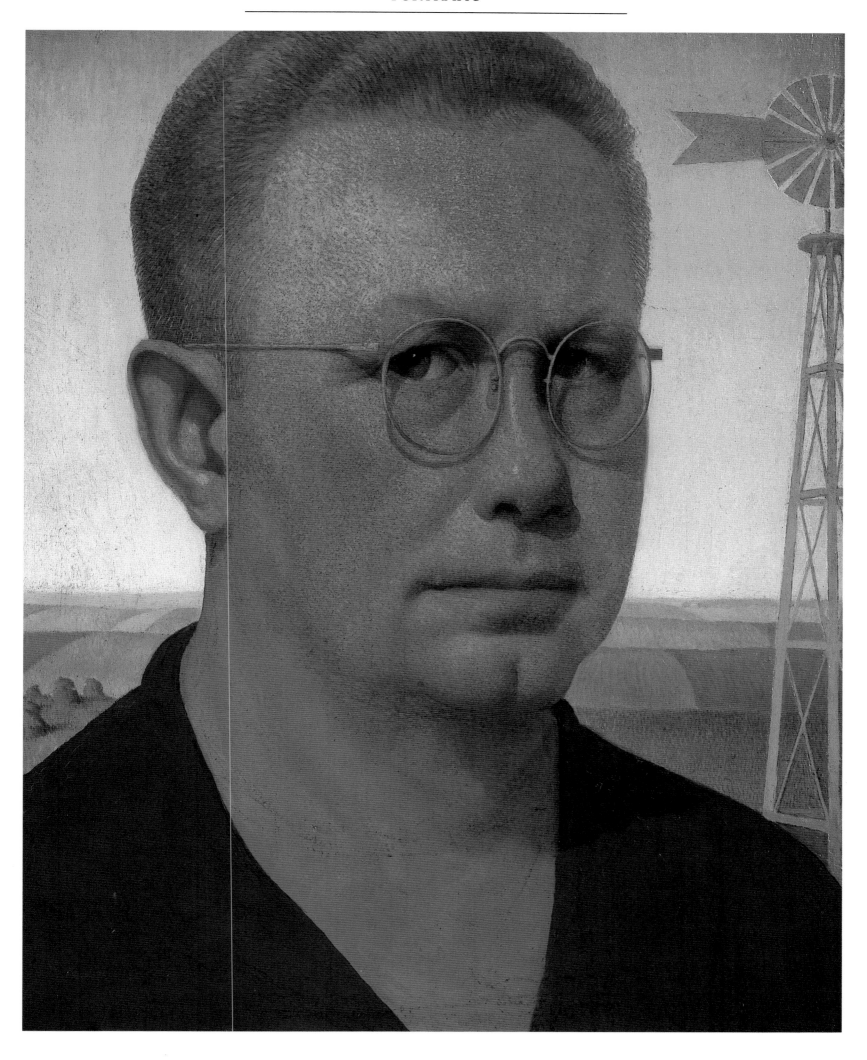

Self Portrait
1941, oil on masonite panel, 14¾ × 12⅜ in.
Collection of the Davenport Museum of Art, Davenport, IA (65.1)

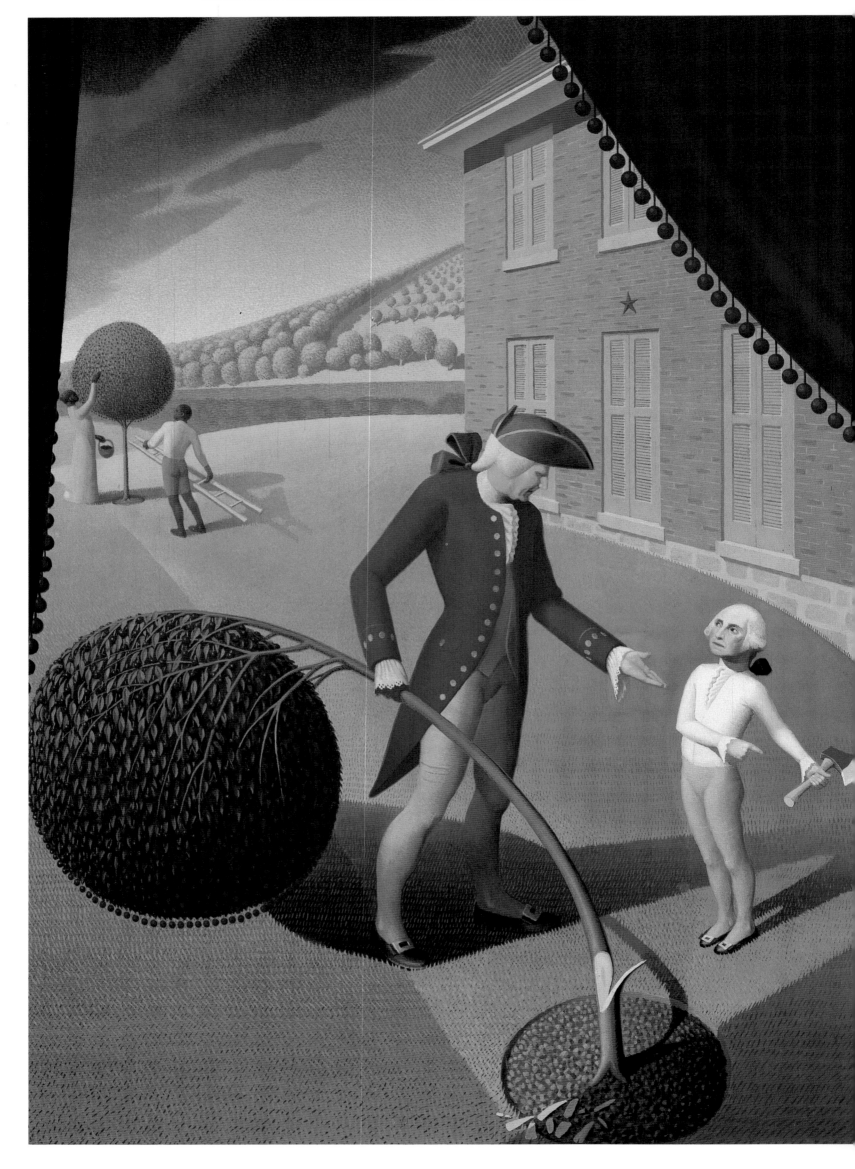

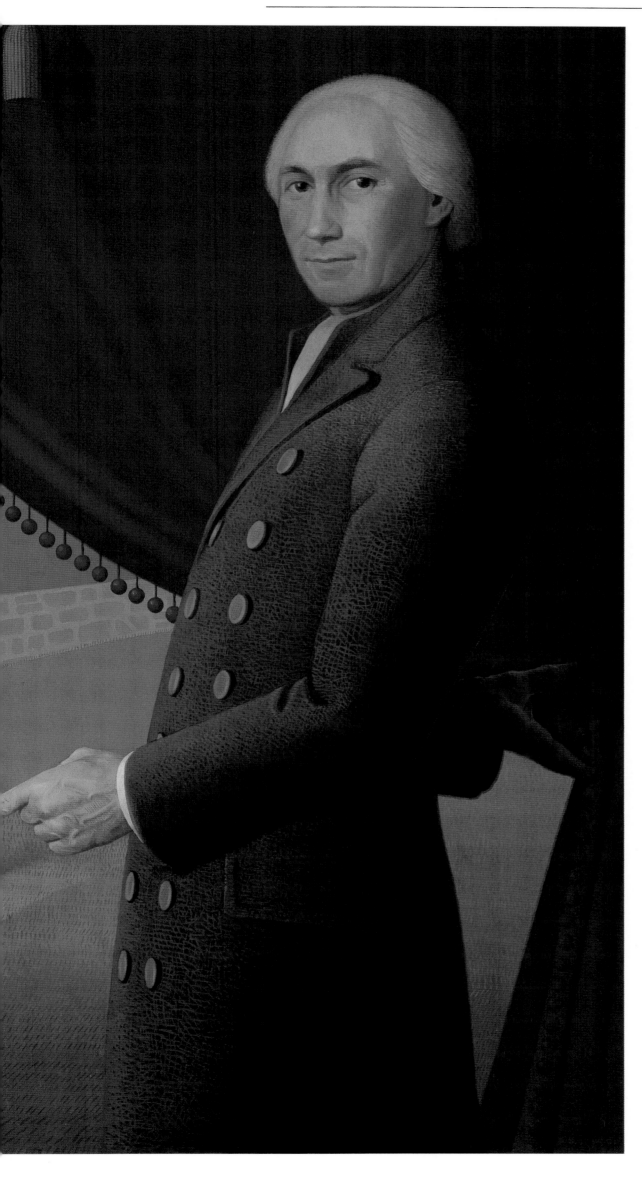

Parson Weems' Fable
1939, oil on canvas,
38⅜ × 50⅛ in.
Amon Carter Museum,
Fort Worth, TX (1970.43)

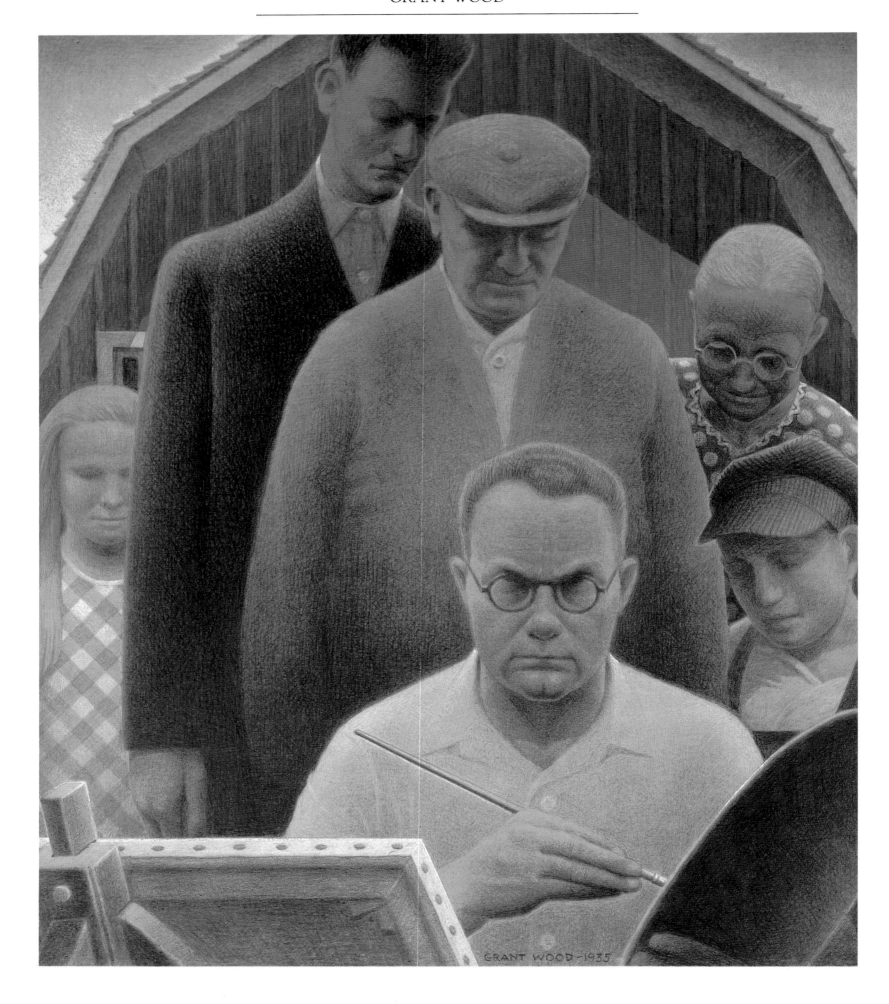

Return from Bohemia
1935, colored crayon, gouache and pencil on brown paper,
23½ × 20 in.
The Regis Collection, Minneapolis, MN

Right:
Cover of Henry Wallace
Copyright 1940 Time Inc.
Reprinted by permission

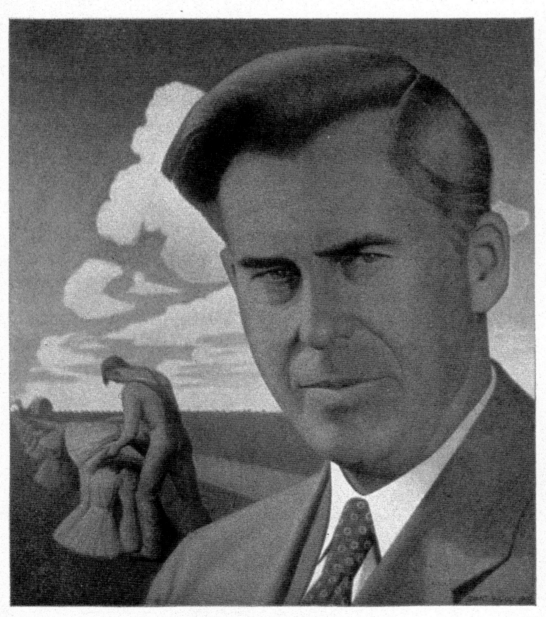

TIME

THE WEEKLY NEWSMAGAZINE

WALLACE OF IOWA
Ceres is a goddess of politics.
(National Affairs)

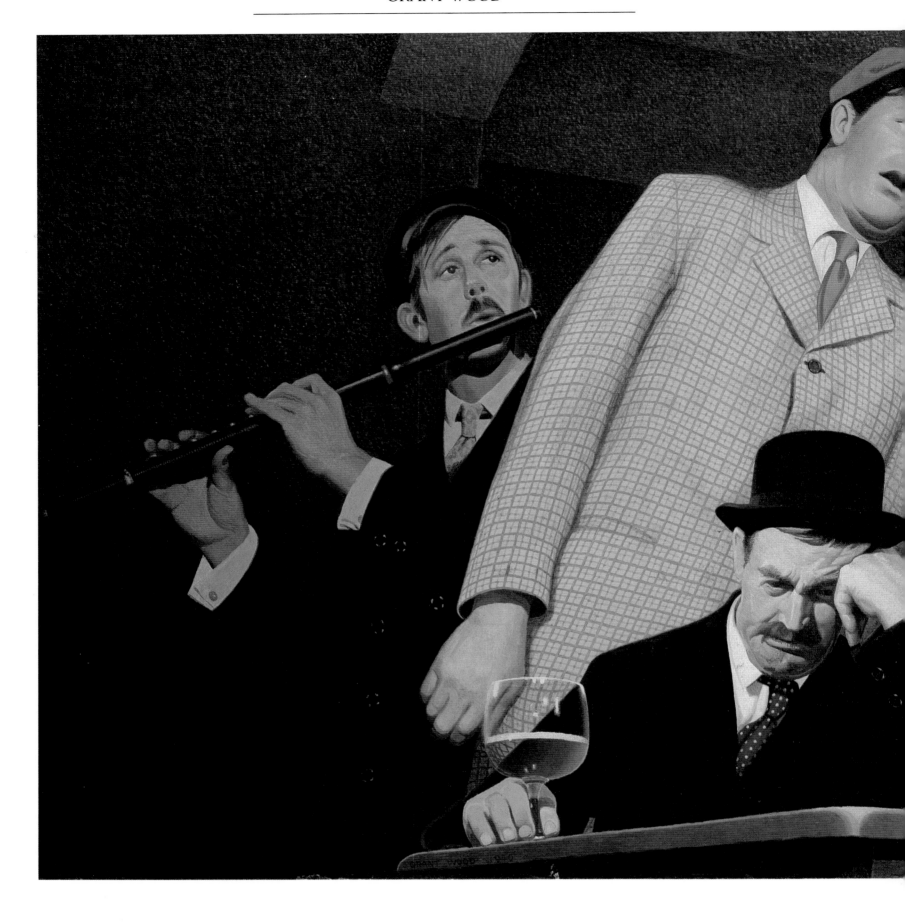

Sentimental Ballad
1940, oil on masonite, 24 × 50 in.
Charles F. Smith Fund, New Britain Museum of American Art,
New Britain, CT (1962.1)

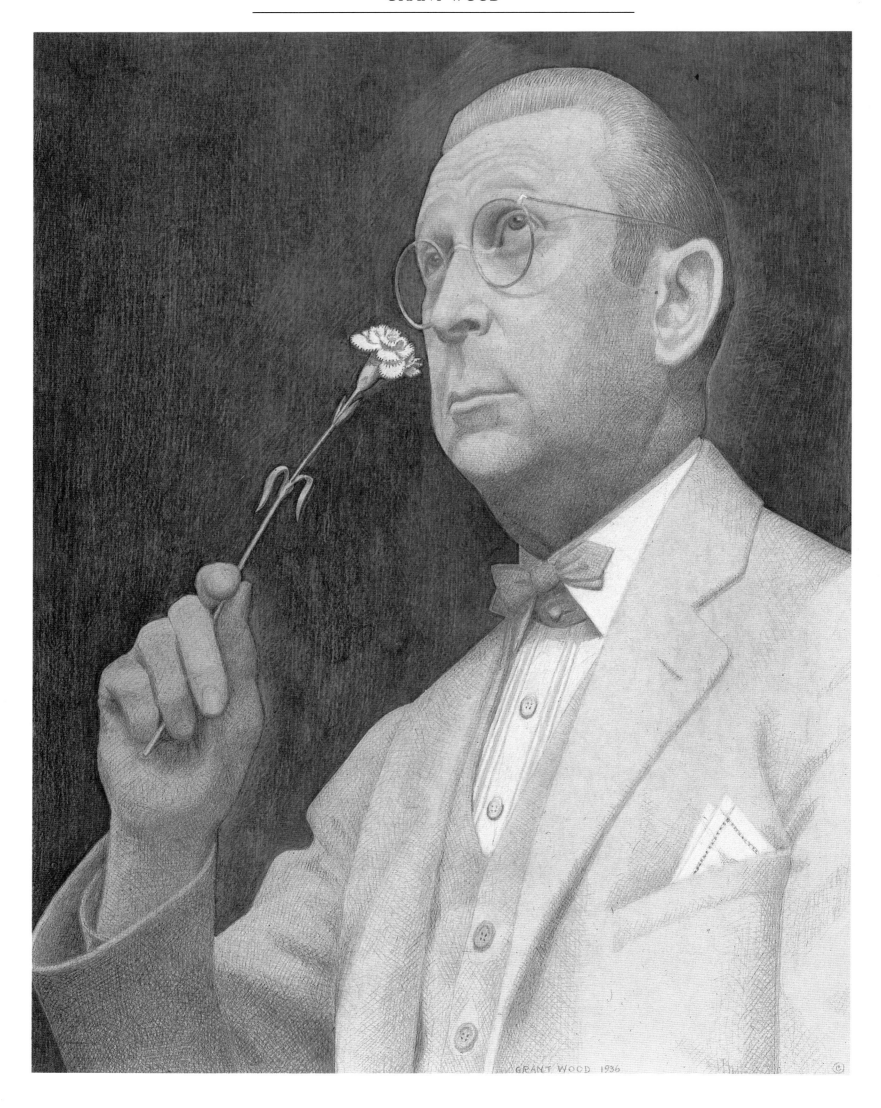

GRANT WOOD 1936

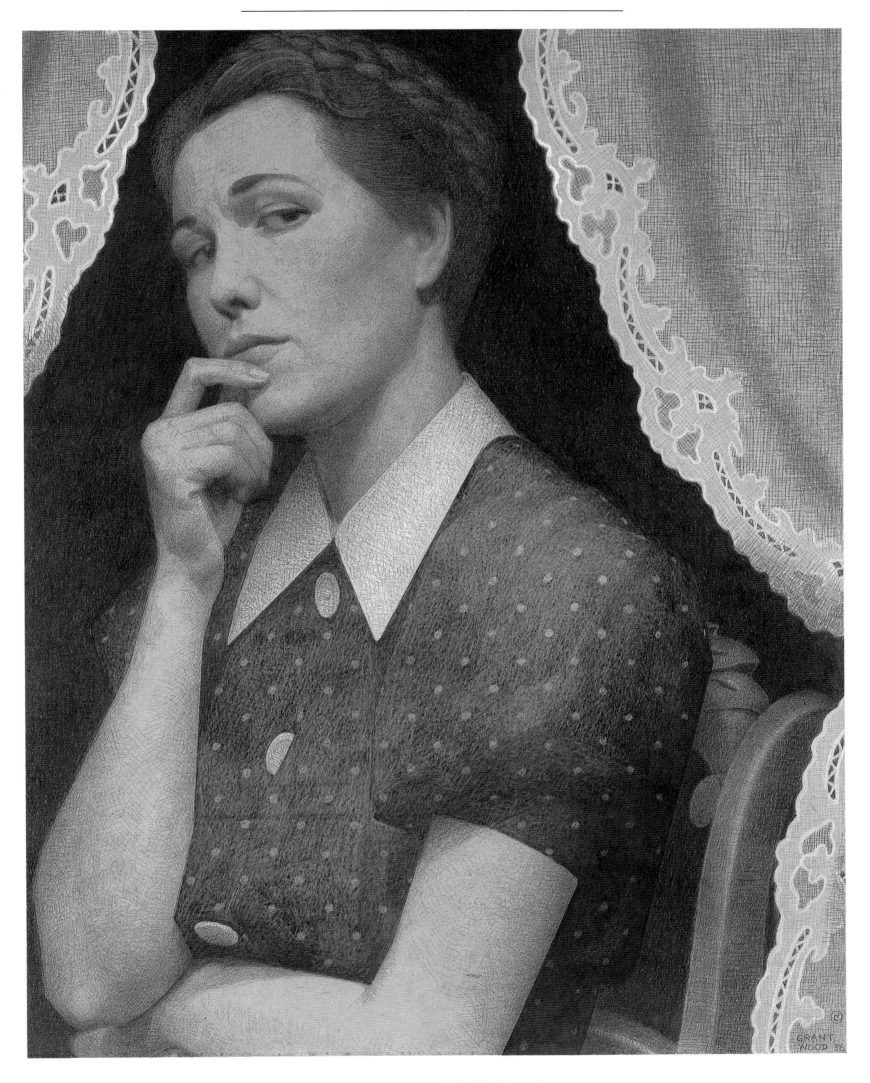

Left: **The Sentimental Yearner**
1936, pencil, black and white conte crayon painted white around image, 20¼ × 16 in.
Gift of Alan Goldstein, The Minneapolis Institute of Arts, Minneapolis, MN (80.91)

The Perfectionist
1936, crayon, gouache, charcoal, and ink on paper, 20 × 16 in.
Achenbach Foundation for Graphic Arts,
Gift of Mr. and Mrs. John D. Rockefeller 3rd,
The Fine Arts Museums of San Francisco, CA (1979.7.106)

89

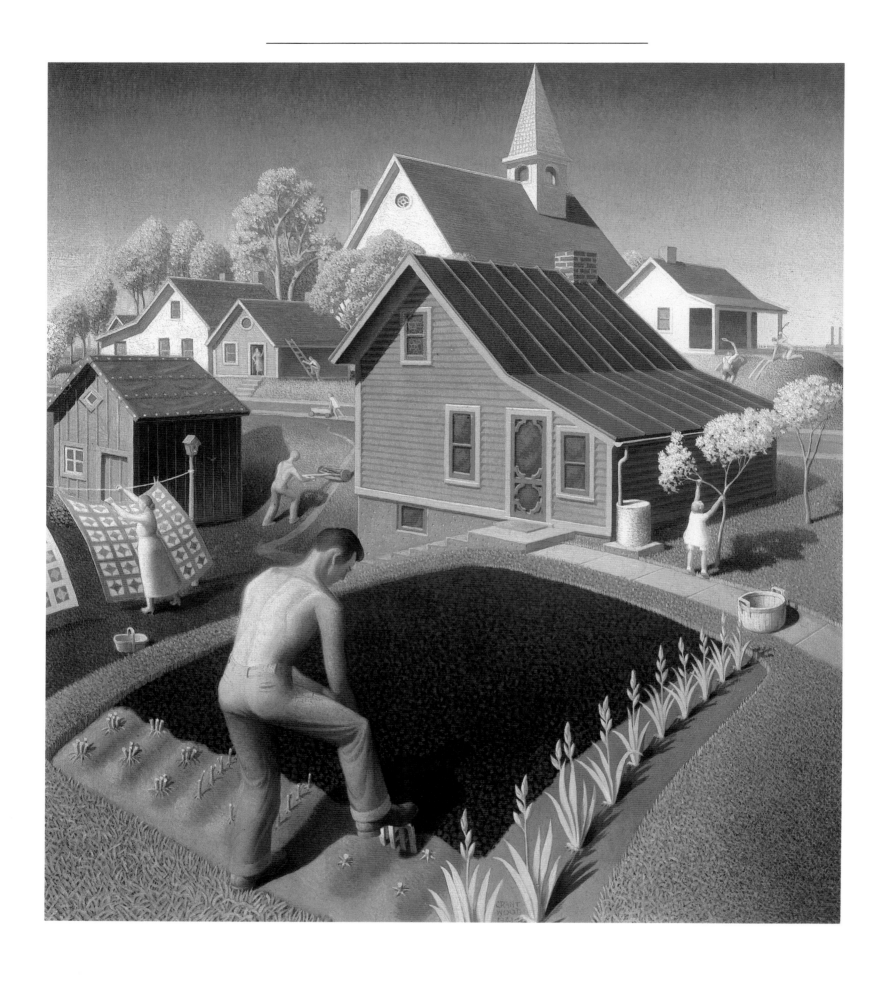

Spring in Town
1941, oil on canvas, 26 × 24½ in.
Courtesy of the Sheldon Swope Art Museum,
Terre Haute, IN (41.30)

REGIONAL SCENES

Grant Wood viewed the external physical world as a scheme with orderly patterns even when he was a child. He remarked to his mother that "cornfields in spring look like black comforters tied in green yarn." The elements of his mature landscape style were derived from winsome Currier and Ives prints, maps in historical atlases that presented a bird's-eye view, and primitive folk art paintings with repetitive patterns and reductive forms.

Stone City of 1930 was his first oil on masonite panel in this manner. It was an idyllic rendering of a town that, in fact, was long past its prime. The quarry business around which life in Stone City had centered had been eclipsed by cement production but Grant Wood's scene conveys unruffled rural harmony. Carefully mowed fields are intersected by smooth dirt roads. Sunshine prevails to modulate ripe yellows, greens and browns in a balanced procession.

Wood's experience as a model maker for a Cedar Rapids home developer can be seen in the symmetry of trees, neat rows of crops and tidy, simplified architecture of the village buildings. He often made clay models of furrows to ensure a quality of depth and scale in his works, and fashioned an entire landscape in clay for *Spring Turning* of 1936. There is a well-defined sculptural aspect to the curves and contours of his domains.

Grant did not travel far from Cedar Rapids for the subject matter of his best known paintings. He followed the dictum of one of his earliest teachers, Ernest Batchelder, a leader in the Arts and Crafts Movement in America: "Art as craft need not be exclusively individualistic but should bear a cultural personality, that anonymous quality which makes Greek art Greek and Gothic art Gothic. We search the world over, look everywhere but within ourselves to find some thought to render with our tools, everywhere but to the abundant life about us to find some motif or suggestion."

Grant Wood was the foremost proponent of regionalism in America during the 1930s. He focused on agricultural rites, farm personages, and Iowa's past almost to the exclusion of any other themes. Herbert Hoover was born in a tiny burgh called West Branch, Iowa, and emphasized his modest beginnings during his presidential campaign. Grant Wood painted *Herbert Hoover's Birthplace* in 1931, the Iowan's third year in office. He depicted the little cottage of Hoover's youth as part of a stage set delineating a highly regimented neighborhood with esplanades of trees and evenly planed rooflines. An elfin character stands in a spotlight in the middle of a bright green, perfectly clipped lawn to point out the humble homestead, which is almost swallowed up by the rigorous patterning of foliage.

Corn assumed heroic properties as a symbol of the Midwest in Wood's paintings, suggesting richness, fecundity and enduring strength. Its form and cultivation were the basis of several canvases, murals and lithographs. Undulating fields punctuated with sprouting husks fill the foreground of *Young Corn*, and gathered cornshocks stand like sentinels stretching far into the horizon in *Fall Plowing*. We are never presented with the sweat or fatigue incurred in its planting or harvesting, only a dreamlike, rhythmic progression of green, brown and gold perfection. There is no atmosphere in these vistas, but rather a clear, distilled light. Motorized machinery is absent except for its smooth results. Wood's lithograph entitled *January* of 1937 is a stylized, mechanistic perspective of cornshocks so dominant they assume a surreal dimension.

Adolescence, one of Grant's last canvases, is an affectionate portrait of the chickens he raised as a young boy. They are viewed close-up and their feathers are densely detailed with arresting patterns. Two short, squat hens squeeze a thin, naked young bird into a vertical pose, creating a dynamic triangular composition and underscoring the awkwardness of youth. Chickens lose their feathers in adolescence and as their caretaker, Grant had put tallow on their wings to relieve sunburn. He frequently pictured them as colorful icons of the agrarian life.

Death on the Ridge Road is the only canvas Wood painted that explicitly conveyed danger and the threat of death. It followed a car accident in which he collided with a milk truck as well as a crash in which his close friend, Jay Sigmund, suffered serious injuries. He has changed all of the flat, smooth, round planes of his typical landscapes so that they tilt precipitously, and he places a tractor trailer and a sedan at right angles to break up the center of the composition. Telephone poles evoke crosses at Calvary and the sharp contrast of light and dark accentuates a sense of foreboding.

In his tripartite mural *Dinner for Threshers*, Wood synthesized the format of religious triptychs painted during the Renaissance with stereotypical farm characters whose well-fed contours and plain, snub-nosed features are arranged in a Midwestern allusion to *The Last Supper*. Wood's murals for the Iowa State University Library in Ames were similar scenarios of figures working cooperatively for the common good. Hands were busily engaged with axes, pitchforks, ropes and reins in the male images, and dustrags, plates and children in the distaff portions.

Wood's output of paintings was limited but they were popular and sold readily to a prestigious group of collectors. They also received a variety of awards in statewide and national juried competitions. *Stone City* captured the top landscape prize at the 1930 Iowa State Fair and was bought for the Joslyn Memorial Museum in Omaha, Nebraska. *Fall Plowing* took the blue in landscapes at the 1932 State Fair and was sold to Marshall Field, III, heir to the Chicago department store fortune.

Hollywood denizens were intrigued by Wood's American style and purchased many of his canvases. King Vidor, the

movie director, bought *January* and *Arbor Day*. Cole Porter selected *Death on the Ridge Road* and George Cukor acquired *Near Sundown*. Katherine Hepburn was another admirer and collector.

A commercial patron, Abbott Laboratories, displayed *Adolescence* at its offices in Chicago. One of Wood's final paintings, *Spring in the Country*, was sold to Cornelius Vanderbilt Whitney in New York.

The regional qualities evident in Wood's landscape painting are also evident in his other genres. Rural, Midwestern background details and personages create a unifying thread of regionalism that weaves through Wood's artwork.

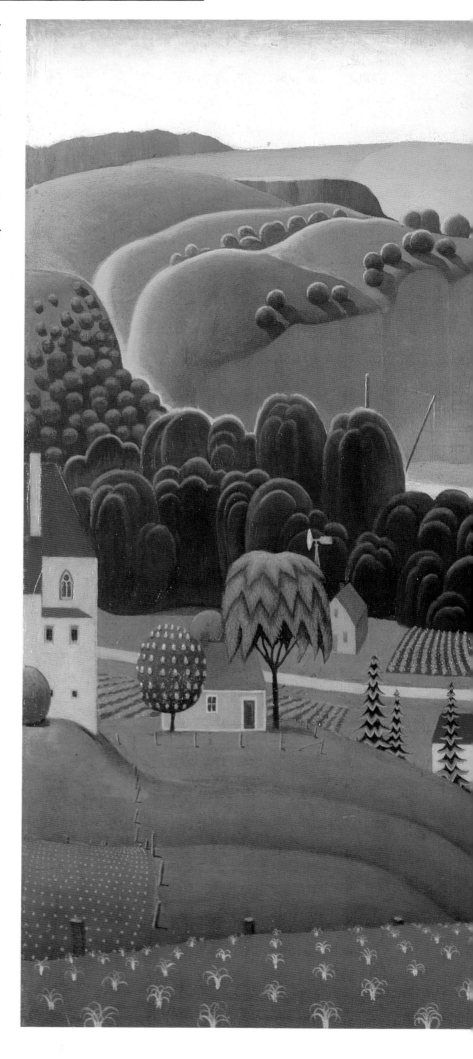

Right:
Stone City, Iowa
1930, oil on wood panel,
40 × 30¼ in.
Joslyn Art Museum, Omaha, NE

Overleaf:
Overmantel Decoration
1930, oil on upsom board,
41 × 63½ in.
*Gift of Isabel R. Stamats in
Memory of Herbert S. Stamats,
1973, Cedar Rapids Museum of
Art, IA (73.3)*

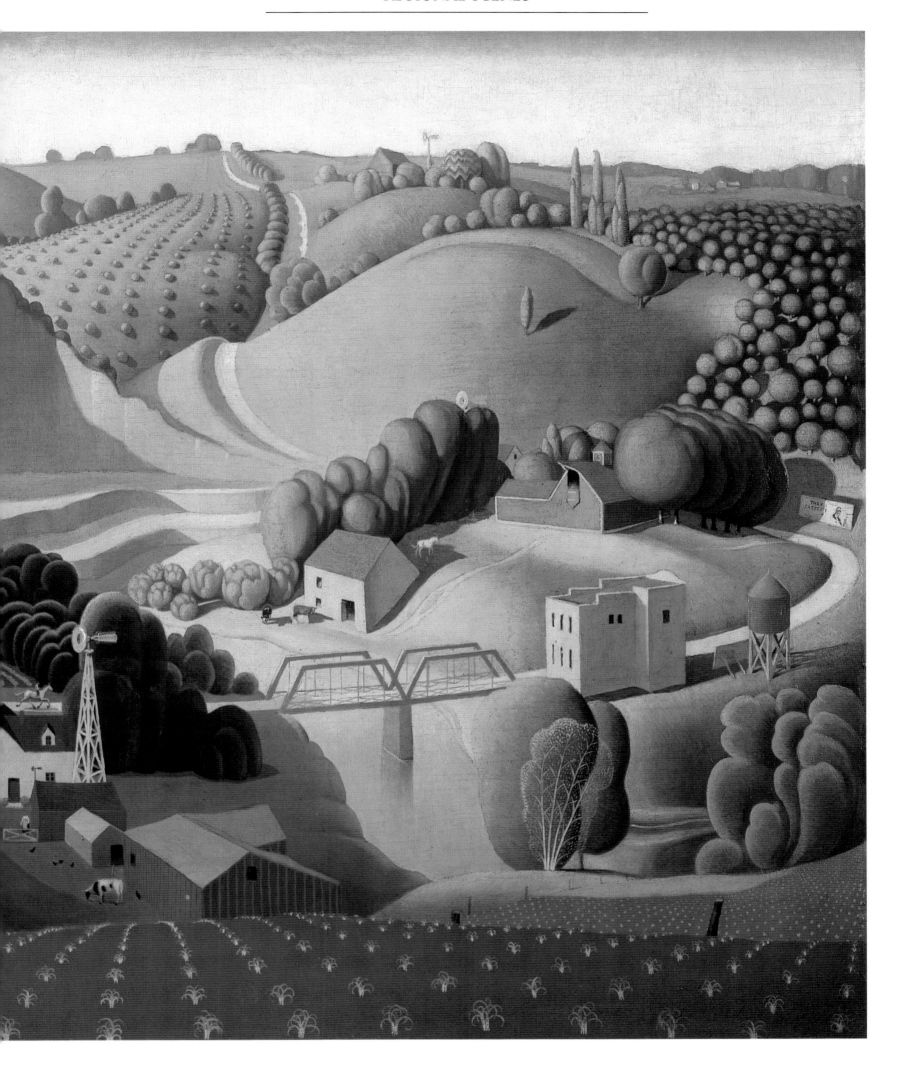

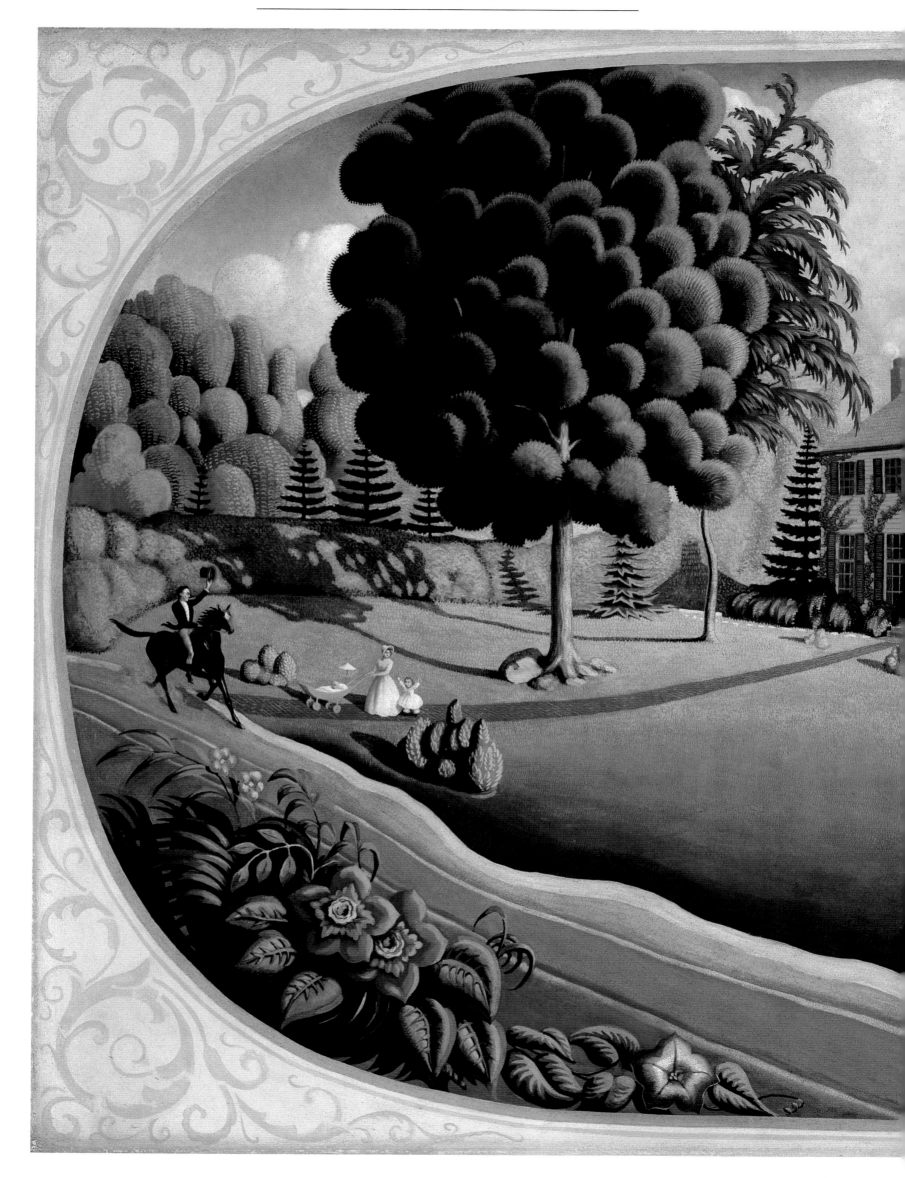

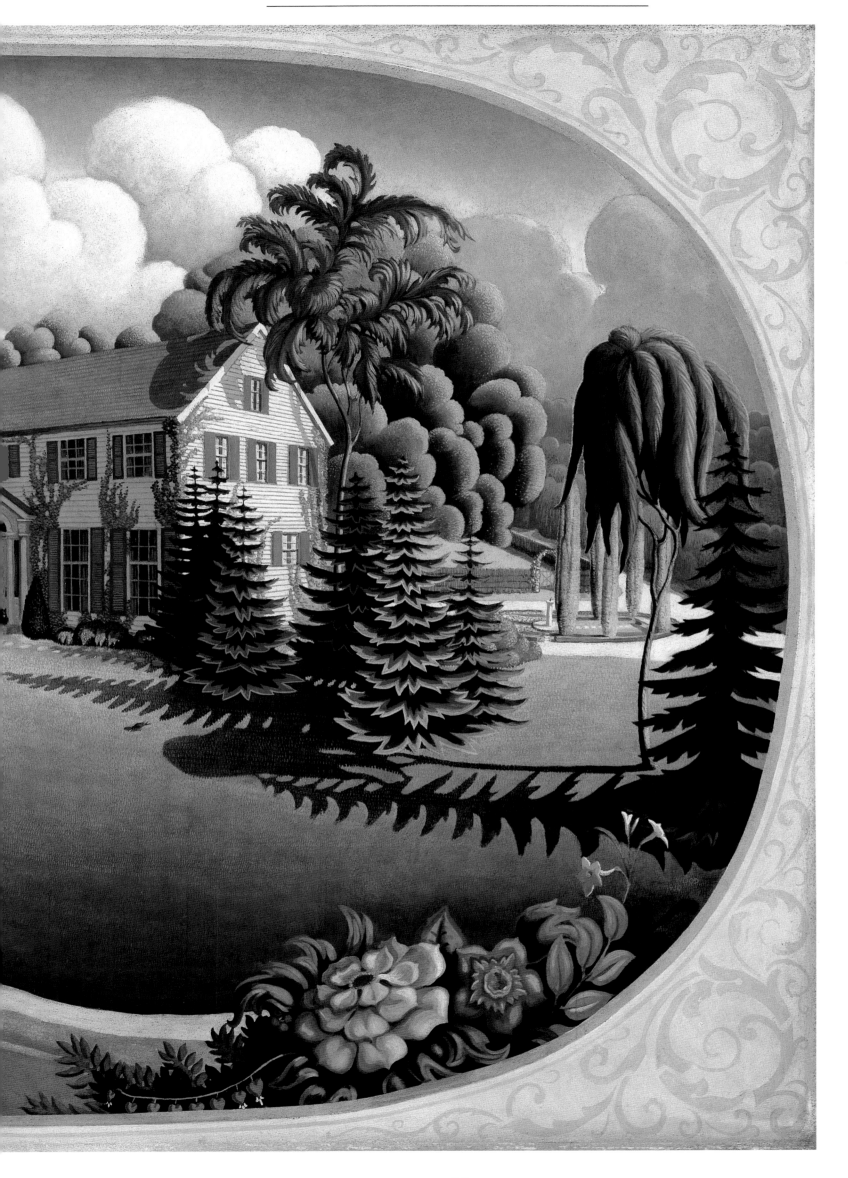

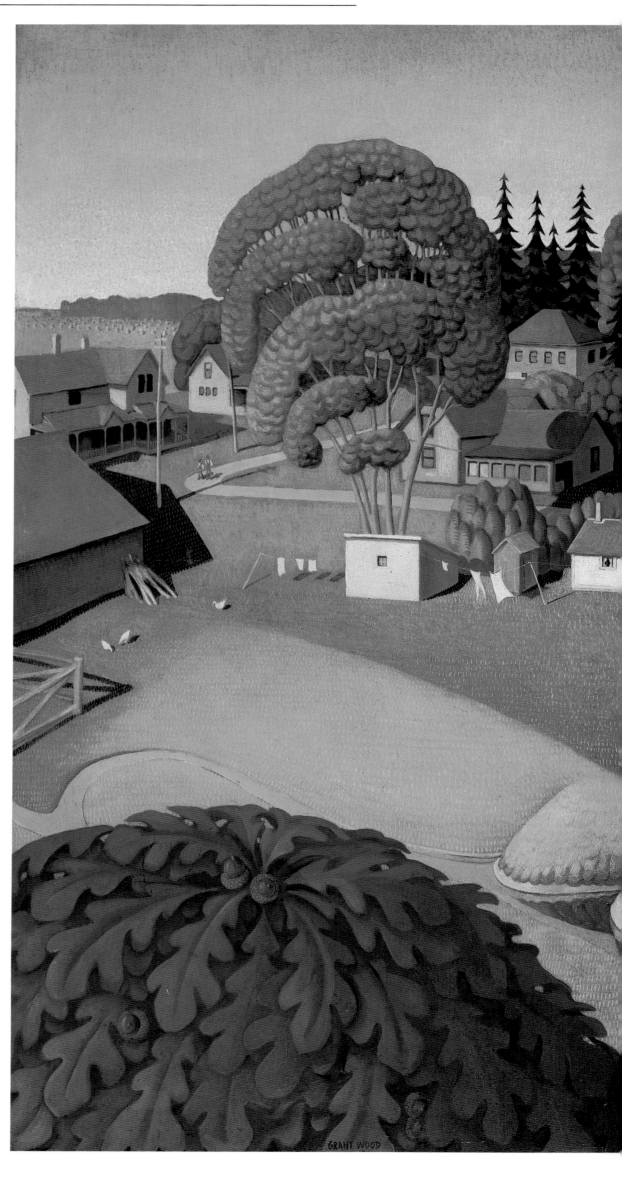

The Birthplace of Herbert Hoover, West Branch, Iowa
1931, oil on composition board, 29⅝ × 39¾ in.
The John R. Van Derlip Fund; owned jointly with the Des Moines Art Center, The Minneapolis Institute of Arts, Minneapolis, MN (81.105)

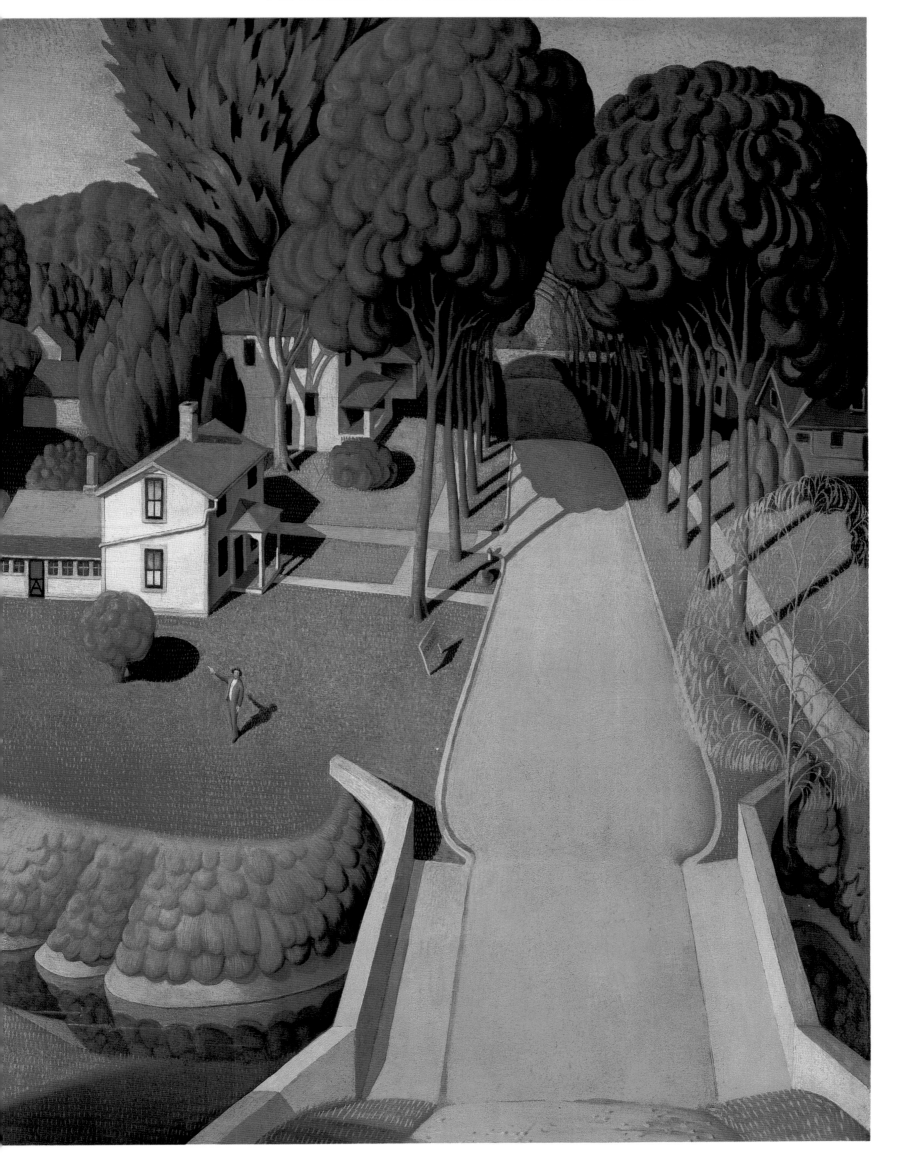

Midnight Ride of Paul Revere
1931, oil on composition board,
30 × 40 in.
*Arthur Hoppock Hearn Fund,
1950, The Metropolitan Museum
of Art, New York, NY (50.117)*

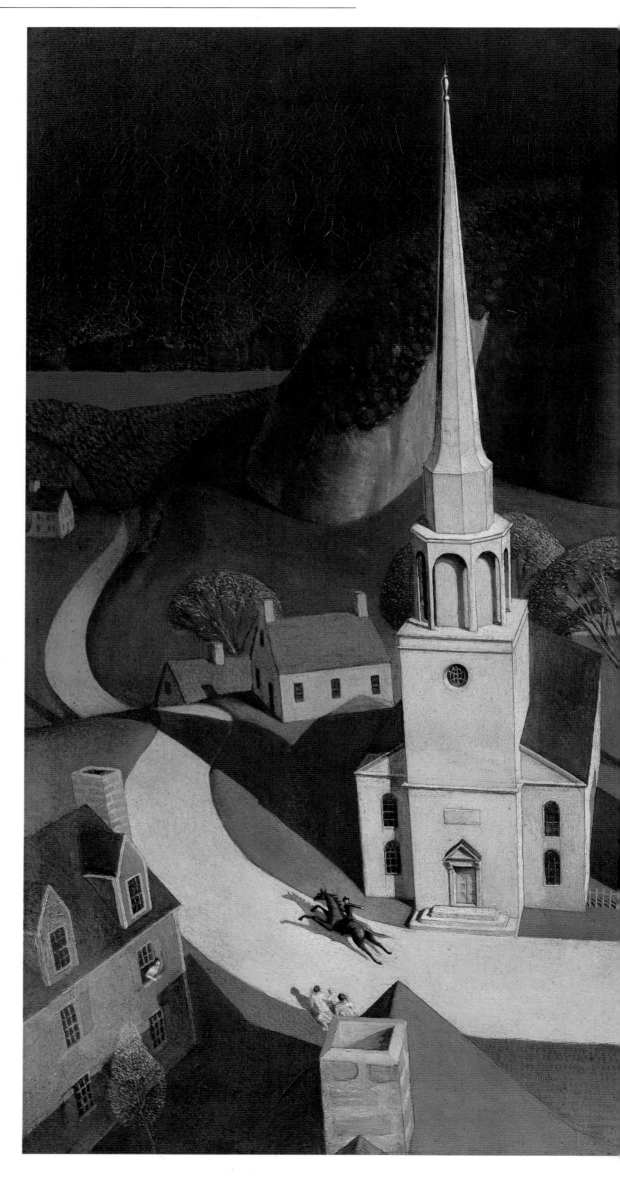

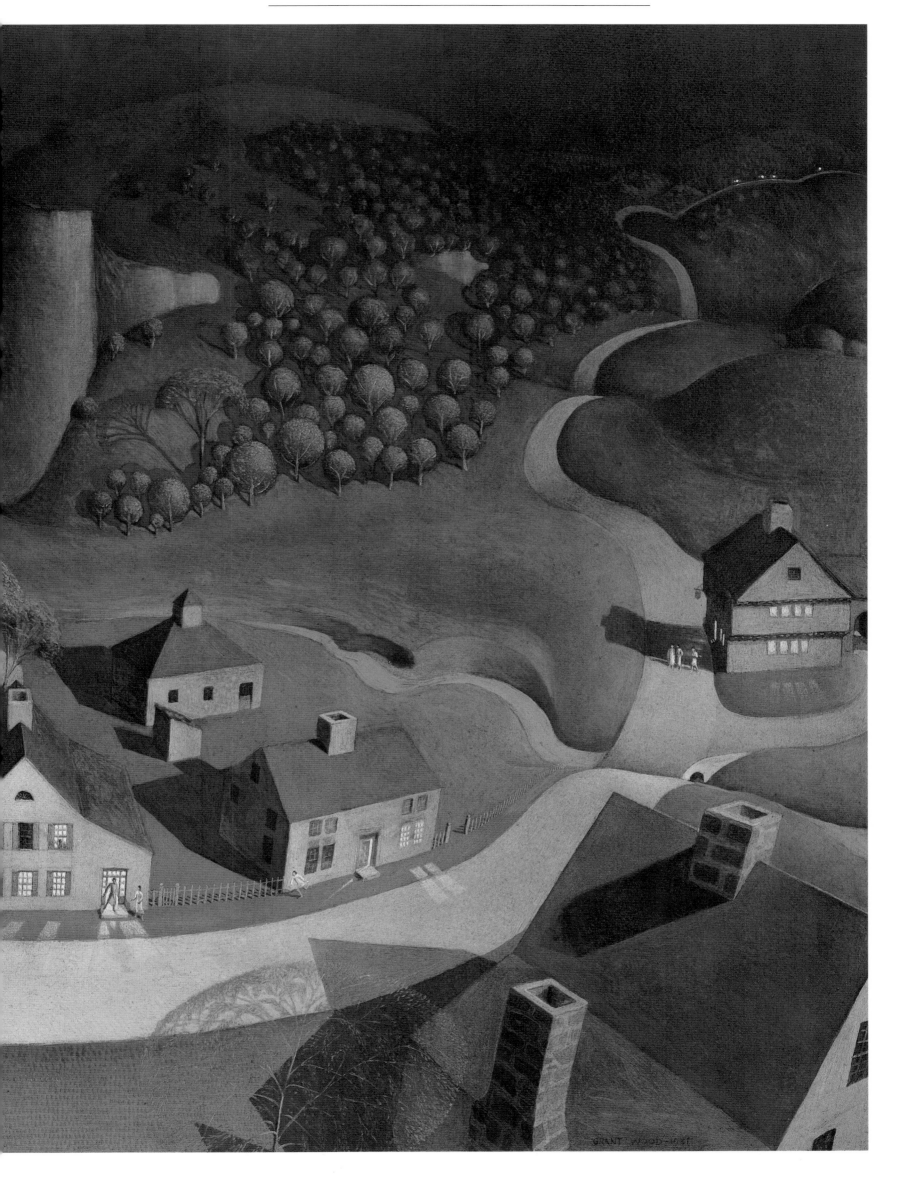

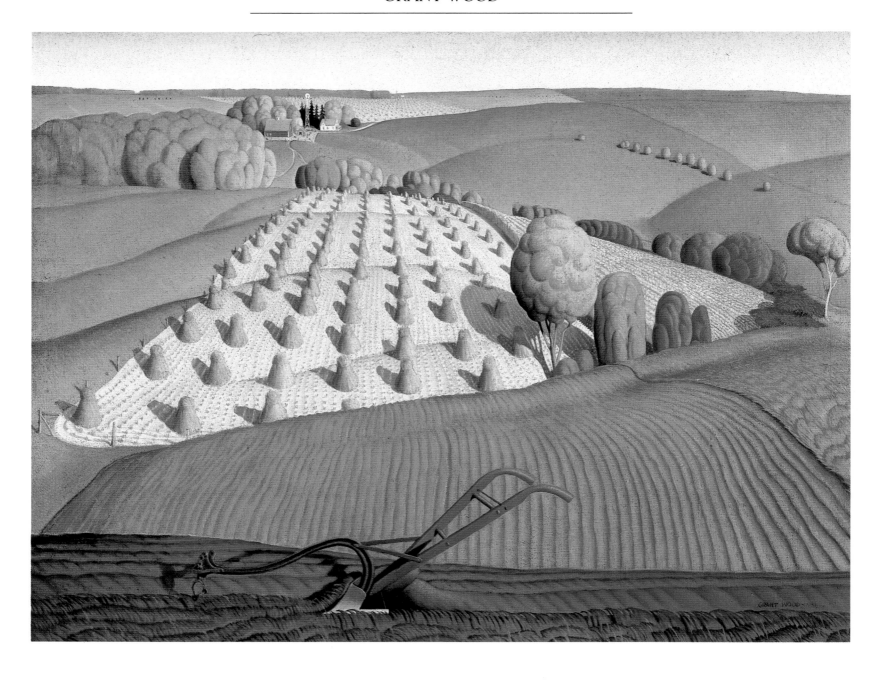

Fall Plowing
1931, oil on canvas, 30 × 40¾ in.
Art Collection of Deere & Company, Moline, IL

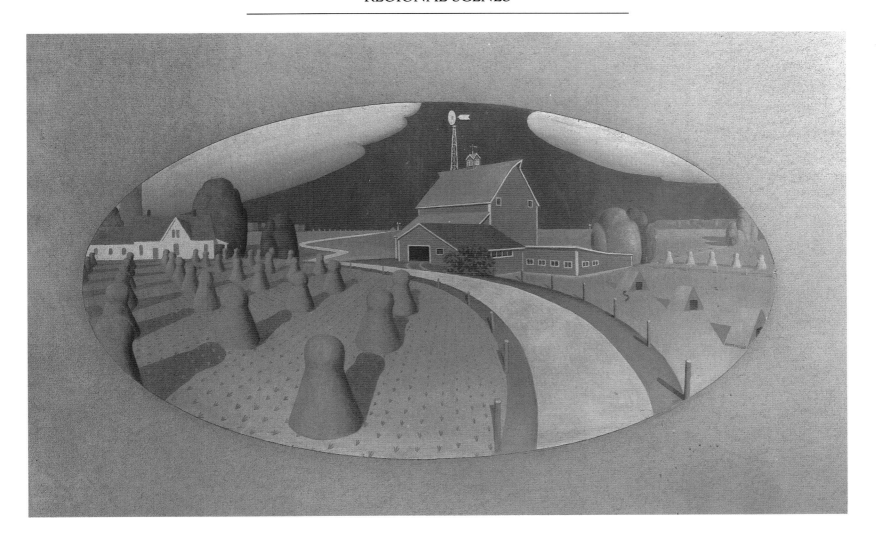

Farm Landscape
1932, oil on canvas, 23¼ × 45½ in.
Coe College Permanent Collection of Art,
Cedar Rapids, IA

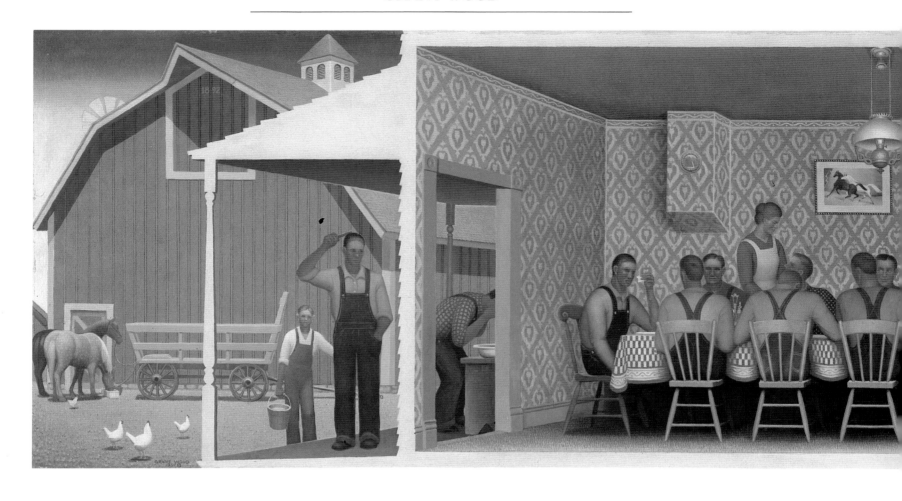

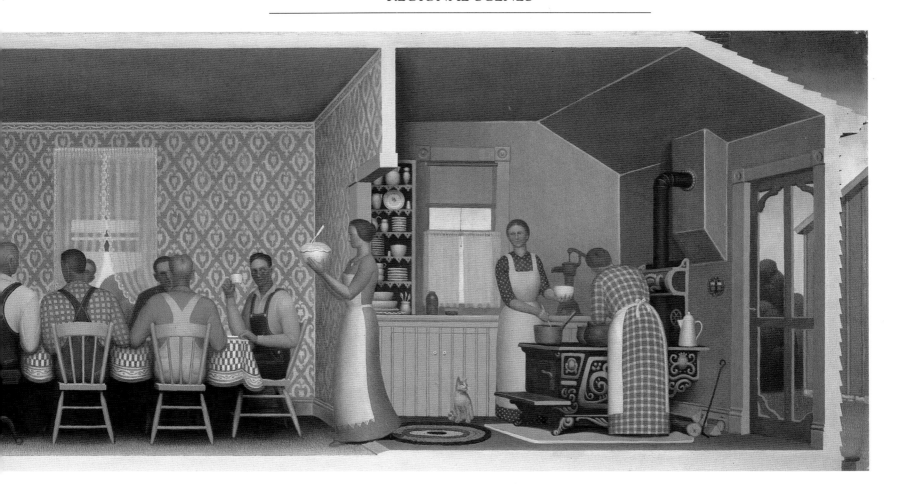

Dinner for Threshers
1934, oil on hardboard, 19½ × 79½ in.
Gift of Mr. and Mrs. John D. Rockefeller 3rd,
The Fine Arts Museums of San Francisco, CA (1979.7.105)

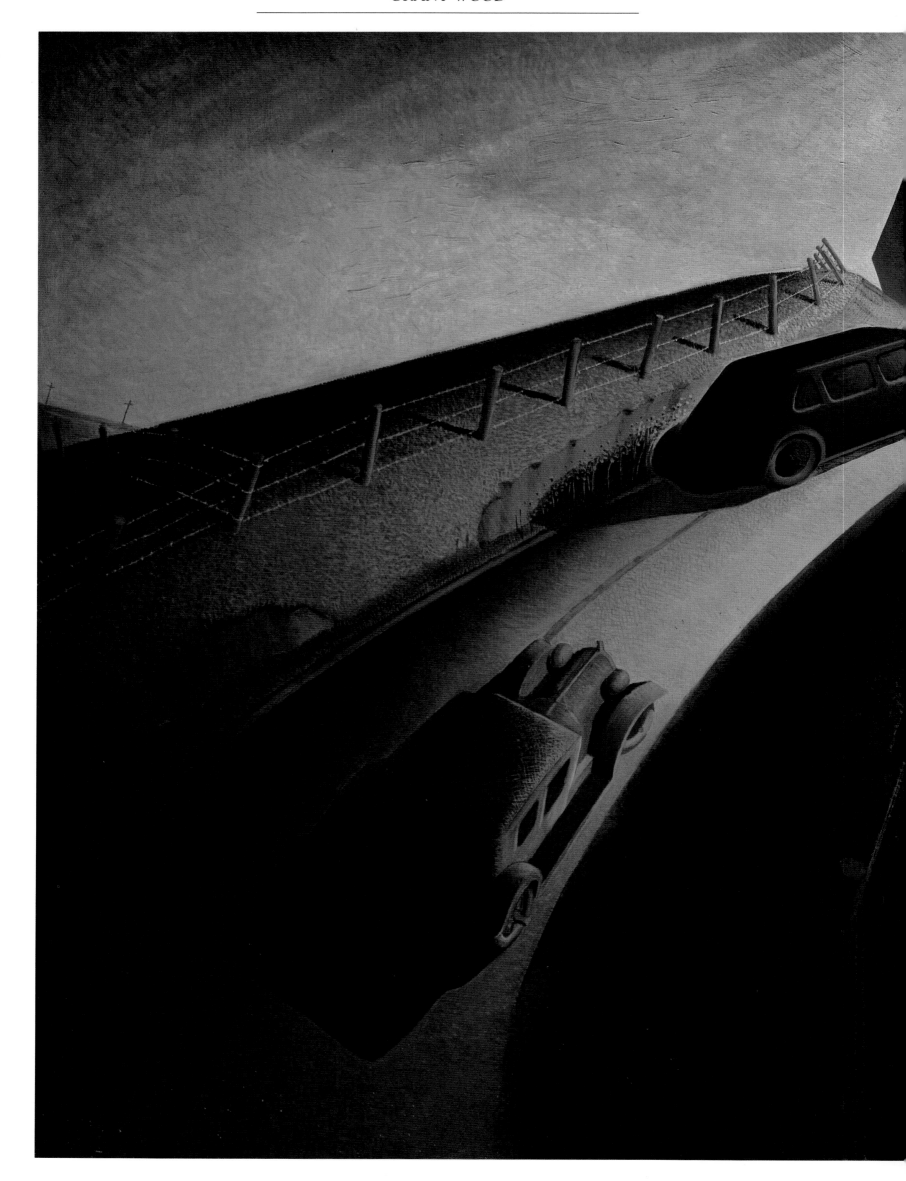

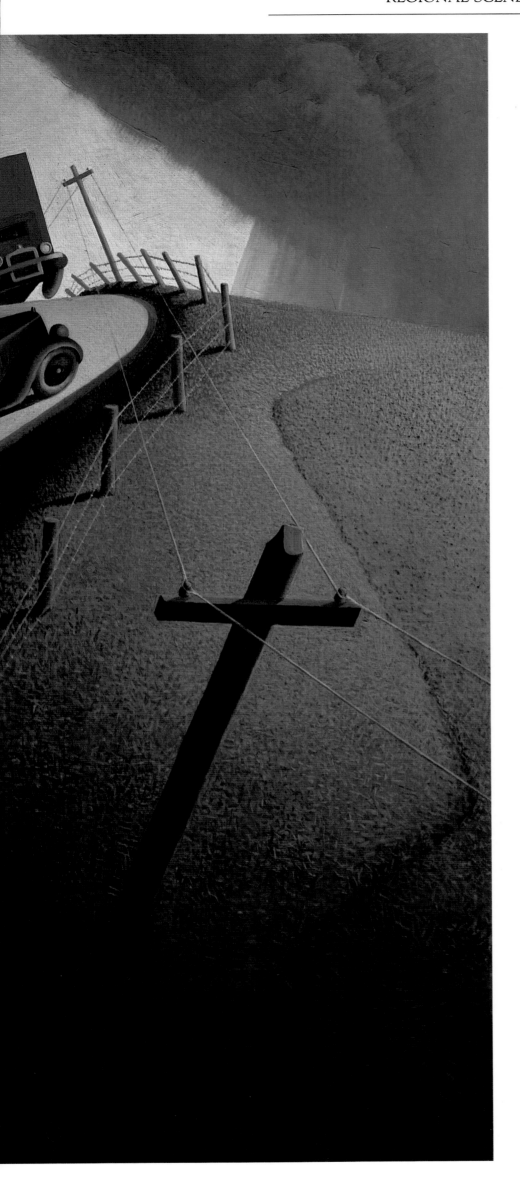

Death on the Ridge Road
1935, oil on masonite,
32 × 39 in.
*Gift of Cole Porter, Williams
College Museum of Art,
Williamstown, MA (47.1.3)*

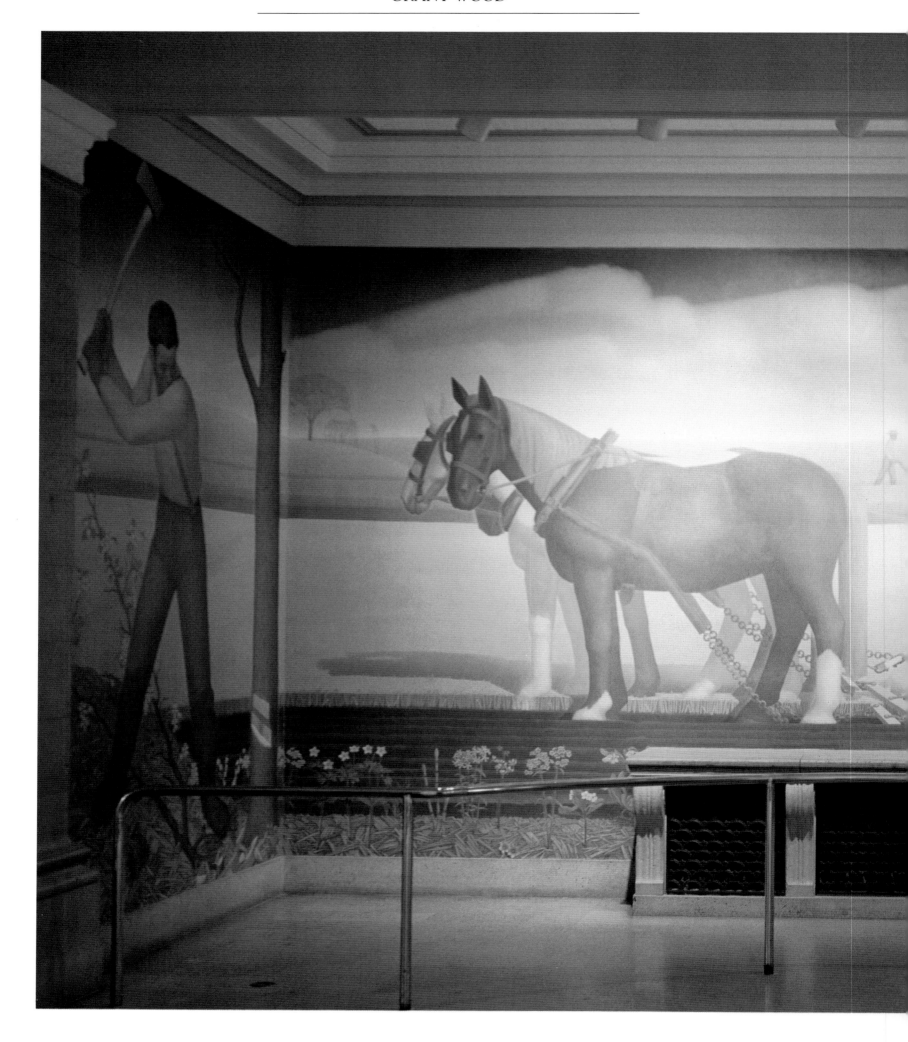

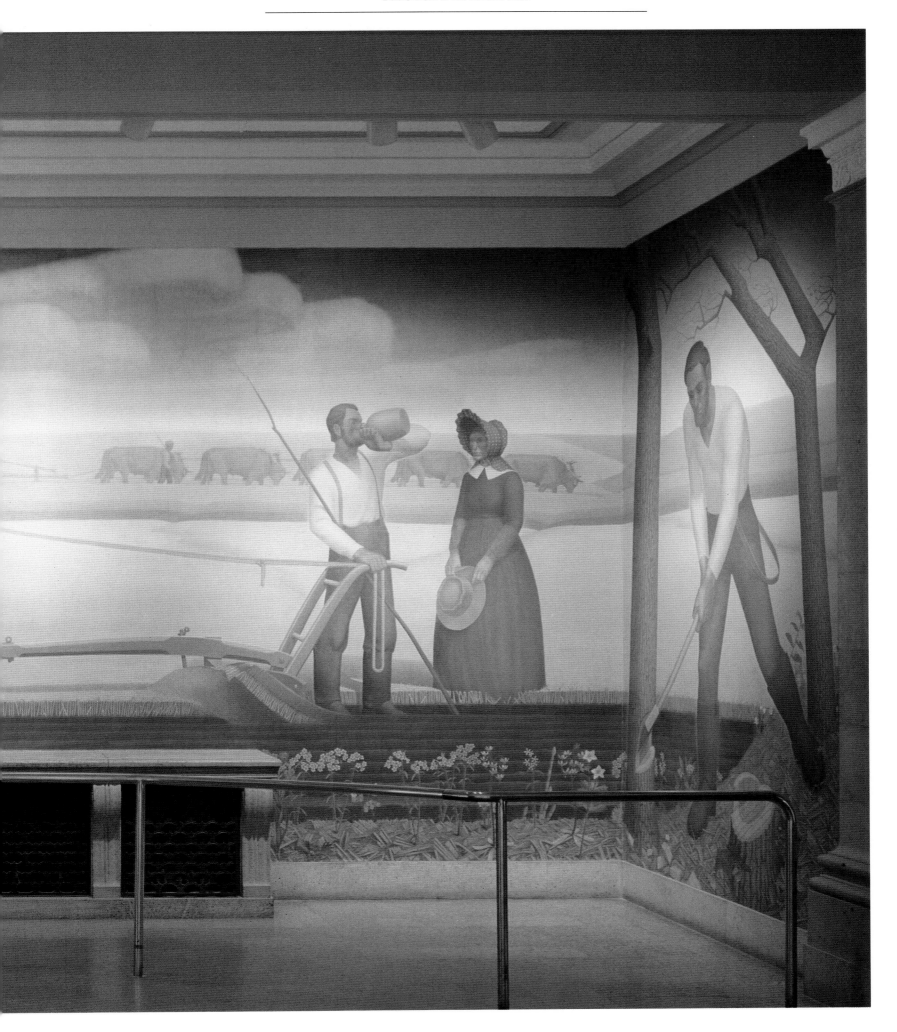

Breaking the Prairie Sod
1937, oil on canvas, center panel 11 × 23 ft.,
two side panels 11 × 9 ft.
University Museums, Iowa State University, Ames, IA

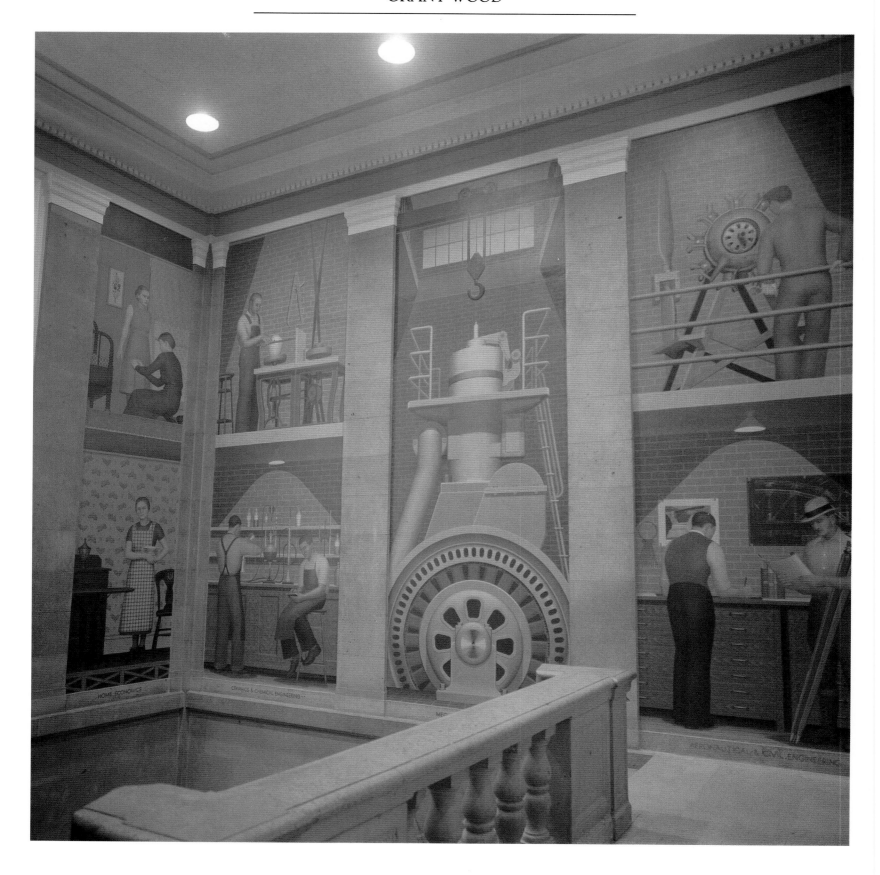

**Ceramics and Chemical, Mechanical, Aeronautical and Civil
Engineering**
1934, oil on canvas, each panel 7′ 4″ × 6′ 3″
University Museums, Iowa State University, Ames, IA

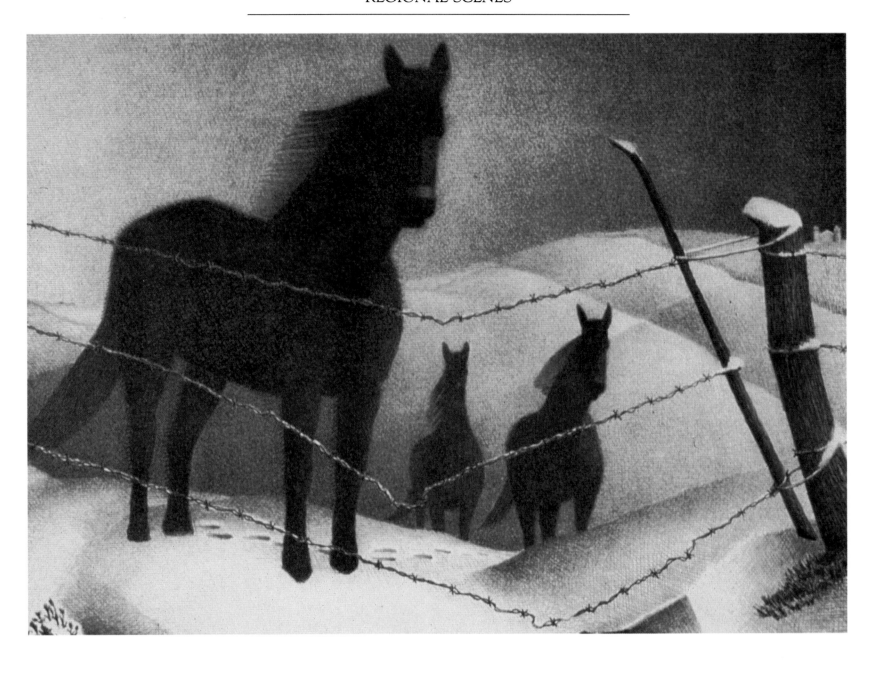

February
1940, lithograph on stone, 8¹⁵⁄₁₆ × 11⅞ in.
Gift of Harriet Y. and John B. Turner II,
Cedar Rapids Museum of Art, IA (72.12.19)

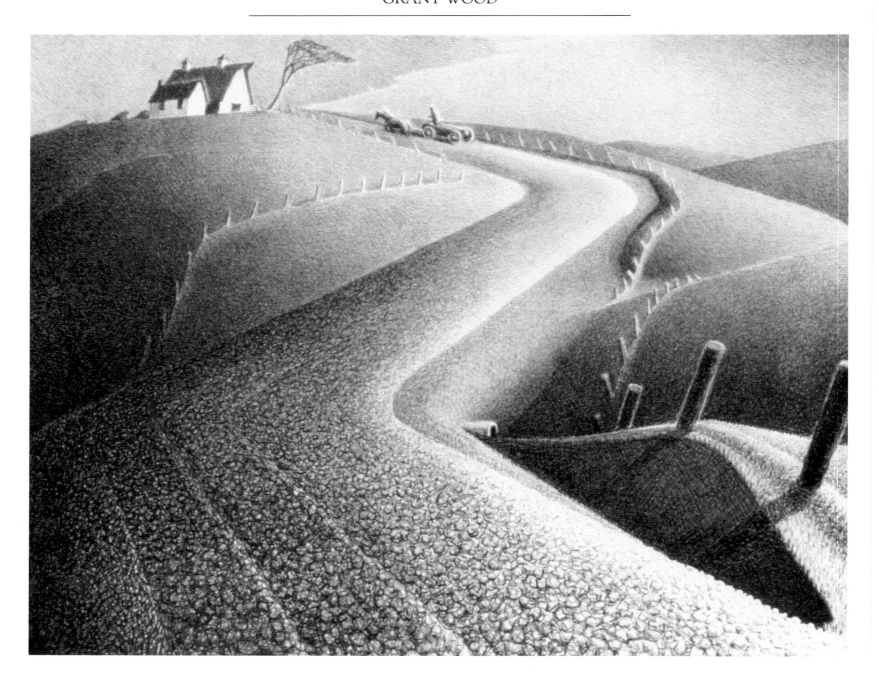

March
1940-41, lithograph on stone, 8¹⁵⁄₁₆ × 11⅞ in.
Gift of Harriet Y. and John B. Turner II,
Cedar Rapids Museum of Art, IA (72.12.41)

Iowa Cornfield
1941, oil on masonite panel, 13 × 14⅞ in.
Collection of the Davenport Museum of Art, Davenport, IA (60.1013)

LIST OF COLOR PLATES

American Gothic	76	Misty Day, Fountain of the Observatory, Paris	62	
Arnold Comes of Age	77	Old and New	58	
At Ville d'Avray, Paris	67	Old House with Tree Shadows	40	
Avenue of Chestnuts	56	The Old J.G. Cherry Plant	48-49	
Basket Willows	47	Old Sexton's Place	43	
The Birthplace of Herbert Hoover	96-97	Old Shoes	50	
Breaking the Prairie Sod	106-107	Old Stone Barn	45	
The Coil Welder	72	Overmantel Decoration	94-95	
Cover of Henry Wallace	85	Parson Weems' Fable	82-83	
Daughters of Revolution	78-79	The Perfectionist	89	
Death on the Ridge Road	104-105	Place de la Concorde	61	
Dinner for Threshers	102-103	Portrait of Frances Fiske Marshall	70	
The Doorway, Perigueux	68	Portrait of John B. Turner, Pioneer	73	
Engineering	108	Portrait of Nan	80	
Fall Landscape	41	Quivering Aspen	38	
Fall Plowing	100	Return from Bohemia	84	
Farm Landscape	101	The Runners, Luxembourg Gardens, Paris	63	
February	109	Self Portrait	81	
Feeding the Chickens	42	Sentimental Ballad	86-87	
Fountain of Voltaire, Chatenay	57	The Sentimental Yearner	88	
The Gate in the Wall	59	The Shop Inspector	74	
Grandma Wood's House	53	The Spotted Man	54	
The Horsetraders	44	Spring in Town	90	
House with Blue Pole	65	St. Etienne du Mont	60	
Indian Creek	52	Stone City, Iowa	92-93	
Iowa Cornfield	111	Truck Garden, Moret	66	
Iowa Corn Room Murals, Montrose Hotel	51	Van Antwerp Place	46	
Italian Farmyard	64	Woman with Plant(s)	75	
March	110	Yellow Doorway, St. Emilion	69	
Midnight Ride of Paul Revere	98-99			

PHOTO CREDITS
Bettmann Archive, New York, NY: pages 1, 29, 37.
Gift of John B. Turner II in Memory of Happy Young Turner, Cedar Rapids Museum of Art Archives, Cedar Rapids, IA: pages 6, 9 (top), 11, 13, 20-21, 30-31.
Collection of the Davenport Museum of Art, Davenport, IA: pages 10 (top), 24.
Herbert Hoover Presidential Library-Museum, West Branch, IA: page 22.
Nebraska State Historical Society, Solomon D. Butcher Collection, Omaha, NE: pages 18-19.
State Historical Society of Iowa, Iowa City, IA: pages 17, 25.

ARTWORK
Page 8: **Currants**
Grant Wood, 1907
Watercolor on paper, 11½ × 4⁹⁄₁₆ in.
Collection of the Davenport Museum of Art,
Davenport, IA (65.9)
Page 9 (bottom): **Lilies of the Alley**
Grant Wood, 1924-25
Earthenware flower pot and found objects, 12 × 12 × 6½ in.
Gift of Happy Young and John B. Turner II
Cedar Rapids Museum of Art, IA (72.12.38)
Page 10 (bottom): **Cedar Rapids** or **Adoration of the Home**
Grant Wood, 1921-22
oil on canvas, 22¾ × 81⅜ in.
Mr. and Mrs. Peter F. Bezanson Collection,
The Cedar Rapids Museum of Art, IA (80.1)
Page 12: **The Swimming Hole**
Thomas Eakins, c. 1883-85
Oil on canvas, 27⁵⁄₁₆ × 36⁵⁄₁₆ in.
Courtesy Amon Carter Museum,
Fort Worth, TX (1990.19)
Page 14: **Soldier in the War of 1812** (study for stained-glass window,
Veterans Memorial Building, Cedar Rapids, IA)
Grant Wood, 1927
Pencil and ink drawing, 79½ × 22½ in.
Gift of Nan Wood Graham
Collection of the Davenport Museum of Art,
Davenport, IA (65.8)

Page 15: **Self Portrait**
Albrecht Durer, 1500
Oil on canvas, 26½ × 19¼ in.
Alte Pinakothek, Munich, Germany
Page 16: **St. George**
Hans Memling, 1433-1494
Oil on canvas, 17 × 12 in.
Alte Pinakothek, Munich, Germany
Pages 26-27: **Threshing Wheat**
Thomas Hart Benton, 1939
Tempera on panel, 26 × 42 in.
Courtesy of the Sheldon Swope Art Museum,
Terre Haute, IN (42.02)
Page 28: **Kansas Cornfield**
John Steuart Curry, 1933
Oil on canvas, 60 × 38¼ in.
The Roland P. Murdock Collection,
The Wichita Art Museum, Wichita, KS (M1.39)
Page 32: **Fruits**
Grant Wood, 1938
Watercolor-tinted lithograph on paper, 7 × 10 in.
Collection of the Davenport Museum of Art,
Davenport, IA (65.42)
Page 33: **Tame Flowers**
Grant Wood, 1938
Watercolor-tinted lithograph on paper, 7 × 10 in.
Collection of the Davenport Museum of Art,
Davenport, IA (65.40)
Page 34: **The Artist in His Museum**
Charles Wilson Peale, 1822
Oil on canvas, 103¾ × 79⅞ in.
Gift of Mrs. Sarah Harrison (The Joseph Harrison, Jr. Collection)
The Pennsylvania Academy of the Fine Arts,
Philadelphia, PA (1878.1.2)
Page 36: **The Good Influence**
Grant Wood, 1936
black carbon pencil, india ink and white gouache on tan wove paper, 20½ × 16¼ in.
Collections Fund, The Pennsylvania Academy of Fine Arts, Philadelphia, PA
(1952.6.2)